ARTISTRY: THE WORK OF ARTISTS

ARTISTRY: *THE WORK OF ARTISTS*

V. A. Howard

Hackett Publishing Company
Indianapolis • Cambridge

Library of Congress Cataloging in Publication Data

Howard, V. A., 1937 -
 Artistry, the work of artists.

 Bibliography: p.
 1. Aesthetics. 2. Art — Philosophy. 3. Education
 I. Title.
BH39.H66 700†.1 81-6265
ISBN 0-915145-06-5 AACR2

To Nelson Goodman,
with gratitude and affection

CONTENTS

FOREWORD

Professor V. A. Howard's concern, in this book, is with the work of artists, not the work of art. He turns our attention from art products and their merits to the artist's underlying techniques and capacities — to the craft in art, and the art in craft.

With this shift in focus, he illuminates a wide variety of topics of interest to art, philosophy, and education: understanding and knowing, rule and skill, description and demonstration, sensation and suggestion, practice and strategy, awareness and inquiry, repetition and routine, imagination and creativity, vision and mastery. Taking the acquisition of craft as his fundamental theme, Professor Howard insightfully studies the special craft-language used to help learners get the right action, and the right feel of action. Such "action directed language," typically meta-phorical, gestural, and suggestive, embodies, in its many-sided symbolic functioning, the lore of the craft as well as the lore of its teaching. Irreplaceable by scientific explanatory language, it yet interacts with that language in a continuing dialectic as science progresses and as arts advance. "Scientific knowledge," Howard says, "can inform though it cannot displace the practical perspective; for such perspective is of the essence of creative imaginative understanding." The numerous penetrating analyses and shrewd observations with which Howard backs up this judgment comprise an important contribution to contemporary discussions both of art and of education; they significantly deepen our comprehension of the links between learning, doing, and thinking.

A distinctive feature of Howard's treatment is his brilliant use of the singing voice as a major domain of application and analysis, a use that will prove especially enlightening to primarily philosophical readers. Conversely, those readers primarily concerned with the art of song will find here a wide-ranging philosophical interpretation of their world of performance and training. For those, finally, from whatever discipline, who seek a general understanding of creative thought and its development, Professor Howard's work on this theme opens broad new avenues of insight, thus providing an example, as well as an account, of its subject matter.

ISRAEL SCHEFFLER

PREFACE

This book takes an epistemological look at artistry, not in the sense of individual achievement or merit, but in the conservatory sense of the occupation of artists, the trained skills and techniques required to be an artist of notable rank. My concern is for the work of artists, what they come to know how to do, or what otherwise might be described as the rôle of craft in art. Indeed, the book is mainly about craft from an artistic perspective, and I once thought to name it *Craft and Art,* the word craft coming first to indicate the dominant concern, until it occurred to me that on one of its meanings, "artistry" connotes just that element of apprenticeship I wished to explore.

Then too, not everything exhibiting artistry qualifies as "Art" in a sense pleasing to purists, let alone to philosophers. There is artistry at cooking, carpentry, tennis, and teaching, to mention just a few arts that are not Arts. So although the discussion centers on craft in the service of Art, especially performing Art, the ideas invoked en route of rules and routines, of instructional languages, of creation and imagination, of practice and skills, are by no means confined to Fine Art. Withal, craft is perhaps the safer if duller word, though failing by itself to capture the special connection to Art intended.

As a philosopher, I became interested in the work of artists when, as an opera singer *(manqué),* I began to wonder what sort of knowledge, if that, it was that I had so painstakingly acquired yet about which I was so inarticulate. For the most part, my philosophically pristine standards for anything called "knowledge" seemed inappropriate. Still, I knew I had learnt something. A decade-long affiliation with Harvard Project Zero did much to sharpen my views of practical knowledge in the arts and to swell the progress of this inquiry. Many of the ideas presented here have been discussed in Project seminars since 1969. As well, my courses in aesthetics and on teaching and learning processes at the University of London and at Harvard University provided a welcome forum for many of the same ideas.

Earlier versions of all but the first two chapters were presented as lectures to either philosophy or education colloquia at the University of London, Sussex University, Harvard University, the University of Pennsylvania, the University of Chicago, the University of Toronto, and the University of Victoria. Would

3

that I could severally acknowledge so many who by their comments contributed so much. Most of chapter 2 appeared as an article by the same title in *Interface* vol. 6 (1977), and ancestral portions of chapter 6 and the Postscript appeared in *The Arts and Cognition* (1977), edited by David N. Perkins and Barbara Leondar and published by the Johns Hopkins University Press. I am grateful to the editors and publishers for permission to use that material.

I have accrued many artistic and intellectual debts too numerous to list. But among teachers of singing, I cannot forego mention of the late Alfred Rosé, Bernard Diamant, and Yvonne Rodd-Marling, who gave so much of themselves in trying to teach me how to give of myself. Among phychologists, Paul Kolers and David Perkins have listened patiently and criticized kindly on countless occasions. Friendship alone accounts for their excessive tolerance. Among philosophers, my primary debt is to Nelson Goodman, as these pages well attest, and to whom the book is dedicated. As founding Director of Project Zero, he launched me on several courses of inquiry that helped to reconcile the artist and philosopher within me. I am no less grateful to my colleague in the Harvard Graduate School of Education, Israel Scheffler, who kindly read an earlier draft of the manuscript and whose encouragement and many valuable comments helped propel me through some dark moments. Heartfelt thanks to Messrs. James N. Rogers and James N. Hullett of Hackett Publishing Company for painstaking editorial assistance and sage advice throughout the production stages. Finally, thanks are due to my students in Britain, Canada, and the United States, who I hope will recognize bits of themselves in these pages. After all, the aforementioned persons *are* partly responsible for whatever is worthwhile herein, though no one, I trust, will hold them accountable for any of my shortcomings and errors.

Deer Island,
New Brunswick
August 1980

INTRODUCTION

1. *Objectives*

Craft, the handmaiden of Utility, poor sister of Art and Science, precursor of Technology, and alleged corruptor of aesthetic theories, stands in need of philosophical defense. More or less as a side effect of attempts to understand other matters with which craft is easily confused, craft has been misunderstood, underrated, and passed off as an inferior brand of "procedural knowledge," if knowledge at all. The result is a gap in epistemology incapable of being filled by a view of craft as "canned reaction" adding "no new factor to our experience" because it does no more than "crystallize prejudices into stereotypes."[1] That is the prevailing philosophical opinion to which this essay gives resistance, notwithstanding, it must be emphasized, craft's humble status as Faithful Servant of Higher Ends.

A word about the phenomena of craft. The kind of practical knowledge — or better, practitioner's knowledge — that I am broadly calling craft includes every sort of outcome: from trained capacities deployable in performances (as in acting or singing), to those having mental or physical effects (as in the healing or teaching professions), to the useful objects of handicraft. The binding element in all such undertakings is learning, knowing, or teaching *how to do* something to achieve a particular outcome. Hence, my interest in craft reflects the modern English use of the term to refer to a skill, art, or occupation in such a way as to include, but without restriction to, manual skills or handicraft.

In setting out the rudiments of a philosophy of craft I have in mind two basic objectives. One is to reconnoiter a philosophically neglected area of human understanding variously labelled "artistry," "craft," "know-how," "technique," or "skill" mostly from the perspective of the arts though in a way broadly sensitive to work, sport, and education. Another is to examine the languages of craft, the special jargons in which recondite, mostly inarticulate procedures and traditional lore find verbal expression that is as fragmentary as it is pointed. Together these inquiries aim to show how, at higher levels of achievement, craft may direct artist and artisan alike beyond itself, beyond technique and skill, to an often immensely detailed vision of mastery.

Psychologists have covered some of this ground in greater,

though different, detail than philosophers — to such an extent that one cannot afford to ignore their findings and theories about skill acquisition, massed versus distributed practice, "plateaus," and the like. Neither of course can one afford to ignore philosophical predecessors like Collingwood and a handful of others who, though few in number, have made significant inroads along lines of the first of my two objectives. Oddly enough, though I hesitate to speculate why, the ad hoc languages of craft, which are often models of model languages, have not much interested philosophers, possibly because, at a distance, they appear to be *merely* ad hoc and of little theoretical significance. Without a detailed case analysis at hand, this impression is difficult to dispel. Again, psychologists have ventured tentatively in this direction with a few studies of the influence on skill acquisition and improvement of tailor-made descriptions. But this remains largely virgin territory to both disciplines. In that regard it is a secondary aim of this investigation to show how the philosophy and psychology of craft dovetail in mutually illuminating ways.

The ultimate target of all this theoretical light is the area of critical judgment and understanding inhabited by the artist or artisan as one committed to the refined execution of a performance or task. We need a broadly illustrative case to analyze to give our philosophy feet. For that purpose chapter 2 undertakes to describe the craft of the classical singer whose art first requires the forging of a singing voice of considerable substance and flexibility. The singer's odyssey is a poignant and revealing one to analyze in a number of respects.

To mention a few: In singing there is a sharp difference between art and craft but no separation. There is a traditional and elaborate metaphoric language of singing used to describe and direct its stages. The singer has a whole-part problem of embedding one facility within another in a structure of staggered progress; in other words, singing is a *complex* skill. Corresponding to this complex of facilities is a regimen of precisely aimed exercises and visual imagery, while working against them are difficult obstacles to self-observation and assessment. Accordingly, there is the necessity of establishing perceptual rapport between singer and trainer, particularly as regards the correlation of sensation and sound. Despite all the communication problems, there is in physiology a reasonably solid and independent diagnostic basis for singing. Finally, the failure rate, even for minimum competency, is very high, leaving the singer in the

permanent quandary of worrying as much over his craft as his art. Certainly other arts and crafts exhibit many of these same features and could just as well be used to illustrate them; but singing is, if not unique, at least salient in combining them.

2. *Plan of the Book*

The book opens by examining the art/craft distinction with the aim of redrawing it theoretically and practically (chapter 1). Chapter 2 presents a case analysis of singing intended to illustrate concretely as print permits both the art/craft distinction and many of the ideas to follow. Thence on to the logical features of the technical languages and symbol systems of craft used for such instructional purposes as directing, showing, and telling (chapters 3 and 4). Chapter 5 considers the roles of creativity and imagination in craft. Chapter 6 offers an epistemological perspective on the practice and routines needed to acquire and to sustain particular skills. Finally, the postscript and conclusion assays some relevant domains of psychological research on practice and skills within and without the arts.

Though written to have a cumulative effect, most chapters stand alone, with the exceptions of 3 and 4, and may be read as separate, intersecting essays.

There are some minor restrictions to be observed, however. Psychologists are requested not to read chapter 6 and the postscript unless they also read chapter 5. Educationists are forbidden to read chapter 5 unless they also read chapter 6 and the postscript. Philosophers are obliged to read chapters 2, 5, and 6 if they intend to read chapters 1, 3, and 4. (They may skip the postscript.) And singers are excused from reading chapter 2 unless they read it all.

"Convenience is just a state of mind," said Dawlish. "It's understanding that's important. Understanding the symptoms you encounter will refer you to just one disease. You find a man with a pain in the foot and the finger and you wonder what he could possibly be suffering from with two such disparate symptoms. Then you find that while holding a nail one day he hit his finger with a hammer, then dropped it on his toe."

Len Deighton, Horse Under Water

1 *Art, Craft, and Skill*

1. *Borderline Cases*

The aim of this chapter is not so much to define as to stake out the ranges and relations amongst our ordinary notions of art, craft, and skill, and then to streamline them somewhat for certain practical and theoretical purposes. A convenient way to begin is by coming to terms with Collingwood, whose deceptively simple discussion of art and craft,1 though by no means the first word, has more or less stood as the last since 1938 — which is to say that there have been many convincing objections to Collingwood's theory of art though none to his theory of craft.

The reader will recall that the opening pages of Collingwood's *The Principles of Art* are primarily concerned with distinguishing art from craft on the grounds that while the two are nowadays overlapping concepts and were once coextensive (up to the seventeenth century), the modern conception of art is essentially different from that of craft. That is, though contingently related to art, craft is neither necessary nor sufficient for art as presently conceived. To think otherwise is to fall prey to a "technical theory of art" which either treats art as the preconceived end of stereotypical means or as the preconceived means of some stereotypical end such as amusement, instruction, or advertisement.

Though craft can no longer be trusted as the genus of art, its influence on art remains considerable, as Collingwood is first to acknowledge. "Great artistic powers may produce fine works of art even though technique is defective; and even the most finished technique will not produce the finest sort of work in their absence; but all the same, no work of art whatever can be produced without some degree of technical skill, and, other things being equal, the better the technique the better will be the work of art."2

Why then does the confusion between art and craft arise? Very simply, because as the two conceptions have drawn apart historically, some art-craft remains as a species of both art and craft in the area of overlap. Though logically an area of borderline cases, this confusion is notably large particularly on the side of the arts. That is owing to the contingent connection between craft and most art and to the even closer connection between craftsmanship and quality whereby the former is "a necessary condition of the best art" though "not by itself suf-

9

ficient to produce it."3 Thus the area of art-craft includes the
bulk of good art besides all the rest that is a product (not only)
of craftsmanship. In addition to mediocre and bad art, art-craft
also comprises so-called "decorative art," objects combining
aesthetic considerations with utility such as automobiles and ash-
trays, and finally, the occasional wholly aesthetic products of
normally utilitarian crafts: ceramic jewelry, textiles, glass sculp-
ture, pottery and the like.

No doubt the advent of the Found Art, Conceptual Art, and
Minimal Art movements and others explicitly repudiating the
ideals of craftsmanship has had the effect not only of widening
the area of art without craft but of undermining even the assump-
tion of a necessary link between craftsmanship and quality. The
overall effect, however, is to strengthen Collingwood's major
contention that the concepts of art and craft are essentially dif-
ferent and to amplify his logical caution regarding certain ways
of trying to show that difference. The fact that art-craft is not
reducible to craftsmanship even where the latter may be a
necessary condition for the best art, points up the futility of try-
ing to draw a theoretical line between art and craft anywhere
within the area of "precarious margins."

> Because art and craft overlap, the essence of art is
> sought not in the positive characteristics of all art, but
> in the characteristics of those works of art which are
> not works of craft. Thus the only things which are
> allowed to be works of art are those marginal ex-
> amples which lie outside the overlap of art and craft.
> This is a precarious margin because further study may
> at any moment reveal the characteristics of craft in
> some of these examples.4

For example, "If unplanned works of art are possible, it does
not follow that no planned work is a work of art."5 Collingwood
cites this as an instance of the "fallacy of precarious margins"
underlying some forms of romanticism. If so, then two recent
writers on the art/craft controversy qualify as romantics: T. R.
Martland, who insists that art is never "something which men
grasp and predict beforehand," never "a service to categories
which men already have completed";6 and G. B. Fethe, who
argues that craft aims "to create objects which have an assigned
place in the world of common activities"7 (as if art never did).

Both writers rummage about on the precarious margins of art-craft for a line that cannot be drawn.

An apparent exception is H. Osborne arguing in the opposite direction to the effect that none of the usual criteria for distinguishing art from craft, including Collingwood's, are sufficient.[8] But Osborne, too, misses Collingwood's point which is not that anything exhibiting the traits of craft is not art, but rather that anything exhibiting *only* such traits singly or together is likely to be just craft. From a Collingwoodean standpoint, these writers are going about the task of distinguishing art from craft in the wrong place in a logically wrong way.

2. *Symptoms of Craft*

The right place is outside the area of precarious margins in whatever distinguishes art plus art-craft from craft *simpliciter;* and the right way, for craft anyway, is to provide a set of flexible symptoms, not fixed sufficient conditions, for its identification.[9] Above all, Collingwood's familiar six characteristics of craft are intended to illuminate the traditional meaning of the term as "the power to produce a preconceived result by means of consciously controlled and directed action."[10] Besides a distinction between planning and execution implied by foreknowledge of results (his number 2), (1) "Craft always involves a distinction between means and end" according to which (3) the ends are prior to the means in planning and conversely in execution; (4) a distinction between "raw material and finished product or artifact"; (5) a distinction between "form" or the changes wrought by craft and the "matter" identical in raw material and finished product; and (6) a tripartite "hierarchical relation between various crafts, one supplying what another needs, one using what another provides" in which (a) the finished product of one craft is the raw material of another; (b) there is a "hierarchy of means" whereby one craft supplies another with tools; or (c) there is a "hierarchy of parts" where different trades or crafts are enlisted to produce the separate parts, say, of an automobile.[11]

Interestingly, Collingwood proceeds more cautiously with craft than with art, at least to the extent of not taking the univocal nature of craft for granted in enumerating its criteria. This strategy is a wise one considering the equally precarious margins separating craft from technology and labor. In any event, after listing these "six chief characteristics of craft," he describes

their logical function:

> Without claiming that these features together exhaust
> the notion of craft, or that each of them separately is
> peculiar to it, we may claim with tolerable confidence
> that where most of them are absent from a certain
> activity that activity is not a craft, and, if it is called
> by that name, is so called either by mistake or in a
> vague and inaccurate way.[12]

Only the first two of Collingwood's criteria of craft appear
to be conjointly necessary, being always involved or "absolutely
indispensable to craft."[13] So instead of fixed sufficient criteria,
Collingwood presents variable symptoms, the major consequence
of which is the trading of sharp definitional lines for blurred
boundaries.

Specifically this means that all six characteristics tend to be
present in craft more often than not, though all but the first
two may be absent from craft and any of them present else-
where, for example, in art or technology. Because the list is not
exhaustive, it does not follow from the absence of some of the
characteristics that an activity is any less, or less genuinely,
craft than one exhibiting them all. Finally, although the items
listed are severally not sufficient, they may yet be conjunctively
sufficient and two of them necessary — which in this instance
means that an activity is craft if it has all of the enumerated
features and only if it has at least the first two of them.

The latter condition might appear to conflict with the claim
that "where most of them are absent . . . that activity is not a
craft"; but of course it does not, keeping in mind that the
presence of features (1) and (2), foreknowledge and the means-
ends distinction, are but a conjointly necessary condition, and
that there may be other features besides those listed which if
conjoined with those that are necessary may be sufficient to
call something craft. It is an otherwise reliable rule that the
absence of most such features marks an absence of craft. A
symptomology requires that each case be examined on its own
in terms of the available criteria, a point to which Collingwood
alludes in his warning against the shoals of precarious margins.

If that is the logic of Collingwood's account of craft, how does
it relate to his effort to distinguish art from craft and, beyond
that, to the nature of art itself? The distinction takes the general

form: craft subtracted from art leaves an aesthetic remainder; that is, art is possible in the total absence of craft or any of its symptoms, and, in its presence, irreducible to craft.[14] Inversely, without excluding any of the traits of craft from art, none of them emerge universal (and therefore essential) to art such that activities exhibiting only those traits are likely to be just craft. The way is then clear, except for two further skirmishes with magic and amusement,[15] for a full address to the question, What is art? Hence the progression is from what craft is and art is not to what art is with an increasing assurance toward the end.

It is true, as Osborne says, that "the grounds of differentiation of art and craft suggested by Collingwood . . . envisage his own peculiar theory that a work of fine art is a mental created object whose material embodiment is irrelevant to its existence."[16] But it is equally true that those grounds are independent of that theory. One can accept Collingwood's account of craft and the negative description of art without accepting his view of art as an imaginative creation expressing emotion[17] and "not an artifact, not a bodily or perceptible thing fabricated by the artist, but something existing solely in the artist's head."[18] Seldom has a theory of art provoked such displays of mock horror amongst philosophers. Still, one cannot ignore the substance of their complaints, aptly summed up in Margaret MacDonald's remark that "an imaginary picture or statue just isn't a picture or statue because these words stand for works which need hands as well as heads to bring them into existence."[19]

Fortunately, the particulars of Collingwood's theory of art are not at issue here, though its logic has one important consequence for the art/craft distinction: the initial negative characterization of the aesthetic remainder, after all traces of craft have been removed, is eventually replaced by a positive set of sufficient conditions. The result is an essential difference between art and craft encompassing both art *simpliciter* and art-craft, the latter being no less than crafty art. Providing sufficient conditions for the aesthetic remainder is what prevents the area of overlap between art and craft becoming a graded merger, over precarious margins, of art into craft. In other words, none of the sufficient conditions for art turn out to be symptoms of craft, so that not merely a difference at the extremes but an essential difference remains throughout. This means that there are no degrees of art, only degrees of craft in art.

Up to the point of introducing his idealistic theory of art, it

is an open question on Collingwood's own ground whether the
distinction between art and craft is one of degree or of essential
difference. However, Collingwood makes it clear from the be-
ginning that he will have no truck with any theory that would
"tend to subsume the philosophy of art under the philosophy of
craft."20 But that is not the only alternative: it is possible to
construe them as intersecting concepts yet differing by degree on
a continuum without any reduction. There are two ways of
arguing effectively against Collingwood on this point. One is to
attack the specifics of his symptomology of craft as being sub-
stantively, not logically, inadequate to craft. The other is to recast
the aesthetic remainder as a matching symptomology for art
having the effect of rendering the margins of art and craft
mutually precarious. A brief excursion in both directions is
justified in the interest of showing that where we cannot always
identify a practical difference, there is little point in forcing one
in theory. Up to now I have strung along with Collingwood in
using the term "art-craft" to designate crafty art. Henceforth, the
hyphen will be taken seriously even to the extent of arty craft.

3. *Symptoms of Art*

One need not agree that the existence of a work of art lies
in its being conceived to find reason for Collingwood's denial
that a work of art is an artifact. Even his generous interpretation
of "artifact" as including musical sounds and other kinds of per-
formances excludes much that now goes under the panoplies of
Conceptual and Found Art. Furthermore, typical *objets d'art*
such as paintings, sculptures, and literary texts may go unap-
preciated, ignored, even unrecognized as works of art. A Mon-
drian used to patch a broken window, a Brancusi used as a door-
stop, or a sonnet in quarto burned as fuel are not functioning
as works of art. Still it is slim consolation to be told that,
"There is no such thing as an *objet d'art* in itself; if we call any
bodily and perceptible thing by that name or an equivalent we
do so only because of the relation in which it stands to the
aesthetic experience which is the 'work of art proper.' "21 We
continue to bewail the loss or destruction of the perceptible
object, and full retreat into the artist's head does not solve the
problem of when any object, event, activity, idea, or experience
is functioning aesthetically.

If indeed that is the problem, then it is less a question of
what and where in the world art is as of *when* it is. Perhaps then

it is possible to avoid some of the ontological hazards of a frontal assault on "What is art?" by the flanking question "When is Art?" — which suggests a reconception of the problem in terms of transient function rather than fixed ontology. That anyway is the advice of Nelson Goodman[22] whose "symptoms of the aesthetic"[23] is a kindred attempt in the recent literature to do for art what Collingwood does for craft; namely, to specify the several conditions under which anything, including recognized *objets d'art,* functions aesthetically.

Goodman's theory of art, though radically different from Collingwood's, nonetheless bears a logical resemblance to the latter's theory of craft. Goodman's theory is a complex as well as controversial one, and I shall have recourse to parts of it later on. For the moment, it is of interest solely for its diagnostic approach to the nature of art as a plausible complement of Collingwood's symptomology of craft and for the light it may throw on the similarities and differences between art and craft.

Goodman proposes to analyze aesthetic function in terms of a special subset of symbol functions. In *Languages of Art,* he outlines a general theory of symbols based on his concept of "notationality"[24] as designating the limiting extreme of five independent syntactic and semantic conditions. Similarities and differences amongst *systems* of symbols[25] in ordinary or extraordinary use are then plotted grid-like by their degrees of conformity or nonconformity to the five requirements of notationality. Total nonconformity defines the limiting opposite extreme from notationality: so-called "dense"[26] symbol systems. Together with other symbol relations such as denotation and exemplification[27] Goodman proceeds to describe logically the types and functions of different symbol systems: language, pictures, scores, maps, samples, diagrams, and the like, variously used to describe, define, measure, notate, exemplify, quote, depict, or express.

Most symbols in common use — language, for instance — are capable of more than one function; for example, to describe, quote, or express. Conversely, such functions as expression and representation are together or separately possible by a wide range of symbols — by pictures, music, language, or gestures. Though works of art are readily observed to describe, represent, or express, the idea of aesthetic function as such is not so readily reduced to any one of them, notwithstanding Collingwood's singling out of expression as *the* distinctive function of art.[28]

Neither, of course, can aesthetic function be denied in principle to even the humblest of objects, say, a stone in the driveway,29 considering the varieties of art and aesthetic experience possible. Nor, despite the wide swath of aesthetic function, does it follow that simply to be a symbol is in itself to be a work of art. Nor, once again, can it be overlooked that even recognized *objets d'art* do not always function as art. In the face of such circumstances, trying to tell what is or is not a work of art is rather like trying to capture a pigeon by pouring salt on its tailfeathers. The question of aesthetic function, however, of "when" rather than "what" is art, is more like spotting a pigeon in flight than capturing one on the ground: it does not require the quarry to stay put.

Goodman lists four symptoms of the aesthetic functioning of symbols:

> (1) syntactic density, where the finest differences in certain respects constitute a difference between symbols — for example, an ungraduated mercury thermometer as contrasted with an electronic digital-read-out instrument; (2) semantic density, where symbols are provided for things distinguished by the finest differences in certain respects — for example, not only the ungraduated thermometer again but also ordinary English, which is not syntactically dense; (3) relative repleteness, where comparatively many aspects of a symbol are significant — for example, a single-line drawing of a mountain by Hokusai, where every feature of shape, line, thickness, etc., counts, in contrast with perhaps the same line as a chart of daily stockmarket averages, where all that counts is the height of the line above the base; and finally (4) exemplification, where a symbol, whether or not it denotes, symbolizes by serving as a sample of properties it literally or metaphorically possesses.30

Emphasis here is upon such aspects of art as its "nontransparency" — "upon the primacy of the work over what it refers to"31 — its nuances of significance and structure, and of course expression considered as species of metaphoric exemplification.32 To weigh the ballast of philosophic argumentation supporting Goodman's symptoms of the aesthetic is unnecessary for present

purposes and would distract from coming to terms with Colling-
wood's distinction between art and craft. Assuming for now the
soundness of Goodman's four technical constructions above,
what is of greatest relevance to the art/craft distinction is his
observation that, " . . . although I hesitantly conjectured in
Languages of Art that these four symptoms may be disjunctively
necessary and conjunctively (as a syndrome) sufficient, I readily
recognize that this would probably result in some redrawing of
the vague and vagrant borderlines of the aesthetic."[33]

Now Collingwood, while tolerant of vagueness and vagrancy
at the borderlines of craft, holds out for a crisp category of art —
not, certainly, as any particular kind of object, symbol, or pro-
duct of handicraft but as an experience of expressive imagination.
Since, however, it is Goodman's contention that "The four symp-
toms tend to be present rather than absent, and to be prominent
in aesthetic *experience*,"[34] they may be construed as applying
eo ipso to anything Collingwood would accept as art. If so, then
the margins separating art from other aesthetic or nonaesthetic
experiences appear more fluid than fixed; in which case it is
difficult to see how the boundary between art and craft could
not but be *mutually* precarious rather than, as Collingwood
would have it, fluctuating only on the side of craft. On such a
view — that is, one that treats both art and craft as syndromes
— the idea of a categorical difference gives way to that of a set
of vagrant yet graded differences occupying the shifty middle
ground of art-craft.

So far, the wedding of the syndromes remains a facile sug-
gestion. In order to show that they belong together, which is to
say, mutual precariousness at the margins of art and craft, it is
necessary to show that their syndromes overlap, that they
share at least one, maybe more, symptoms.

4. *A Mutually Precarious Margin*
The chief advantage of settling for a weak syndrome in place
of a real definition of art as well as of craft is elimination of the
dual tendencies to convert typical, indicative properties of art
such as expression into rigid, universal ones, and, conversely,
to exclude other equally typical if not universal ones as not
properly belonging to its definition. On the first tendency note
that in Collingwood's view, the *sine qua non* of art, its expressive-
ness, is but one amongst other symptoms of art in Goodman's
view. The latter view allows for expression being altogether absent

from some art and present elsewhere, for instance, in craft. The reward for such liberality is a better fit for the facts. Osborne states the facts well:

> Expressiveness is not on any account a universal feature according to which all works of fine art can be appraised, but one possibility among many. On the other hand expressiveness cannot be wholly eliminated from the products of craftsmanship. The love of materials, devotion and care in their shaping for a purpose, joy and pride in the application of skill and know-how, delight in fine appearance, functional and elegant design, appropriate decoration — all these are reflected in craft objects and are communicated in their appreciation.[35]

Where expression is but a symptom and not an inevitable or infallible sign of art, there is no reason to deny the rugged expressiveness of a hand-tooled Western style belt in order to protect the piquancy of a Degas. Neither on the balance of other indications are we likely to confuse the aesthetic function of the Degas with the predominantly practical function of the belt.

Regarding the second tendency — to exclude certain typical features of art from its definition — Collingwood allows that foreknowledge of an outcome in the form of a plan to be executed — a conspicuous characteristic of craft — "is a *permissible* characteristic of art, not a compulsory one" for the reason mentioned earlier, that "unplanned works of art are possible."[36] Hence the distinction between planning and execution cannot belong to the (real) definition of art proper. In the very next breath, however, Collingwood acknowledges that "It may very well be true that the only works of art which can be made altogether without a plan are trifling ones, and that the greatest and most serious ones always contain an element of planning and therefore an element of craft."[37]

Though Collingwood is mainly concerned here to avoid anything that would "justify the technical theory of art,"[38] he virtually concedes by this statement a technical theory of *good* art. But aside from that, such a prominent, even if contingent, feature of art is clearly more than "permissible." By the same token, unplanned variations in materials and execution distinguish the products of craftsmanship even where error tolerances are

minute, as in the construction of traditional musical instruments. Even should it be argued that some form of foreknowledge is compulsory (necessary) for craft though not for art, it remains on any view more a typical then merely permissible feature of art. As such, and depending on how it is weighed in with the other symptoms of art or of craft, it may well be indicative of either. That a single symptom may be ambiguous should cause no more difficulties for art theory than it does for medical pathology. Just as expressiveness may on occasion combine with obvious utility to indicate craft, so planning may combine with expression and symbolic density to indicate art.

In lieu of a real definition of art or of craft, the more of their symptoms that appear in the area of overlap, the more inclined we are to admit that area as undecidable for objects or events falling wholly or mainly within it. The Elgin Marbles, or better, the Portland Vase, spring to mind as examples of "art" that is both functional and highly crafted, and what is more, are products of times when the distinction was not drawn. Certainly objects and activities falling partly within the overlap, but with the balance of their symptoms on either the side of art or of craft, may be readily decidable. The extent of the overlap is the extent of what I have chosen to call with deliberate ambiguity art-craft. All well and good; but however attractive in some ways, the proposal to analyze art and craft symptomatically with regard to their ranges and relations is not without its obstacles.

5. *Products and Provenance*

One difficulty with the argument thus far is that it passes all too quickly over the *un*precarious margin between art and its origins, between works of art and the production of art. And that difficulty applies also to the parallel difference between the products and the processes of craft. Expression, as discussed previously, on whatever analysis, is an attribute of *works* of art or craft; whereas planning, foreknowledge, and the distinction between planning and execution are characteristics of the *activities* of artisans and some artists. So are the rest of Collingwood's traits of craft, making their logical wedding to Goodman's symptoms of the aesthetic look suspiciously like an apples and oranges affair.

The difficulty goes back to some important differences so far ignored between the questions "What is art?" and "What is craft?" Neither Collingwood's ontological version nor Good-

man's functional version of "What is art?" concerns how art is produced, whereas "What is craft?" very much concerns a particular manner of production of art or anything else. Thus, Collingwood's symptoms of craft are clues to the nature of an object's provenance, while Goodman's symptoms of the aesthetic are clues to the nature of an object's peculiar symbolic function as art or as an object of aesthetic experience. If it is not so difficult to see how the products of craft may be expressive, it is by no means easy to see how the lack of a preconceived result could be a *symbolic* feature of art.

Still it is not outrageous to suggest symbolic analogues of the indeterminate, spontaneous, nuances of effect intended by saying, as have many others besides Collingwood, that the artist's results are never fully preconceived. Besides, on the semiotic view under consideration, it is only as works of craft symbolize at all that they are liable to be confused or actually to overlap with works of art. A hat rack or a urinal is just a hat rack or a urinal unless it is a Duchamp, or unless, having seen a Duchamp, hat racks and urinals *in situ* never look the same again.

Now expression on Goodman's analysis is a symbol function which, if attributable to works of craft as of art, implies the possibility of certain other symbol functions. If the products of handicraft can exemplify metaphorically (express), so may they exemplify literally by exhibiting, showing forth, their materials, textures, shapes, structures, special uses, and the like. The more such properties that capture our attention, the more "replete"[39] is that object as a sample-symbol of its kind; and there are no a priori limits on which or how many of an object's properties may be offered to our attention, just as there are none on the nuances ("density"[40]) of that object's expressiveness. Density and repleteness thus emerge as the symbolic face of the unpredictable details of literal form and expression, not only of the products of art but of craft as well. In epistemological terms, unlimited cognitive richness is the obverse of the absence of full preconception of a work or art, but also of craft whenever the latter takes on a significance beyond its preconceived utility. This may happen as when Duchamp invites us to view a bottle rack as sculpture, or when we confront an object, such as the Portland Vase, having an aesthetic as well as practical function more obviously combined.

The category of art-craft is therefore inhabited by things having a mostly preconceived utility but at most a partly preconceived

aesthetic function. Such aesthetic function can be entirely missing from objects of clear symbolic utility, such as clocks, thermometers, and road signs (though a Duchamp turn of mind can change all that), or conspicuously present in objects of non-symbolic utility such as vases, Greek columns, and clothing. In their aesthetic respects, the products of craft are no more preconceived than utterly "useless" works of art; and as noted before, the respects in which they are preconceived apply equally to art, including utility in the case of art-craft. What can be said in this vein about their differences is that art is necessarily symbolic[41] whereas craft is not; and that the products of craft are fully preconceived in regard to their utility, whereas some aesthetic functions of works of art typically are preconceived. Aesthetically, works of art and craft alike have lives of their own beyond that given them by their creators.

Strictly, the criteria determining something's status as art, craft, or both overlap only in respect of certain symbolic features of works of art or craft. Only as craft products symbolize in ways characteristic of art does the question of their degree of aesthetic functioning or status as art arise. Otherwise craft status within or without the arts accrues to an object's provenance, to its having a special history of production meeting at least Collingwood's necessary conditions. Besides this difference in the determinants of status as art or craft or both, there is another deserving of brief mention concerning the identification of particular works of art or craft.

Again, if we follow Goodman's semiotic suggestion, the identification of works of art is established either by their having a unique history of production (so-called "autographic" arts like painting and sculpture), or by the use of notational devices like musical scores, scripts, exact texts, and the like (so-called "allographic" arts).[42] The former are susceptible to forgery in ways that the latter are not. Works of craft, on the other hand, are identified by their utility or practical uses including the use of various symbols to inform, amuse, measure, direct, issue warnings, and so on. Such utility is defined by the "ends" for which the object or operation in question is the "means." The means-end distinction, one of Collingwood's necessary conditions of craft, thus plays an important role in the identification of craft products, though it is but one feature of craft processes.

While the utility of an object or instrument may be misunderstood, misrepresented, or disguised, that hardly amounts to for-

gery. That is because identification of craft products, unlike unique works of art, normally concerns the *kind* of object or instrument something is — a shoe, an auger, a violin — rather than its authenticity or authorship. Still, the products of craft are susceptible to forgery, not only in the arts, wherever the question of authenticity arises whether of an alleged Stradivarius or a medieval halberd. The question of authenticity applies also to the craft status of things alleged to be the products of handicraft; such status can also be faked as when a machine-made sweater is passed off as hand-knitted. Indeed, the hot debate over whether something like Duchamp's hat rack is "really a work of art" seems to center less on the absence of any particular aesthetic quality than on its not having been crafted by the artist himself.

Depending, then, on whether interest focuses on what something is, on its authorship, or on its craft status, identification of a product of craft may be given in terms of its utility alone or in combination with evidence of its authenticity in either of the two aforementioned respects. Though it is possible to argue over whether something is a painting or a mere accident of spilt paint, the borderlines of art and non-art are notoriously vague. Also, since utility is of subsidiary importance to art, questions of identification tend to focus on authenticity in the sense of authorship in the autographic arts. Art-craft, however, may involve all three criteria, particularly when one's aesthetic judgment is affected by how well a practical as well as aesthetic purpose is being served as in architecture or in decorative or didactic art.

More has been broached than settled in the course of the preceding discussion, but enough has been said to indicate the outlines of a revised art/craft distinction as a wedge into the discussion to follow. The position advocated here differs from Collingwood's chiefly in admitting expression and other aesthetic functions into craft without *requiring* any of them of art or craft; in making aesthetic functioning a symbolic feature of objects, artifacts, and performances, having the effect of putting it back into the world of public events; and in allowing degrees of art or aesthetic functioning in craft along with degrees of craft in art. If on this view art remains irreducible to the products and activities of craft, it may yet encompass both to a greater or lesser extent ranging from crafty art to arty craft, with not a little that is ambiguous between.

What is to be gained from substituting transient for crisp differences? A major advantage of looking at art-craft in the proposed way is that features formerly confined to or excluded from the closed category of art may now enter or exit the realms of art or craft without forcing differences that cannot be told or threatening any that can. By treating art and craft as non-disjoint, overlapping syndromes none of whose separate symptoms are necessary (possibly excepting Collingwood's first two traits of craft) — that is, present in every work of art or of craft, nor sufficient — such that whatever has the property is a work of art or craft, I am not merely celebrating in theory the historical drifting apart and "open endedness" of the concepts of art and craft.[43] Rather, I am suggesting that the properties cited in each syndrome, depending upon their clarity, capture prominent features of art or craft or both. At the moment, it is the "both" that bothers. Eventually, it is the clarity that counts most; for it is not my intention to legislate verbal reform by strengthening the weak, open-ended conditions of art or craft but instead to pursue further distinctions illuminating the craft syndrome itself, particularly craft *in* art. For that it does not matter that one may not always be able to detect a strong difference, provided one gains a sharp insight into what may on occasion be an aspect of both.

So far I have been concerned just to show that the syndromes of art and craft actually do overlap in the respects of expressiveness, planning, and the indeterminacy of some effects. But the fact is that once the quest for real definitions is given up, the way is open for virtually any aspect of craft, or anything else for that matter, to function aesthetically in one way or other without thereby succumbing to a technical theory of art. Even the homely activities of a blacksmith, to use Collingwood's example, of "lighting the forge, cutting a piece of iron off a bar, heating it, and so on,"[44] have their aesthetic aspects; that is, may be viewed in aesthetic perspective. Inversely, since craft is no necessary condition of art, the difference between art and non-art within the realm of aesthetic functioning remains deliberately vague and the concept of art open-ended.

6. *Craft, Skill, and Technique*

Most writers on art-craft have been content to refurbish Collingwood's objections to a technical theory of art on the mistaken assumption that his objections presuppose his idealistic

theory of art. Mental art is not easily confused with physical craft, but art that requires hands as well as heads to make is more likely to be; so the safe way is to get tough with craft. This attitude has sometimes led to simplistic, even pejorative opinions of craft, such as those mentioned in the *Introduction*45 in an apparent effort to make of it a lowly thing incapable of being confused with exalted art whatever the latter turns out to be. But it is a poor and unnecessary strategy that is unfair to craft in order to be fair to art. As observed above, Collingwood himself provides sufficient reasons — in the form of counter instances — against the reduction of art to craft prior to the announcement of his theory of art. So it is not the difference so much as the nature of the distinction that is moot up to that point in his argument. Paradoxically, then, Collingwood's position allows for greater involvement of craft in art than does a position taking a less categorical view of art than his, but a more categorical view of craft.

I have suggested a noncategorical distinction between art and craft intended to encompass a number of issues obscured or neglected by the traditional discussion. For example, if we accept Collingwood's general characterization of craft as some kind of informed ability to bring about a preconceived result according to plan, what exactly is its epistemic status? Is craft a form of knowledge, of "knowing that" or "knowing how," or something beyond the scope of either? The teacher of a famous soprano once remarked, "She understood, she knew instinctively what to do, but she never knew how she did it."46 Presumably the teacher did know how, and therein lies a difference — several, in fact — between what the teacher "knew" and what the singer "understood" without knowing. From a practical standpoint, this is anything but a verbal quibble or mere ellipsis. And given a set of refined, mostly teachable procedures constitutive of a complex skill, how is their deployment encapsulated and explained by that body of received and tested opinion we call "established lore"? Though many an aspect of many a craft, skill, or technique resists articulation, just as many are discerned, described, evoked, or directed with the aid of elaborate systems of metaphor, neologisms, gestures, images, and the like. What, if anything, distinguishes these specialized "languages" of craft, the seemingly impenetratable trade jargons of wine tasters, Method actors, athletes, and opera singers, from ordinary or scientific discourse or plain nonsense? Perhaps most conspicuously ab-

sent is attention to the broad differences and kinships amongst craft, technique, and skill to which the remainder of this chapter is devoted.

As general, singular nouns of close family resemblance, "craft," "technique," and "skill" are often used interchangeably in reference to virtually any set of consciously directed training procedures judged "useful" by their sure productivity of a separately prized result. This meaning is usually signalled by the presence of the definite article with no other qualification, as when we speak indifferently of *the* skill, craft, or technique of the surgeon, the potter, or the singer. The possessive mood as in "the potter's craft" may similarly indicate this indiscriminate use of terms, though not so reliably. Outside this common ground their uses tend to vary in a number of ways.

"Technique," for instance, on two narrower usages can designate one or other special procedures (*a* technique) of craft, or one or all steps in a regimen aimed at their acquisition, as in the "Matthay Technique" of keyboard touch, for instance.47 Technique is thus closely linked with the idea of a performance of some kind. Even its most general, singular uses tend to apply to aspects of performances as ends — the pianist's display of technique — or as means, which is to say, as performances *on* or *for* something — the surgeon's or salesman's technique, whether evident or not, as achieving certain results. In a slightly elliptical usage, technique as displayed in performance may emerge as a distinctive feature of performance *style* by no means confined to the arts. It makes sense, for instance, to speak of a surgeon's technical style. In the arts, however, the notion of technical style may or may not carry the burden of ripe critical *assessment* of a performance, as when a musician is "complimented" for his technical competency or virtuosity but nothing else. But here we begin to draw away from the core of the matter.

Because it is not redundant to speak of a technique of craft, though not conversely, "craft" is the more general term ranging over its several procedures (techniques) particularly where the making of a physical product is concerned. By the barest analogy, "craft" is applied also to the set of techniques productive of performance ends, especially where one is concerned to differentiate amongst, say, the musician's art, his craft or general technique, and any of his more specialized techniques. Except for the modern vagaries mentioned, both terms remain close to their Greek (*techné*) and Latin (*ars*) roots as designating useful ac-

tivities or abilities of a knowledgeable kind.

Like the modern conception of art, "skill" has travelled some-what farther afield of its origins. Derived from the Old Norse *skil* for understanding or competence and *skija*, to comprehend (especially languages), "skill" became "the power of discrimination" in Middle English, according to the *Oxford English Dictionary,* which lists "practical knowledge in combination with ability" and "a craft, an accomplishment (now U.S.)" among its current meanings. Thus by a roundabout route "skill" converged on "craft" and "technique" not without importing some old and new semantic luggage of its own.

"Skill" is very wide ranging and encompasses, besides "craft" and "technique," much that is peripheral or antecedent to, or beyond their scope. For example, there are echoes of the Old Norse in such phrases as "reasoning skills" and "language skills"; of the Middle English usage (not just modern psychological jargon) in "perceptual skills" and "social skills"; and of contemporary American usage in a statement such as "The politician's skill is getting elected." The latter usage particularly, when predicated of the highest levels of accomplishment in any realm, explicitly reaches beyond the limits of craft altogether, as in "He knows the craft of politics alright, but he lacks the charisma to get elected."

At the opposite extreme, one hears talk of skill at typing, deciphering Morse Code, fly casting, and the like, without any suggestion that such facilities by themselves amount to crafts, though they may involve special "techniques" of learning or execution in one of the narrower senses of the word. So while there are skills (techniques) of craft, and crafts that are skills, there may also be skill without craft, or degrees of skill that go beyond craft or any traditional practical wisdom. Skill, ranging from dull routine to the imaginative stretching of routine beyond its established limits, offers in its higher reaches the possibility of the revision of craft insofar as its accomplishments can be analyzed and passed on to others. It is the task of a later chapter to sort out the various dimensions of skill, its conceptual topology, as it were, and normative stages with a view to illuminating its development and its discoveries. What is wanted now is an object lesson in artistic craftsmanship, a representative case to study, but also to introduce the standpoint from which things are learned, practiced, and done.

REFERENCES

Introduction

1. T. R. Martland, "Art and Craft: The Distinction," *The British Journal of Aesthetics* 14 (1974): 234-235.

CHAPTER 1

1. R. G. Collingwood, *The Principles of Art* (London: Oxford University Press, 1938), chs. 1 and 2.

2. Ibid., p. 26.

3. Ibid., p. 27.

4. Ibid., p. 22 fn.

5. Ibid.

6. T. R. Martland, op. cit., pp. 233-234.

7. G. B. Fethe, "Craft and Art: A Phenomenological Distinction," *The British Journal of Aesthetics* 17 (1977): 134.

8. H. Osborne, "The Aesthetic Concept of Craftsmanship," *The British Journal of Aesthetics* 17 (1977): 138-148.

9. Why it should not be any different for art is the subject of the next section.

10. Collingwood, op. cit., p. 15.

11. Ibid., pp. 15-17.

12. Ibid., p. 17.

13. Ibid., p. 16.

14. Ibid., pp. 20-26.

15. Ibid., chs. 4 and 5.

16. Osborne, op. cit., p. 146 n.

17. Collingwood, op. cit., p. 275.

18. Ibid., 305.

19. M. Macdonald, "Art and Imagination," *Proceedings of the Aristotelian Society* 53 (1953): 210.

20. Collingwood, op. cit., p. 19.

21. Ibid., p. 37.

22. Nelson Goodman, "When is Art?", in D. Perkins and B. Leondar (eds.), *The Arts and Cognition* (Baltimore: Johns Hopkins University Press, 1977), pp. 11-19.

23. Nelson Goodman, *Languages of Art, An Approach to a Theory of Symbols,* 2nd. ed. (Indianapolis: Hackett, 1976), pp. 252-255. Hereinafter cited as *LA.*

24. Ibid., ch. 4.

25. On the important difference between a symbol scheme and a symbol system, see ibid., p. 143ff. Roughly, a symbol system consists of a symbol scheme correlated with a field of reference.

26. For the definition of syntactic and semantic density, see ibid., pp. 135-137 and 152-154 respectively.

27. On the "difference in direction" between denotation and exemplification, see ibid., pp. 50-57.

28. See section 4 below.

29. Goodman's example in "When is Art?", pp. 16-17.

30. Ibid., pp. 17-18; see also *LA,* pp. 252-255.

31. Ibid., p. 18.

32. See Goodman, *LA,* ch. 2.

33. Including the vague borderlines of the "artistic" considered as a subset of the aesthetic. The difficulty in saying what kinds or degrees of human intervention qualify something to be "art" defies attempts to fix the boundaries separating art from non-art. See Goodman, "When is Art?", p. 18.

34. Goodman, *LA,* p. 254; italics mine.

35. Osborne, op. cit., p. 145.

36. Collingwood, op. cit., p. 22; italics mine.

37. Ibid.

38. Ibid.

39. See pp. 16 above.

40. Ibid.

41. See Goodman, "When is Art?", passim.

42. See Goodman, *LA*, pp. 112-115. For the sake of simplicity, I am deliberately ignoring the many qualifications and refinements Goodman introduces into the autographic-allographic distinction.

43. On the open-endedness of the concept of art, see Morris Weitz, "The Role of Theory in Aesthetics," *Journal of Aesthetics and Art Criticism* 15 (1956): 27-35.

44. Collingwood, op. cit., p. 20.

45. See p. 5 above.

46. From a conversation with Bernard Diamant at the University of Toronto, 18 January 1978.

47. After Tobias Matthay (1858-1945), long associated with the Royal Academy of Music. Matthay's views are set out in his *Art of Touch* (1903) and briefly described by David Barnett in *The Performance of Music* (London: Barrie and Jenkins, 1972), pp. 31-37.

You know, nothing makes me more furious than when people say, 'Oh, she just opens her mouth and the music comes out. It seems so simple.' Well, it's not simple. There are no secrets. It is hard work. But when you learn how to free the voice, the door opens and there stands the artist, able to speak to the audience for the composer. That is singing.

Rita Streich

2 *In Search of Nature's Way of Singing*

1. *Craft Inside Out*

Though one may argue over details of the art/craft distinction, there is little reason to doubt Collingwood's main contention that a theory of craft, while orthogonal to a theory of art, is not one. Neither is a theory of craft as such a theory of imagination or creativity, but a theory of craft that excludes them from its purview is as questionable as a theory of art that cannot accommodate craft. The prevailing view of craft as mindless routine, as "canned reaction"[1] utterly bereft of creative imagination, is but another version of the same baseless fear of a reductionist *liaison dangereuse*: If craft can be creative, what is there to distinguish it from art? I trust that enough has been said to allay that fear despite the fact that the answer may on occasion be, "Nothing."

If art has nothing to fear and everything to gain from creative craft, just how what we ordinarily understand by "creativity" and "imagination" becomes involved in craft is best argued by a demonstration; and it is one purpose of this chapter to provide a demonstration of creative craftsmanship in an art form. The demonstration will take the shape of a description, an anatomy, if you will, of the singer's craft of voice-building — which ideally should be heard and seen as well as read. Another aim is to elaborate through example the theoretical queries already raised about "understanding" versus "knowledge" of craft lore, the languages of craft, and the relations amongst craft, skill, and technique, as well as to raise other queries. It is perhaps worth reiterating here that to speak of the craft of voice training, as opposed to the singer's Art, is in keeping both with Collingwood's and the modern English conception of craft as the planned production of specific results.

Since we are dealing with a practical matter in philosophic perspective, it is appropriate to take sides on the aesthetic pronouncements or other normative claims of any "school" of singing while yet deferring to the superior judgment of the singer, the voice trainer, or the physiologist within the areas of their special expertise. That is easier said than done, however. In an area teeming with conflicting theories and therapies it is difficult to keep clear the fine lines separating theory from precept, expla-

nation from speculation, hard fact from established fancy, and metaphoric sense from literal nonsense — but most of all, half-truth from full falsehood. Not the least of reasons why is that the perspectives of singer, voice trainer, and physiologist are seldom contained within a single, coherent purview.

Among recent works on singing, by far the one best suited to the purposes at hand to serve as an expository foil and source book is Frederick Husler and Yvonne Rodd-Marling's *Singing, The Physical Nature of the Vocal Organ*.[2] The book is by no means a mere articulation of the ad hoc precepts and procedures of a proven successful teaching team, but an approach to a comprehensive theory of the singing voice encompassing its physiology in relation to the language and "science of the ear,"[3] the latter comprising the ubiquitous terms and aural distinctions emerging from history's vast natural experiment with the voice. The authors' program links up the art, craft, and science of singing by offering practical guidance to confused students of voice, while at the same time tracing the collective wisdom and common nonsense of vocal tradition to their physiological bolt-holes. The result is a vivid interior portrait of singing which simultaneously puts the craft of singing — the building of a voice of some artistic potential — to experimental test.

While the physiological and applied aspects of the book are of paramount importance to anyone wanting to sing, this discussion will focus on Husler and Rodd-Marling's general approach to singing (known familiarly as the "Husler Technique") from a philosophical perspective, introducing points of physiology or practice primarily to illustrate the Technique and to acquaint the reader with what is typically involved in singing. Of prime importance are the authors' steps toward scientific vindication of the older French and Italian schools of singing,[4] and their argument that virtually all subsequent techniques are based on incorrect or incomplete conceptions of the vocal "mechanism," as singers are fond of calling it. Their "functional-interactionist" view of the voice (so-called herein) will be examined in light of their basic theory of singing, and an attempt will be made to analyze and relate the special "understanding" afforded by the singer's "language of the ear" to physiological "knowledge" of the singing voice.

2. *The Predicament of Singing*
 The singer's lot is a difficult one; he or she has to perform on

an invisible, immensely complex instrument consisting of parts of one's body extending from head to buttocks, with most of these parts not under direct voluntary control. Yet unless the separate parts of the vocal mechanism are brought into fine coordination relative to the act of singing, the unhappy results are all too audible if not visible and are "felt" by singer and listener alike. It is also true that certain patterns of innervation and muscular overdevelopment (and corresponding enervation and underdevelopment) engendered by swallowing, breathing, speaking, grunting, and the like may actually leave the mechanism unfit for singing — all this despite the widespread opinion that singing is the most "natural" and "spontaneous" way of making music. Little wonder then that all but the very best or very ignorant amongst singers seem constantly in distress, with so much to control and so little to control it with.

Enter now the legions of voice trainers with their theories, techniques, precepts, rules, and exercises promising to alleviate in one way or other the singer's predicament. To the surprise only of beginners at singing, the various accounts of the voice and advice proffered present a bewildering (and depressing) spectacle of conflicting opinion — for instance, that voices are born and not made; that though born, they can at least be made over; that one should sing as little children scream, or as an adult whispers, or as a dog yawns; that a refined "technique" is the singer's salvation; that one should dispense with all technique and sing "naturally"; that speech and singing are the same and should be developed coordinately or one "from" the other; that the two are entirely different and must be developed separately; that the singer must "drive" the voice by a great effort of muscle and breath; that singing should be totally effortless and free of all tension. Simultaneously, the voices of great singers are often invoked to "prove" the wisdom of this or that way of singing.

Despite all successes, the cacophony of opinion alone would suggest that these and many other "myths" of singing are highly questionable both as regards the assumptions they make about the nature and function of the vocal apparatus and the conclusions drawn as how best to activate, correct, or develop a voice. Beyond these confusions in theory and practice, the singer's predicament is further complicated by vexatious obstacles to accurate perception and communication, giving rise to problems of the intersubjectivity of certain experiences and of the language used to describe them.

To begin with, the "mechanism" of the voice consists, very simply, of an energy source (the lungs and diaphragm), an oscillator (the vocal folds or "chords"), and a resonator (the vocal tract consisting of the pharynx, nasal pharynx and cavity, and mouth).[5] Vocal sounds are produced by closing the glottis so that air pressured upwards from the lungs forces the vocal folds apart in a vibrating action not unlike the "puttering" effect of forcing air through compressed lips, as a child imitating the sound of an automobile. Though it is occasionally useful for the singer to visualize the vocal apparatus as it actually works (primarily for *ex post facto* explanatory purposes), its mechanical action, except for certain gross thoracic movements, is invisible to the singer, whose control operates through a combination of aural and physical sensory "feedback" effects. For that reason, neither direct inspection of the mechanism by means of a laryngoscope or X-ray nor elaborate physiological descriptions and diagrams are much help to the singer wanting to know what to do next or how best to achieve a particular result.

While such information has high diagnostic value for voice trainers including of course singer-teachers, it is generally conceded by singers and trainers of every School, Theory, or Therapy that the singer's predicament is circumscribed by three conditions: "(1) The singer cannot hear himself as others hear him; (2) Every sound is accompanied by a definite sensation within the singer's body; and (3) By teaching him how to experience a sensation which, in the opinion of the teacher, should accompany the production of a desired sound, one can teach him to produce the desired sound."[6] Such a correlation of sound and sensation is accomplished, or rather, induced, by a combination of trial and error, imitation, and verbal commentary intended to communicate the "feel" of some vocal sound.

So construed, the singer's understanding of the voice, especially his own, clearly exhibits the difference between a highly developed aural/physical acuity and theoretical knowledge of auditory phenomena. The accomplished singer, who is most often thoroughly unread in Husserl or Merleau-Ponty, is nonetheless a phenomenologist of sorts whose technical metaphors of vocal "registers," "breaks," "placement," "support," and the like help to systematize nuances of sound and physical sensation relative to an aurally imagined ideal of singing. The ear is of course the chief diagnostic tool of singers and teachers in their work toward that ideal.

But it also happens that this elaborate, metaphoric language of the ear represents a "heard physiology"[7] in a sense which permits correlation of the singer's aural distinctions to different physiological functions of the combined laryngeal and respiratory systems. That prospect gives credence to a *science* of voice pedagogy even though, for obvious reasons, the language of instruction must needs be that of the ear and not physiology. The latter stands in a mostly theoretical, not a commanding, relation to the act of singing. What is noteworthy for present purposes is how the language of the ear gives way to an understanding that is almost entirely procedural (the singer's "know-how"), or to an understanding that is purely explanatory in the terms of physiology. Whatever the other relations between these two kinds of discourse, the physiology of the voice does give a radically different understanding — in the form of theoretical explanations — of vocal experience than is afforded by the language of the ear as reflective of that experience. The science of acoustics offers yet another perspective on vocal phenomena, particularly with respect to the harmonic partials and resonances of the singing voice.[8] To be useful to the singer, however, such information must be joined to the practical lore either as confirming or disconfirming certain of its practices.

To a very great extent, Husler and Rodd-Marling have realized that program at least to the point of having a clear conception of its components (including the practical importance of the singer's jargon) and taking pains to relate the voice trainer's "heard physiology" to its functional counterparts. There are, then, two sorts of answer to the question, "How is a particular sound produced?" that ought properly to be distinguished: the scientific, and for want of a better term, the active, couched in the craft language of the ear. The latter alone is solely directed toward the cultivation and control of a voice of the quality, projection, and flexibility equal to the demands of the classical repertoire. Such demands of the music itself delimit vocal artistry to which the singer's craft is but a necessary means overall, though perhaps sufficient to one or another special effect.

3. *Toward a Philosophy of Singing*
Given the teleological character of any craft activity, including voice training, it is not surprising that Husler and Rodd-Marling should rest their investigations of singing on certain "basic principles" of a distinctly Aristotelian cast having mostly regula-

tive force.9 Aristotle held as the keystone of his philosophy that all men by nature desire to know, are endowed with an inborn but fragile curiosity susceptible to atrophy or even extinction by the contravening forces of habit, boredom, and the limitless varieties of fear, intimidation, frustration, and neglect.10 Similarly, Husler and Rodd-Marling hold that "the urge to sing is inborn. It is one of the attributes of Man, and for its fulfillment requires no extraneous aids or adaptations."11 Like Aristotle, the authors mean to say that, "Every human being normally possesses by nature the physical means for singing — even if he 'has no voice', or to be accurate, even if he cannot sing."12

Why therefore are we not all singers? "In the normal person, inability to sing is due either to an impairment of the vocal organ or, in the majority of cases, to the natural inborn faculty being hampered and obstructed; it needs to be released, to be 'unlocked.' "13 In affirming a universal *capacity* (the word "faculty" is perhaps mildly misleading) for singing, the authors not only deny any "special" (i.e., unique, inherited) "physical equipment" required to sing but also the equally common opinion, with which theirs might initially be confused, that an actual, "good" voice already exists *intact,* locked away unsung in our physiologies. The "unlocking" is rather a matter of innervating and coordinating a complex musculature in the throat and organs of breathing, parts of which are overdeveloped while others are underdeveloped but all of which are required to sing in any but the "normal," stressful way.

What is normal? According to the authors' usage of the term, *"The normal voice is not 'normal' but phonasthenic,* an aspect that clarifies much that is problematic in our subject."14 In other words, *"Normal . . .* always means being afflicted with the weaknesses of the average human being, the average singer. The great natural singer (with a vocal organ that has functioned perfectly from the very beginning, i.e., as nature intended), and what singers would call the totally 'voiceless' individual (with a completely sterile singing mechanism), cannot be taken as norms."15 Similarly, "unphysiological" singing, on their special usage,16 meaning, roughly, something less than or contrary to optimum structural-functional efficiency, is not to be confused with *non*-physiological singing which, with the possible exception of angels, is quite literally unheard of. Finally, while taking care to note that vocal disorders are not all of a kind nor due to a few simple causes, the authors adopt the aforementioned term "phonas-

thenia"[17] to cover any type or degree of vocal weakness from the slight, often temporary difficulties of the expert or "natural" singer to the more serious ones of the "normal" singer to "chronic collapse of the instrument" of the so-called "voiceless."

On this view it would appear that even the greatest of singers is somewhat phonasthenic, inevitably trading off certain vocal achievements against others. Whether or not the implication is intended,[18] it has two major advantages over any static ideal or prototype of perfect singing: it allows for the limitless nuances, shades of style, and levels of achievement possible to the voice, and it provides latitude for the critical analysis of acknowledged "great" voices, for example, the relative abilities of Caruso and Gigli to contract the inner muscles of the vocal folds (thyreo-vocalis and ary-vocalis) while keeping the larynx in the lowest possible position.[19]

But are not voices "great," "beautiful," or "phonasthenic" relative only to highly variable and culturally determined preferences? Is there not a hidden aesthetic agenda here, one that selects as "best" those physiological functions of the vocal mechanism most conducive to the classical Western styles of singing? Far from hidden or suppressed, at the most general (philosophical) level these queries are central to the authors' investigations, the answers to which emerge as conclusions of those investigations. Otherwise put, there are philosophical as well as physiological and practical dimensions to the way one arrives at a theoretical vision of singing mastery from the initial evidence and experience of one's senses.

Obviously, only the barest impression of Husler and Rodd-Marling's investigations can be conveyed by summary. Chiefly, these concern the anatomy and physiology of the vocal "instrument" ("mechanism," "organ") and its "functional unity" both as necessary and sufficient condition for the very existence of the singing voice. The authors do not of course present the latter claim in terms of its logic, but they do make use of it as the major premise of their answers to the aforementioned queries. The logical point is therefore noteworthy, since any shortcomings or gaps in the overall *argument* concerning "beauty of voice" in no way impugn the factual basis of its premises. In other words, the physiology, while an integral part of the authors' philosophy of singing, stands on its own. But on the larger view, what was just described as the theoretical vision of singing mastery is joined up by the physiology of the "instrument" of singing to

an elaborate vocal casuistry in what amounts to an extended practical syllogism. As with the scientific vindication of any set of craft practices, the main throughway is from practice to theory and back again.

4. *The Instrument of Singing*

What, then, constitutes the instrument of singing and its functional unity? As to the former, the authors follow tradition in identifying three "main spheres" corresponding to what were described above in acoustical terms as the oscillator, the resonator, and the energy source. These are: (1) the cartilaginous framework and muscles of the larynx;[20] (2) the web of neck muscles between the tongue bone and chest in which the larynx is suspended, the "suspensory mechanism";[21] and (3) the "organ of breathing" comprised of the skeleton and muscles of the thorax, chiefly the lungs and diaphragm, the upper inner chest muscles, inner and outer muscles of the back, and the muscles of the buttocks.[22] For present purposes, many of the details may conveniently be ignored without imperiling the accuracy of a general impression.

As to the "functional unity" of the voice, the phenomenon of which, though not its proper description, seems widely agreed upon, Husler and Rodd-Marling describe it as follows.

> To represent them (the anatomical and physiological details) as scientifically as possible we are forced to describe them separately, one after another, but — and this is the point — isolated muscle movements do not constitute the organ of the singing voice. It is only the sum total of these movements that creates it. It cannot come into existence without this functional unity. In singing, the many muscle-systems work together in a harmonious cyclical process, if, that is, the physiological nature of the organ is perfectly fulfilled and the process represents an intact whole. Or to put it differently: a particular co-ordination of all parts of the vocal organ first permits the specific functional form of the instrument of song to originate; a special kind of co-ordination, used for no other purpose whatsoever, not even for speaking.[23]

One could say that a piecemeal analysis of the voice necessary

to *comprehend* how it functions must not overlook the fact (as many piecemeal "techniques" do) that in a healthy, fully developed condition, the voice *exists* and *functions* all of a piece. Hence my term, "functional-interactionism," to underscore, first, that the singing voice is but one function of a physiology linked to many other physical processes including speaking; and second, has a character (comprised of range, timbre, volume, flexibility, and the like) entirely dependent upon how the different elements of the "instrument" interact, or fail to.

Among the many consequences of this perspective on the voice are three of practical as well as theoretical significance. First, while separate parts of the vocal apparatus are in constant use for a variety of physical processes such as breathing, swallowing, and speaking, and are therefore better innervated and conditioned for those purposes, yet "The body . . . is capable of producing *an elementary pattern of movement,* one that is able to fashion the mechanism of singing by fusing its many parts together at one 'stroke' or 'grip.' "[24] If I understand correctly, what is meant by "an elementary pattern of movement" is something tantamount to an "automatic," near-reflex coordination of parts relative to the vocal function of singing, one not so much "trained in" as "triggered off." In the authors' words, "The various organic parts (always providing the *laryngeal* muscles are in fairly good condition) almost immediately slip of their own accord into the mechanism's 'predetermined' functional form."[25] At that point, "technique" is dispensable in much the same way that a building erected from scaffolding stands on its own — or so the tale is often told, though it is easily misunderstood.

In this context, talk of the dispensability of technique is usually intended to suggest that where technique refers to ways of searching for and retaining this elusive reflex-grip on the voice, little more than finding it is required to match the voice to the "technical" demands of most vocal music. Such talk also evokes the extent to which certain dormant reflexes may become routine — a matter of doing it without thinking, so to speak. On neither interpretation is technique dispensable as a "means" either of discovery and training or of therapy for phonasthenic symptoms picked up often in the course of strenuous performance schedules. What it means for an aspect of skill to be discovered by technique, then to become routine and perhaps later subjected to therapeutic inspection, is a subject for a later chapter (chapter 6,

section 7).

Certainly it is possible to build a singing voice of limited capacity on a shriek, a sob, a whisper, on speech (articulate phonation), or breath "congestion"[26] using techniques that extrapolate from these and other functions such as coughing and defecation the sensations of which we are already aware. Typically they require great pressure of breath in the thorax combined with deliberate, strenuous contractions of the diaphragm to compensate for the loss of tone engendered by the former.[27] For each of these approaches, the "technique" amounts to little more than selective emphasis of portions of the joint action of the larynx and respiratory apparatus at the expense of the strongest, most complete and versatile link-up requiring a minimum of breath pressure and resulting in a maximum of elasticity of the vocal folds.[28] In summary, what ideally should happen is this:

> As the lower parts of the respiratory organ (diaphragm, back flanks, abdominal wall) prepare to set the breath in motion, a vigorous reflex action simultaneously establishes contact between the throat and the organ of breathing. At the same time the epiglottis is raised, the larynx inspanned from above, below and behind in a strong network of muscles, while the larynx itself effects a series of movements, the most important of which are: the vocal folds are stretched, tensed (contracted), brought into opposition and caused to vibrate.[29]

The nonsinger perhaps comes closest to experiencing this somewhat atrophied, largely eclipsed reflex state when indulging in a loud yawn. It is thus not so surprising that "It takes no 'technique' to establish this functional connection between the larynx and the organ of breathing. We have to realize that the combined action needed in singing is not something artificial that has to be acquired, that has to be 'learned'; it is one of the oldest physical functions that has to be found again."[30] Though initially elusive, this set of reflexes is "there" to be exploited in the best interests of the voice; and the instantaneous results in terms of breath control, flexibility of tone, range, and volume indeed "seem little short of miraculous to any singer who happens to find it."[31] Often the startling difference in ease of production

or in the quality of sound produced is sufficient to bring about one trial learning; which is to say that one realizes at once what it is to have the voice properly "placed." But while common experience would tend to confirm these observations, it also confirms another, rather melancholy one: that what is so painstakingly "found" is easily "lost."

Mentioned earlier were three practical as well as theoretical consequences of a functional-interactionist approach to the voice. The second and third bring the controversy over the nature of the singing voice to a head. The "functional unity" of the voice means that "It is only by operating collectively that individual muscles can gain the freedom necessary for carrying out their own specific tasks. From which one has to conclude: if musculatures work in *chronic* isolation, the vocal organ disintegrates, it loses its particular configuration, and if the functional unity is disrupted, the separate muscular parts of the whole must suffer too. That is how so-called 'breaks in the voice' occur."[32]

That explanation of breaks in the voice, for example, between the "legitimate" and falsetto voices, revives ancient vocal wisdom in modern physiological terms and provides a physical account of the seventeenth- and eighteenth-century Italian ideal of *bel canto*. Though *bel canto* is better heard than described, Pleasants effectively describes it as,

> . . . a mellifluous kind of singing aimed at an agreeable, well-rounded tone, an even scale from bottom to top, an unbroken legato, a nicety of intonation, an eloquence of phrase and cadence, a purity of vowels and a disciplined avoidance of shouting, nasality, harsh or open sounds, disjointed registers, undue vehemence and any other evidence of vulgarity or bad or negligent schooling.[33]

Certainly the elimination of breaks (Pleasants' "disjointed registers") represents the quintessence of *bel canto*. Now according to Husler and Rodd-Marling, breaks between registers of the voice are a phonasthenic symptom, common enough to be sure, but "natural" only as a sign of vocal ill-health.[34] They are the result of the isolated operations of different parts of the vocal mechanism. Accordingly, to techniques that purport to construct a singing voice on one or the other of these separate operations, breaks and registers appear as fundamental "givens"

of the voice to be "blended over" or otherwise disguised. There is, then, a part-whole problem in the very conception of the singing voice itself which must be resolved, preferably nowadays with the help of science, in the interest not only of furthering but of recapturing the best of the singer's craft.

Husler and Rodd-Marling acknowledge, indeed stress, that "every muscle function in the vocal organ produces its own distinctive sound."[35] But, and this is the third consequence, "registers should never be anything more than the sounds made by the activity of individual muscles temporarily dominant within the whole co-ordinate process"[36] — which is to say that in a *fully* activated voice, "All that happens is that, without destroying the balance of the whole, the functional *accentuation* shifts from one musculature to another according to the strength of tone desired, its pitch, colour, and so on."[37]

By now singers and trainers alike will have risen to the bait: there is a world of difference between taking breaks and registers for granted and taking them as phonasthenic symptoms.[38] On perhaps no other single point are they traditionally more divided. Suffice it to say that the "older" wisdom of the eighteenth- and nineteenth-century French and Italian schools, as well as modern physiology applied to the singing (not the speaking) voice,[39] would appear to favor the latter opinion. However the issue may be resolved, there seems little reason to agree with Sergius Kagen's pronouncement of 1950 that "The scientific information at our disposal today is as insufficient for our understanding of the factors which govern the immensely complex operation of our sound-producing apparatus as the caloric theory was once insufficient for our understanding of nutrition."[40]

On the other hand, there is every reason to agree with Kagen's equally plangent claim that "no type of direct muscular control can make [the singer] sing as he wishes to . . ."[41]; and therefore, "We do not possess the faculty of compelling our vocal cords to flex in any precise manner without first having conceived an image of the sound we wish to produce."[42] Though accurate so far as the advice goes toward suggesting the nature of the singer's indirect action, it needs also to be kept in mind that "the image — in fact a congeries of images — is an interior one, combining aural and physical sensations with heavier reliance on the feelings accompanying the sounds produced than would otherwise be necessary if singers could only hear themselves *in the act of singing,* as others do. Thus, while bits of

physiological information, vocal exemplars, use of tape machines, and the assurances of an expert trainer that the sounds produced are the "right" ones and rightly produced may all in their way contribute to an awareness of public standards of effective singing, the controlling images *in performance* are ultimately those of one's own voice as heard and felt from within.

5. *Beauty of Voice*

I wish now to return to the philosophical points raised at the end of section 3; for we are now in a better position to appreciate as well as to criticize Husler and Rodd-Marling's rather uncompromising view that "beauty of voice" is not a matter of taste or culturally derived norms.[43] Taste they hold to be appropriate only to the "artistic utilization" of the voice as in song "when the voice and its beauty are used as the material for making music."[44] But is not the *beauty* of a voice an "artistic" feature of any performance of vocal music and therefore as much subject to the varieties and vagaries of taste as the music itself?

The authors' answer is, in effect, No, on what philosophers would call "naturalistic" grounds; namely, that "the aesthetic principles of singing, as regards the voice itself, are primarily dictated by the physico-physiological laws according to which the singing voice originates. Hence, in judging beauty of voice the question of taste cannot seriously enter the argument. It [the judging] is limited to a narrow choice between a number of possible, legitimate forms of 'beauty'—not between beautiful and unbeautiful or between 'right' and 'wrong.' "[45] In other words, beauty of voice (of the sounds produced) as contrasted with beauty of singing music is more an aesthetic fact, as it were, than an aesthetic value, and hence something to be determined, observed, described, analyzed, and explained, but not arbitrated by variable taste.

Now why should anyone bother to take such a (philosophically) extreme position? In this instance the concern is to avoid two apparent consequences of what might be called an "anything goes" aesthetics of voice: " '(1) that there are as many concepts of vocal beauty as there are kinds of culture' "; and (2) that beauty, consequently, cannot provide a uniformly valid criterion for rational physiological research on the voice . . . ' "[46] — that the "goodness (physiological intactness)" of a voice is distinguishable from its "beauty," since a voice may be intact but not beautiful and conversely (Caruso being the most com-

monly cited example of the latter).

The idea seems to be that if anything goes aesthetically, then beauty of voice *in general* cannot be a reliable guide to physiological science of what to look for in the way of "intactness" or "good" vocal functioning; and if, *within* a given standard, say the classical Western style of singing, "beauty" and "goodness" of voice are not coextensive, then the former cannot be a *specific* guide to the latter, there being too many exceptions — unless, of course, one makes them coextensive by definition for limited purposes which, in fact, Husler and Rodd-Marling do, but for unlimited purposes.

There is one good reason for making "beauty" and "goodness" of voice coextensive (not synonymous): it is that tradition, or some traditions anyway, take *as* beauty the aural results of good physiological functioning; or, what amounts to the same thing, that the sort of complete, reflex functioning described in the previous section *causes* an aural event that those in the tradition recognize as "beauty of voice." The authors wish to go further, to make beauty of sound the "specific characteristic," the *sine qua non* of the singing voice as such.[47] But that goes too far in virtually denying that "bad" (aurally or physiologically) singing is even singing. While there is no singer like a good singer, it is sheer hyperbole to imply that no singer is a bad singer. Beauty of voice is the ideal, not the very idea, of singing.

Those outside the tradition in question — Flamenco singers, modern "pop" singers, and Alpine yodelers, to mention only three — fare even worse, being accused of " 'Alienation' of the singing voice" and " 'cantatory' trends" having "nothing to do with singing."[48] From the standpoint of the authors' tradition, that may very well be true enough; but it still is no reason to deny either that they sing — whether in imitation of Alphorns or longhorns — or that some achieve a peculiar, though admittedly limited, "beauty of voice" appropriate to their vocal ambitions. Perhaps the same could be said of "pure singing" as has already been remarked of "pure art," namely, that it is the preoccupation of modern European civilization.[49]

It would seem that Husler and Rodd-Marling come off better on a limited-purpose construal of the equivalence of "beauty" and "goodness" of voice; that is to say, a construal limited to the tradition within which that equivalence makes sense and does not amount to verbal legislation. Take the two counterinstances that threaten to undo the equivalence: that some voices are "good"

but not "beautiful" and conversely. From an aural standpoint, what "good" means is a combination of such qualities as "free of accessory sounds, of pressure, of chronic faulty hypertensions, is loud or soft on high pitches as desired, flows resonantly," and so forth.[50] Such a voice may yet be "cold," lacking emotional qualities, or inexpressive, and thereby fall short of real beauty.

The authors' reply is as telling as it is simple: "that is simply because it is not good enough to be beautiful."[51] By thus recognizing degrees of "goodness" and the fact that we tend to reserve the epithet "beauty of voice" for the higher degrees, the challenge is defused while preserving all the distinctions one should care to make in this regard. The converse case, of beauty without goodness, is not so easily dismissed.

Setting aside dramatic impact, force of personality, sentiment, and other peripheral factors, what are we to make of the case of Caruso whose voice, though seriously impaired by age thirty-six, was acknowledged as "beautiful" long thereafter? It simply will not do to chalk it all up to Caruso's dramatic and interpretative "genius." According to Husler and Rodd-Marling, Caruso retained throughout his career, despite nodules in the larynx and the incipient cancer of the lungs which eventually took his life, *the* crucial function essential to beauty of voice: an ability to draw the larynx radically downwards resulting in "maximum stretching together with minimum tensing (by the vocalis system) of the vocal folds. . . . In every "heaven-sent" voice this functional combination is . . . distinctly audible. Nothing else, apparently, is able to give the vocal folds sufficient vibratory capacity."[52] This ability enabled him to keep his throat "absolutely free" in spite of the "specialization" required to give the voice baritone coloring and an increasing resort to massive breath congestion to drive the instrument — "an astounding feat, perhaps unique in the annals of singing."[53] If, as seems widely agreed, such positioning of the larynx despite all else is the essential element in the "secret science" of the superb singer, then in Caruso we have not an exception to but an heroic instance of the rule that "beauty" is equivalent to "goodness" of voice. Certainly this would not be the first time or circumstance where tradition and ingenuity agree in showing a sapient preference for the expedient.

6. *The Language and Science of the Ear*
For the practical purposes of singing, the ear is the chief

diagnostic tool of singers and teachers, it being the first require-
ment of singers that "the perceptivity of the ear . . . be heightened
until the different tonal qualities can be distinctly heard."[54] It
is further required of teachers "to realise . . . that these vibra-
tions are always effects produced by definite functions in the
vocal organ, some of which can be determined fairly accurate-
ly."[55] This is what Husler and Rodd-Marling mean by a " 'science
of the ear,' a 'heard physiology' "[56] linking the singer's aural
acuity and physical sensations to the descriptive "mute science"[57]
of voice physiology. Provided the latter includes "the actual
functional product: the tone and its character" — which *is* the
link — within its scope, it may then become an objective basis
for the trainer's work, "something he must have if he is not to
remain an amateur whose efforts are more or less at the mercy
of chance."[58] Needless to say, the applied connections between
skill and science in this instance are delicate and complex across
the whole range of vocal phenomena the physical details of which
need not detain us. In keeping with the philosophical tone of
this discussion, I wish to focus now briefly and at length in
chapters 3 and 4 on the nature of the singer's jargon which,
though rife with ambiguities and vaugenesses and hence all too
easy to dismiss, is "in reality the language of the ear."[59]

Any singer intuitively knows what that phrase means, though
to say what it means is difficult. In the neutral sense of the term
roughly meaning "hybrid speech," "jargon" refers to the special-
ized or technical language of a group, trade, profession, or dis-
cipline. I should like to distinguish three kinds of jargon, the
second of which encompasses the pejorative sense of the term
derivative of the Old French, *jargoun* (twittering), meaning gib-
berish" or unintelligible language.

First is what I shall call *theoretical* jargon, consisting of a set of
neologisms especially coined for highly specialized theoretical
concepts such as "positron," "valence," "positive and negative
reinforcement," "gross national product," and the like. Such
terms are employed within a logical nexus of classification, ex-
planation, and prediction, a nexus which consists of statements
arranged in arguments of either a deductive or inductive sort.
Ideally, the terms of such a jargon are nonmetaphorical, which
is to say they are fully and literally defined and, except for re-
dundancies, indispensable for any precise statement. The work
of the physicist, engineer, or music theorist simply cannot get
on without the aid of a tailor-made vocabulary.

Second is *gratuitous,* often euphemistic, jargon of the sort afflicting such fields as politics, education, and popular psychology — terms such as "developing nation," "underachiever," and "transactional analysis." Though giving the appearance of precision, such language at worst amounts to plain nonsense and is at best dispensable in favor of plain speech. Certainly much of the persiflage of art instruction, not to mention criticism, falls into the gratuitous category, though that liability may be avoided provided such discourse is sufficiently grounded in concrete experience, on the one hand, or in adequate (exactly formulated, testable) theory on the other. That brings us to a third and the most relevant kind of jargon, that closely associated with complex skills within and without the arts.

Technical (or practical) jargon in the original sense of *"techné"* or *"ars,"* relating to specific crafts or skills, consists of a mostly ad hoc selection of metaphoric usages of terms and phrases borrowed from ordinary discourse the special meanings of which are drawn from aspects of the skilled activities in question. The singer's vocabulary of "registers" and "breaks," of "chest" and "head" voices, "cover," "placement," and "support," to mention just a few conspicuous items, is an excellent source of examples of technical jargon.

Though partly explanatory of the activities in question, and by no means exclusive of theory, a technical jargon is of limited explanatory value by the standards of science and for good reason: it is, by and large, an *action*-directed language that aims to direct, discriminate, identify, and classify relative to certain intersubjective, often recondite, sensations and behavior considered in one way or other to be essential to the correct development and deployment of a skill. From a practical standpoint such a language is indispensable for cognition and communication about the details of one's efforts and their results. Where a particular skill has been refined over a long period, the discourse of its lore contains the collective wisdom of what might be viewed as a vast trial-and-error experiment — but this only when such discourse is properly understood, and that broaches two further noteworthy characteristics of technical jargon.

First, technical jargon is mostly "ostensively" learned and calibrated to the perceptual here-and-now. That is to say, its terms are indexical *pointers* the meanings of which, like color terms, are "defined" by experience rather than by equivalent, synonymous phrases. This feature is consistent with the primary

aim of such discourse, which is to *induce* the relevant perceptions and actions and only secondarily to describe and explain them — whereas in science the primary aim is precisely to describe and explain, not to induce in the sense "to provoke." Einstein is alleged once to have remarked that it is not the purpose of chemistry to reproduce the taste of the soup. Chemistry may nevertheless *explain* that taste, and that suggests not a bad analogy for the relation between voice physiology and the phenomena of the voice as metaphorically described but mainly induced by the singer's jargon along with illustrations, imitation, gestures, and other provocative devices: it is like the relation between a recipe and a chemical analysis.

Second, though the refinement of technical jargon may be considerable, as in the case of the singer's jargon, it is first and foremost directed toward the refinement of an activity rather than itself.[60] In rough outline, once the ostended relevant features become intersubjective (once one's "got it"), the jargon has, in effect, served its purpose. And though it is retained for ease and speed of communication, immeasurable further "systematizing" continues at the activity level in ways that far outstrip its "technical" description, however useful such description may have been in producing such nuances.

It is exactly here that science (in this instance voice physiology) becomes relevant as an explanatory tool "to indicate the physical processes that underlie the singer's organic experiences and, without disturbing them, to translate the hidden meaning of his terms and fictions."[61] This enterprise is facilitated in at least two ways by the aforementioned complementary aims and differences between the *theoretical* jargon of voice physiology and the *technical* jargon of singers. "In practice it means that the voice trainer, while working, must constantly translate the singer's impressions, concepts and methods into the exact knowledge provided by science."[62] In theory it means also a redirection of the explanatory apparatus of physiology toward specific vocal phenomena. In that respect, what the singer does (and distinguishes) may guide scientific investigators to attend to phenomena the latter might otherwise overlook.

In their chapters on "registers" (VII) and "placing" (VIII) particularly, Husler and Rodd-Marling do much to swell this progress; but just as important is the model their researches suggest for similar inquiries into a wide range of artistic and other sorts of skills. It happens elsewhere besides in singing that the

body "understands" reasons that only the intellect can "know." And therein lies yet another philosophical distinction deserving of brief preliminary scrutiny in advance of a more detailed examination in chapter 3.

7. *Knowing and Understanding Singing*

Husler and Rodd-Marling conclude their book on this leading note: "Knowing is not understanding, nor is understanding knowing. The exact Scientist (who knows all), and the perfect Singer (who does and understands all) — neither will find it easy to unlock a singing voice unless they learn to complement one another."[63] As the previous section may have helped to clarify, the singer's "technical" jargon to a large extent reflects his "understanding" of singing (without constituting it, since anyone can learn to *talk* like a singer), whereas the jargon-laden statements (where true) of the voice physiologist constitute his "knowledge" of the voice. The difference between "knowledge" and "understanding" in this context is illustrated by the fact that hardly anyone would expect the scientist to be able to sing merely on the basis of what he "knows" about the voice — whereas, somebody who talks like a singer is more likely to be expected to be able to sing, on the assumption that he "understands" what he is talking about.

This distinction between "knowledge" and "understanding" overlaps with one philosophers are accustomed to draw between two kinds of "knowing": *propositional* "knowing-that" and *procedural* "knowing-how."[64] Though contingently related in innumerable ways and contexts, their logical independence is demonstrated by showing that neither one implies the other. For example, knowing how to ride a bicycle may be explained as a constant adjustment of the curvature of the bicycle's path in proportion to the ratio of the unbalance over the square of the speed;[65] but clearly, knowing that bit of physics is neither necessary nor sufficient for knowing how to ride. Similarly, a singer may know how to produce an "open," well projected tone by "placing" the voice on the upper edge of the chest bone without knowing that this is "the most effective way of influencing the Closers (lateralis and transversus muscles in the larynx) but also the safest because the chest bone-shield cartilage muscle draws and anchors the larynx downwards."[66]

Propositional knowledge is expressed in statements conforming to logical standards of belief, truth, and evidence,[67] whereas

procedural knowledge consists of skilled performances, activities rather than statements, conforming to quite different standards of achievement as variable as skills themselves and their purposes. Though measured by different standards, judgment and intelligence nevertheless are still required to "know how." In other words, "know-how" in the sense of intelligent action refers to a trained ability, keeping in mind that not every ability is trained, for instance, one's ability to see colors, feel a pinprick, or digest cabbage.

Now however many reflex responses and other untrained abilities may be involved in singing (e.g., the ability to discriminate pitches, to experience certain physical sensations, and the like), the singer's "understanding" would seem to encompass at least this much: intelligent, trained ability or "know-how" as directed and described and, to an extent, explained by the technical "language of the ear" — which is to say that the singer "understands" both through his actions and their effects *and* "propositionally" in the terms of his own special language; that is, whenever the singer or trainer uses that language to utter a declarative sentence about the voice. Otherwise, the singer's "understanding" embraces far more in the realms of sound, sensation, emotion, and musical performance that can ever be circumscribed by trained procedures, and still less by the strict logical conditions of propositional knowledge whether "technically" or "theoretically" expressed. I wish simply to observe here, and further on to argue, that "understanding" so construed may be involved at all stages of a complex skill, even the most elementary. It is a considerable feat of imaginative concentration and motor control, for example, merely to import a particular vocal achievement, say, that of the "supported falsetto" or "head tone,"[68] painstakingly built up over many months, into a simple musical phrase with its "complications" of variable consonants and vowels, not to mention textual sense or expressive dynamics. Within the scope of such small-scale accomplishments, one finds the first congruence of craft with what Collingwood is fond of calling the Creative Imagination.

Philosophically, it is not enough merely to declare this a fact, if indeed it is one. First it must be shown how, conceptually, imagination and creativity are compatible with craft, how imaginative, creative craft is possible; and beyond that, what role, if any, imagination and creativity have in a comprehensive theory of craft. Even without sharp borderlines between art and craft,

there appear to be at least two fundamental objections to the suggestion that craft is either imaginative *or* creative.

First is the opinion of Collingwood and those following him that the ordinary conception of craft as established lore, of routines and hierarchic means to ends, precludes its being in any way imaginative. Far from promoting inventive, atypical, variable responses to situations, craft engenders stereotypical efficiency at the direct expense of imagination. Second is the view, also Collingwood's, that creation is origination the results of which are unforeseeable,[69] whereas any work of craft or product of technique is the result of planning and execution according to an elaborate preconception of what is to be achieved. By contrast, "works of art proper," says Collingwood, "are not made according to any preconceived plan. . . . Yet they are made deliberately and responsibly, by people who know what they are doing, even though they do not know in advance what is going to come of it."[70] Between rote response and beforehand knowledge of results, craft would seem the antithesis of imaginative, creative activity.

Though these objections are popular and formidable, I am reluctant to concede them as fatal to a theory of craft that allows a measure of creativity and imagination within its scope. But just to allow as much requires that a new theory of craft, able to meet the objections, be devised along lines so far merely suggested in the account given of the singer's craft of voice building. The suggestions drawn from that case study are intended to be quite general insofar as analogues of the singer's grasp of particular facilities — their connecting together in his expanding awareness of the voice, as well as his initiation into singing aided by a vocabulary tailored to the perceptions and efforts required — are readily to be found elsewhere, indeed anywhere a body of lore exists for the training and guidance of skill.

Psychologists have devoted a goodly amount of attention to learning rates and the perceptual and motor components of skill while virtually ignoring the nature and influence of the "know-how" or lore that is passed on in life outside the laboratory. That is an understandable limitation of the experimental approach which tends to focus in isolation on one or another aspect of skills, rather than examining them holistically in the glassworker's foundry or the singer's studio. There are advantages to both approaches. For the moment, it suffices to say that the question of the nature and influence of craft lore on skill is a many-faceted

one of evident psychological and philosophical interest.

The question is of interest philosophically chiefly for the way traditional lore constitutes and may at the same time be used to cultivate a refined practical judgment governing action. That craft of any kind involves judgment and continuous adjustment to changing conditions in ways often imaginative and creative seems to have escaped the notice of those who would *reduce* craft to rote means to fixed ends, as if all that were involved was a "running off" of mindless routines. Routines there are aplenty in craft, but judgment directs first their development and ultimately their deployment — or should.

To a degree, such judgment is codified, or encapsulated, in the lore's technical jargon, which I have chosen to call the languages of craft. From a philosophical standpoint, the distinctive features of such discourse, some of which are outlined above, offer a convenient starting place for a general analysis of the craftsman or artist-craftsman's special "understanding" and the contribution to it made by critical judgment and creative imagination. Utilizing the case study at hand and other examples, an examination of the languages of craft showing the implications for imagination and creativity in craft is undertaken in chapters 3 and 4.

Two final caveats. Nowhere in the sequel do I assume that the craftsman's *peculiar* grasp of things, whatever it should amount to, is in the least imaginative or creative simply because it is peculiar. If there is anything imaginative or creative about it, it must be shown how, and under what conditions. Neither can it be safely assumed that the judgment of the craftsman at work is the same as or coincident with the *ex post facto* appreciation or judgment, by himself or others, of his achievements however akin or contingently related the two judgments may be. In craft, we are dealing with an understanding and practical judgment exercised in actions the results or quality of which may be judged separately or differently.

REFERENCES

CHAPTER 2

1. T. R. Martland, op. cit., p. 235.

2. Frederick Husler and Yvonne Rodd-Marling, *Singing, The Physical Nature of the Vocal Organ, A Guide to the Unlocking of the Singing Voice,* illustrated by Frederick Husler, revised edition (London: Hutchinson, 1976). Books on singing are legion. Among those I found most useful are: Sergius Kagen's *On Studying Singing* (New York: Dover, 1950), a short, generally reliable account of voice training but devoid of any scientific underpinnings; D. R. Appleman's *The Science of Voice Pedagogy* (Bloomington: Indiana University Press, 1967), an immensely detailed physioacoustic study of the processes of phonation that loses sight of the forest for the trees; and three works by C. L. Reid, *The Free Voice, A Guide to Natural Singing* (New York: Coleman-Ross, 1965); "Functional Vocal Training," in two parts, *Journal of Orgonomy* 4, 1970, pp. 231-249 and 5, 1971, pp. 36-64; and *Voice: Psyche and Soma* (New York: Joseph Patelson, 1975). Reid's work, though rich in practical details and theory leavened by sensible criticisms of overly "scientific" approaches to singing, characteristically eschews appeals to physiology to explain the success or failure of one or other technique or training device.

3. Husler and Rodd-Marling, op. cit., p. 69.

4. See especiallly the discussions of *Martellato, Messa di Voce,* and *Bel Canto* in ch. X, ibid.

5. Johan Sundberg, "The Acoustics of the Singing Voice," *Scientific American* 236, 1977, p. 82.

6. Kagen, op. cit., pp. 79-80.

7. Husler and Rodd-Marling, op. cit., p. 69.

8. Sundberg's discussion of vocal "formants" is a good example, op. cit., pp. 86-88.

9. Husler and Rodd-Marling, op. cit., pp. 1-9.

10. Aristotle, *Metaphysics,* Book Alpha.

11. Husler and Rodd-Marling, op. cit., p. 1.

12. Ibid.

13. Ibid.

14. Ibid., p. 76; italics theirs.

15. Ibid., p. 100.

16. Ibid., p. xviii.

17. Ibid., pp. 1 and 119-120.

18. Cf. ibid., p. 131: "Every form of specialisation within the functioning of the vocal organ is bound to lead, more or less, to what might be termed degeneration."

19. Ibid., p. 131.

20. Ibid., pp. 15-24.

21. Ibid., pp. 24-30.

22. Ibid., pp. 30-51.

23. Ibid., p. 12.

24. Ibid., pp. 37-38; italics mine.

25. Ibid., p. 38; italics theirs.

26. See ibid., pp. 44-46, for an interesting discussion of the pitfalls of "congesting" the voice — an all-too-common mistake of beginners, incidentally, especially as they try to imitate the top notes of accomplished singers.

27. See ibid., p. 33.

28. In this connection, see especially the sections entitled, "The Tonic Regulation of Breath," "The Respiratory Scaffolding," and "Movements of the Respiratory Organ in Singing," ibid., pp. 33-39.

29. Ibid., p. 12.

30. Ibid., p. 32.

31. Ibid., p. 44.

32. Ibid., p. 57; italics theirs.

33. Henry Pleasants, *The Great Singers From the Dawn of Opera to Our Own Time* (New York: Simon and Schuster, 1966), p. 20. The ability to execute an effective *messa di voce,* to increase and decrease dynamic intensity at will at all pitch levels, is of course the sine qua non of *bel canto.*

34. Husler and Rodd-Marling, op. cit., pp. 57, 64-65.

35. Ibid., p. 58; italics deleted.

36. Ibid., italics deleted.

37. Ibid., p. 64; italics theirs.

38. For ease of communication, but other reasons as well (see section 6 below), the authors continue to speak of "registers" now understood as referring to vocal accentuations or emphases rather than so many separate parts of the voice. C. L. Reid, in direct contrast, considers registration a fundamental vocal phenomenon: "There are two registers, one the *falsetto,* the other the 'chest.' " Still, he contends that the major concern of training "is not so much one of maintaining the registers as separate entities, but of bringing them together into a harmonious functional relationship." *The Free Voice,* pp. 48, 50. Interestingly, a brief comparison of the Husler and Reid training programs for *achieving* the desired "functional relationship" reveals no major conflicts. However, Husler and Rodd-Marling go much further toward explaining *why* there are breaks in the voice and what physically is required to eliminate them.

39. See Husler and Rodd-Marling, op. cit., ch. XII, "Singing and Speech," pp. 95-99.

40. Kagen, op. cit., p. 78.

41. Ibid., p. 45.

42. Ibid., p. 41; italics deleted.

43. Husler and Rodd-Marling, op. cit., p. 89.

44. Ibid., p. 94.

45. Ibid., p. 93.

46. Quoted from G. Panconcelli-Calzia, *Die Stimmatmung* (Leipzig, 1956), ibid., p. 89.

47. Ibid., p. 90.

48. Ibid., p. 93.

49. But neither, for that matter, is Western music altogether free of influences "corruptive" of pure vocal beauty, inasmuch as most songs consist of sung language. Cf. ibid., pp. 96-97.

50. Ibid., p. 90.

51. Ibid., p. 91.

52. Ibid.

53. Ibid., pp. 131-132.

54. Ibid., p. 10.

55. Ibid., p. 69.

56. Ibid.

57. Ibid., p. xvi.

58. Ibid.

59. Ibid.

60. Again, as contrasted with science where the conceptual refinement is in the language and logic of science relative to the phenomena to be described and explained.

61. Husler and Rodd-Marling, op. cit., p. xvi.

62. Ibid.

63. Citing Pierre Bertaux: "Knowing is not understanding. Science does not lead of itself to comprehension. To arrive there requires a great leap which the strict scientist's methodological principles prevent him from making." *Mutation der Menscheit* (Frankfurt, 1963).

64. See Gilbert Ryle, *The Concept of Mind* (London: Hutchinson, 1949), ch. 2; and Israel Scheffler, *The Conditions of Knowledge* (Glenview: Scott, Foresman, 1965), ch. 5.

65. The example is Michael Polanyi's in *Personal Knowledge: Towards a Post-Critical Philosophy* (London: Routledge & Kegan Paul, 1958), p. 50. Polanyi's comments on skills (ch. 4) are particularly apropos of Husler and Rodd-Marling's researches.

66. Husler and Rodd-Marling, op. cit., p. 69.

67. See Scheffler, op. cit., p. 21.

68. See Husler and Rodd-Marling, op. cit., pp. 59-62, for the physiological description.

69. Cf. Vincent Tomas: "To create is to originate. And it follows from this that prior to creation the creator does not foresee what will result from it." "Creativity in Art," in Vincent Tomas, ed., *Creativity in the Arts* (Englewood Cliffs: Prentice-Hall, 1964), p. 100.

70. Collingwood, op. cit., p. 129.

*Ask yourself: How does a man learn to get a "nose"
for something? And how can this nose be used?*

Ludwig Wittgenstein, Philosophical Investigations

1. *Languages and Nonlanguages of Craft*

Much about craft goes without saying or with the aid of other kinds of symbols: gestures, diagrams, pictures, demonstrations, samples of finished work, technique, or special effects, and a wide range of heuristic imagery for the guidance of mind and body in complex actions. One is reminded, for instance, of the interlaced comments and gestures of a diving coach to indicate to a just-surfaced diver when and what went wrong, or the detailed "mental rehearsal" of high jumpers and gymnasts, not to mention opera singers and actors. And then there are the standard devices of musical scores, Labanotation for the dance, "stop motion" photography, play diagrams, interpretative gestures, and the like.

Many such adjuncts to discourse about craft and skill, though certainly not all, have the semantic force of "observation sentences" (to borrow Quine's apt phrase)[1] used to signify or query the presence of something perceived or done, or the success of something attempted; for example, a tap on the chest bone and a nod to the effect, *"That* is a full chest sound!" or a querying raise of the eyebrows in mid-phrase to the effect, *"Is* that a full chest sound?"

In addition to serving the aims of description, a great many of a conductor's gestures, for instance, are command-surrogates — musical traffic lights, so to speak — to the effect, "Ready . . . Begin!" or "Enter violas," "Exit woodwinds," "Pianissimo, please"; while others are interpretative of rhythmic, dynamic, or expressive qualities of the music being performed. However idiosyncratic, such gestural codes and messages reinforce as well as supplement the notational, linguistic, and diagrammatic instructions of the score as quick and silent ways of talking to the orchestra: coaxing ("Come along, get with it!"), reassuring (a "Just so!" wink), and correcting ("Less volume, strings!" signalled by the left palm down). There is nothing particularly striking in this, since we are accustomed in everyday life to a wide variety of coded, in this instance, gestural, abbreviations of sentences wherever their written or verbal equivalents would be cumbersome for any reason at all. Pictorial road signs, directional arrows, Morse code, semaphore, insignias, and the like, are

common enough.

What is important is to distinguish linguistic codes — by which I mean any surrogate for the written or spoken characters[2] of language — from essentially nonlinguistic symbols. The strictly notational parts of a standard musical score (pitch, duration, and meter indicators) are nonlinguistic; and certain of the conductor's interpretative gestures may well be construed as command-*representations,* rather than sentences, giving the pattern of a musical phrase in ways more akin to a picture or diagram than a sentence. Such a gestural representation differs as much from a gestural sentence-surrogate as does a picture from a word.

In the same category of command-representations are the varieties of heuristic imagery suggested or described in language that are intended to guide or help control bits and pieces of a technical or interpretative effort; for example, "Think of the voice as placed forward against the teeth," or "The second phrase mirrors, not merely repeats, the first." In such cases, one is expected to use the image, to exploit its potential for control or the achievement of an effect, by a kind of induced synaesthesia. As an act of imagination, heuristic imagery must be distinguished from merely *having* images, say, of one's mother's face — images which, I shall argue, are not at all representational — as well as be distinguished from other forms of imagination. (See chapter 5, sections 7 and 8.)

Notations, diagrams, pictures, descriptions, and gestures all have their special referential usages separately or in combination and sometimes in substitution. So also, though less obviously, do the demonstrations, samples, model exercises, and illustrations offered for imitation or as signal-indicators of what or what not to do. Often a single demonstration is worth a thousand metaphors or synonyms to communicate the "meaning" of a technical word or phrase. Just as often, a thousand words of description may be required to get one to grasp the point of the demonstration. So the reference may, and does, go in either direction: from words or other symbols to demonstration or backward from sample action to the labels and descriptions applied to it.

An interesting philosophic problem arises here from the familiar fact that demonstrations are so frequently exaggerated to increase their salience. Consider, for example, the athletic or dance coach's comic rendering of a defect in a movement. It may even amount to a *caricature* of what went wrong and by that very exaggeration of aspect help to exorcise the fault with an ef-

ficiency that no literal imitation could do. Correlative, then, to the problem of distinguishing literal from metaphoric forms of discourse is the equally vexing problem of distinguishing literal from metaphoric demonstrations relative to a description. (See chapter 4, section 8.)

As a first stage of analysis of what in reality are the languages and nonlanguages of craft, this chapter seeks to clarify an individual's initiation into a symbolic lexicon, and the expansion of that lexicon for controlling, describing, querying, and in a practical way, explaining what one is about particularly at the point of "getting it." In other words, it is intended to throw some light on "understanding" in a sense characterized by Wittgenstein as, "Now I understand the principle. . . . Now I can go on."[3]

2. *Understanding How to Go On*

When the novice singer declares, "Now I understand the head voice!" we are not at that moment alerted to any particular mental state nor even, from a practical standpoint, to the momentary configuration of his larynx. Though possibly he experienced some sensation causally resulting from movements of the muscle system embedded in the vocal folds, his statement describes neither of those events. Rather, when uttered, it has the illocutionary force[4] of a *signal* putting us on notice; "and we judge whether it was rightly employed by what he goes on to do."[5] If further attempts to produce a head-voice sound fail to show a fairly high incidence of success, or at least close approximation to the desired sound (results are of course *weighed* in such cases), we readily conclude that he does not yet understand the head voice.

If asked, What happened when you understood? the singer may describe certain sensations he felt just as one who suddenly is able to continue a series of numbers may reply with the formula for that series. But clearly one may have such experiences or be able to recite a (correct) formula without understanding, without being able to go on, barring any extraordinary interference. Though the relevant experiences may differ markedly from one task to another or from one person to another at the same task, the two cases have in common, in Wittgenstein's words, that "it is *the circumstances* under which he had such an experience that justify him in saying in such a case that he understands, that he knows how to go on."[6]

The circumstances, of course, will vary. For instance, there

are learning stages to take account of: what counts as understanding for the novice may only approximate that of the expert. Yet, because he is able to go on and do better we say of the novice that he understands. Similarly, the circumstances may restrain us from denying understanding in an instance where one is unable to go on. John McCormack, musing in retirement over his recordings — "I was a damned good singer, wasn't I?"7 — may have lost his mastery though hardly his understanding of singing. Nonetheless, at the dawn of understanding signaled by the claim to have understood, we generally require some demonstration of the light.

While a demonstration is perhaps the best evidence of the *onset* of understanding in Wittgenstein's sense of knowing how to go on, even then "understanding," "knowing how" to go on cannot be reduced to the mere ability to go on; for not only may one continue to understand long after losing the abilities once demonstrated, but it is quite conceivable that one be able to go on without understanding how. If a demonstration now or then may be considered necessary to understanding, the circumstances justifying a claim to understand also extend to having some inkling (1) of the *means whereby* one is able — a "tip," formula, or procedure ("By cocking my wrist just so I've been able to improve my golf swing"); and (2) of the *standards* of correct performance or other result. Naturally, one thinks of "means whereby" the more one needs to think of them, and the less as the need does not arise or as such means become a matter of routine. This allows for the so-called "natural" performer, craftsman, or athlete who understands what to do and how well but not very much about how he does it. For such understanding as that, "know-how" in the sense of *formulable* technique is neither necessary nor sufficient, though observation of such fortunates may help to swell the available sum of such knowledge.

Further qualifying circumstances of a criterial nature pertain to the broad conceptual differences between understanding and knowing. Epistemically, "understands" does not imply "knows" in the usual way that one may understand, say, a theory or explanation without either believing it or having any evidence for it. Beyond that, however, it would be fair to say that knowing as a traditional quarry of philosophers is relative to standards of propositional assertion, usually some combination of belief, evidence, and truth conditions.8 How one construes such conditions of knowledge is less important here than the fact that on any

construction they represent standards appropriate to linguistic or quasilinguistic formulation — appropriate to stated versions of things. But as stressed at the beginning of the previous section, the sort of understanding that enables one to go on typically encompasses nonlinguistic as well as linguistic (including coded) versions — images, expressive gestures, notations, and the like for which there are discernible criteria of accuracy, of fit or fidelity, or "rightness of rendering" not easily accommodated to the model of fixing a belief on adequate evidence.9

Indeed, it appears that understanding some elusive yet scrutible phenomenon such as the "supported falsetto"10 may altogether defy ponderable evidence even where declared in statements to the effect, "Now I understand!" I have in mind an exercise of intelligent perception that Wittgenstein calls "expert judgment." He raises the issue of expertness of judgment in connection with our ability (or lack of it) to recognize the genuineness of expressions of feeling.

> "You're all at sea!" — we say this when someone doubts what we recognize as clearly genuine — but we cannot prove anything. Is there such a thing as 'expert judgment' about the genuineness of expressions of feeling? — Even here, there are those whose judgment is 'better' and those whose judgment is 'worse'. Corrector prognoses will generally issue from the judgments of those with better knowledge of mankind.11

The connection between this kind of knowledgeable judgment — what I call understanding — and learning a technique is described by Wittgenstein:

> Can one learn this knowledge? Yes; some can. Not, however, by taking a course in it, but through *'experience'*. — Can someone else be a man's teacher in this? Certainly. From time to time he gives him the right *tip*. — This is what 'learning' and 'teaching' are like here. — What one acquires here is not a technique; one learns correct judgments. There are also rules, but they do not form a system, and only experienced people can apply them right. Unlike calculating rules. What is most difficult here is to put this indefinite-

ness, correctly and unfalsified, into words.[12]

Well, granted it is difficult, but is not the expert himself then left permanently at sea as regards *justifying* his judgment? Is there no evidence he can present besides the authority of his past successes? Wittgenstein's answer is yes, "But 'evidence' here includes 'imponderable' evidence."[13] In the case of divining expressions of feeling, that would include "subtleties of glance, of gesture, of tone." The question, then, is "what does imponderable evidence *accomplish?*"[14] And the answer to that question is that imponderable evidence often has ponderable consequences. So, for example, one might be convinced on imponderable evidence of the genuineness of a painting which judgment might later be confirmed or disconfirmed by documentary evidence. This is the precise analogue of the relation between what Husler and Rodd-Marling call the "science of the ear" and the science of physiology as applied to the singing voice. Similarly, Wittgenstein notes,

> I may recognize a genuine loving look, distinguish it
> from a pretended one (and here there can, of course,
> be a 'ponderable' confirmation of my judgment). But
> I may be quite incapable of describing the difference.
> And this is not because the languages I know have no
> words for it. For why not introduce new words? —
> If I were a very talented painter I might conceivably
> represent the genuine and the simulated glance in
> pictures.[15]

Certainly in art/craft situations we regularly do introduce new words, imagery, and metaphors made up to capture crucial differences, phenomena, and the like; and the more circumspect the activity in question, the more likely such language or other types of symbolization *will* form a system — the "lore" built round the all-too-ponderable consequences of a failure to understand. The need for technique, to make expert judgment as ponderable as can be, arises from the failure to understand spontaneously, so to speak, what the desired result is and how to get it. It then becomes requisite to show and tell what went wrong as well as to supply corrective exercises, sound procedures, and exemplars to a fledgling judgment. If so much is obvious, it is nonetheless not always obvious exactly where the failure of understanding lies.

The shortfall in results is the best clue we have, usually amounting to a *syndrome* — "typical" single or concatenated errors — such that one works through the ponderable parts of such an activity as singing, drawing, or tennis, adjusting and honing them in very deliberate ways.

As Wittgenstein observes, the grammar of the word "knows" is closely related to that of "can," "is able to," and "understands" in the sense of mastery of a technique,[16] what the vernacular calls "know-how" and philosophers "intelligent capacities" or "procedural knowledge."[17] "But," Wittgenstein continues, "there is also *this* use of the word 'to know': we say 'Now I know!' — and similarly 'Now I can do it!' and 'Now I understand!' "[18] As signal alerts to the possibility of a demonstration, such locutions function alike; but as claims to know, to be able, to understand they may differ in significant ways. Furthermore, where does the "expert judgment" of the experienced observer, the master craftsman, the connoisseur, or the virtuoso racing ahead of ponderable evidence and technique fit into the picture? Overlooking many details, it is possible to construct at least a sketch map of this difficult terrain.

3. *Going On to Understand How*
Anyone who observes the seemingly endless stream of talk that accompanies the learning of such a complex skill as singing, or peruses the equally endless stream of books on the subject, might be tempted to equate "know-how" in this or similar undertakings with just those evidential features of trained abilities as are picked out and to whatever degree systematized in the traditional lore. Resting on the ponderable evidence of generations, such judgments as comprise "know-how" would then constitute the eminently practical among other possible statable versions of the activity; for example, the language of the ear *versus* the language of physiology.

Of course, colloquial use is rather more ambiguous, sometimes equating "know-how" with trained ability simply as when we say, "He knows how to ride a bicycle." But since nothing much beyond indicating that he *can* ride is intended by the statement, it might be thought to eliminate the ambiguity as follows: To say that *A knows* how (besides being able) to ride is to say that he could give an account of how he acquired the ability — could describe and perhaps demonstrate what is involved in learning to ride a bicycle. Such a legislative distinction

preserves the difference between knowledge and abilities while respecting the possibility, however unlikely, of one's being able to ride without knowing how.

Now while a propositional construction of "know-how" captures its *formulable* aspects, its uses are much too fissile to permit a wholesale reduction to "know-that" locutions. In the first place, it is simply not the case that nothing more than the ability to ride is implied by saying, "*A* knows how to ride a bicycle," where no parallel explanation is forthcoming. This is shown by the fact that there are circumstances in which we would deny that he knows how, even when able, that involve no reference to his also formulating an account of his ability. For example, we would likely deny that *A* knew how to ride, to sing a high "C," or score a "bull's-eye" at darts if he succeeded on the very first attempt. In such instances, the implication of the denial is that such abilities generally require training and practice.[19]

We might of course be wrong in our judgments of particular cases — whether and how much practice is required — but the point is that we have a conception of "know-how" that presupposes practice to be applicable to demonstrated abilities. Accordingly, we should be inclined to "explain away" a successful first attempt at bicycle riding perhaps on grounds of a "transfer" of skill (particularly if it were disclosed that the easy rider was also an acrobat), or of "hidden" practice (if *A* was in the habit of daily workouts on a stationary exercise bicycle). Similarly, a bull's-eye at darts on the very first attempt at the game is derisively dismissed as "beginner's luck." Still, if the feat is repeated time and again thereafter without any evidence of transfer or hidden practice, we might say *either* that *A* is able without knowing how, *or* that he knew how right from the beginning, depending on our assumptions about one-trial learning and the speed of "talent."

Such latitude in our ordinary judgments of know-how goes also to show how vague our ordinary conception of practice can be. But that is another story to be pursued later on (see chapter 6). For the moment, it is worthwhile to attempt a rough sorting of "know-how" locutions later to be woven into the larger skein of craft. The popular distinction between propositional and procedural knowledge earlier rehearsed,[20] though useful, tends to obscure the propositional uses of "know-how" and indirectly its relations overall to "expert judgment" of the sort described above. Hartland-Swann[21] makes a similar point to the effect that on

a "dispositional" analysis of knowledge of the kind undertaken by Ryle,[22] every case of "knowing-that" turns out to be a case of "knowing-how." For example, " 'I have learnt that the earth is round' can be dispositionally analysed as "I have learnt how to reply correctly to the question, 'What shape is the earth?' " Conversely, "I know French," ostensibly a case of knowing how (to read, to translate French), not only implies certain competencies or skills but "also the actual knowledge *that* the French word for *knife* is *couteau,* for *boy* is *garçon* and so forth."[23] The upshot is that the how/that distinction is far less stable or clear-cut with respect to various capacities "to know" than Ryle's presentation of it would suggest.

4. *Types of Know-How*

Well and good, but this remains something of a verbal quibble, since we are then constrained to draw fairly much the same distinction between different capacities to know how as Ryle drew between "knowing-that" and "knowing-how." J. R. Martin argues that point in a sequel to Hartland-Swann, maintaining that the difference between the capacities involved in answering a simple question of fact and those involved in knowing how to swim are "more basic" than the difference between the capacities involved in knowing how to swim and knowing how to ice-skate or play the violin.[24] If so, then we should have to recognize a difference between intellectual and procedural capacities — a difference distinguished, perhaps, by the latter's being inculcated by practice; whereas, the capacity to answer the question, "What is the shape of the earth?" is not, in any relevant sense, acquired or improved by repeating to oneself, "It is round," "It is round," etc.

However one slices the how/that distinction, these caveats to Ryle alert us to some confusing vagaries of use of "know-how." In general, some four characteristic uses attach to "know-how," the differences among which it is well to keep in mind whenever it is claimed that somebody knows how to do something. Martin[25] proposes three categories of capacity to which I shall add a hybrid fourth ingredient to any interconnected body of skills.

Capacity Type A corresponds to the aforementioned use of "know-how" presupposing practice: ordinary and extraordinary skills such as cooking or Karate. Capacity Type B is Hartland-Swann's knowing how, without practice, to make factual assertions and answer correctly questions presupposed by knowledge

that, for instance, the earth is round. Martin's third capacity Type C is exhibited by such claims as, Johnny knows how the accident happened, how the motor works, how Flagstad felt on the occasion of her debut, how the Prime Minister manages to get his way. Though severally quite different, Type C claims to "know-how" are alike in not requiring practice: it is not required to practice "witnessing" and "asserting" to say, firsthand, how the accident happened. There is, then, a crucial difference between Type A and Type C capacities to "know-how."

Like Type B capacities, those of Type C presuppose certain factual information, but unlike Type B, of an unspecified kind. "We know only that Johnny has certain knowledge which presumably could be elicited from him upon demand"26 — whereas Type B sentences are specific about what factual propositions are known, and hence exclude a larger number of alternatives than a Type C characterization. The difference is not just one of relative generality (or specificity); for, though Martin does not observe this, Types B and C are logical *duals,* the one being specific about *that* (the particular propositions known), the other about *how* (the subject-matter covering a range of propositions). One and the same proposition may easily belong to different subjects-matter. "The Prime Minister blew a gasket" could be part of one's knowledge of how the accident happened or how the Prime Minister got his way. Conversely, one might state how the accident happened or how the Prime Minister got his way in several different but equally correct versions. In any event, Type C capacities reflect the sense in which it is sometimes sufficient to know how to be able to *say* how — a prerogative of critics and other observers that does not require them to be doers.

"Know-how" is exponible into at least the foregoing three categories of use. As well, a further use, highly relevant to craft, combines Type A and C capacities, presupposing practice *plus* the ability to say how. This is to say that there are circumstances where we should be prepared to deny "complete" or full-fledged "know-how" of anyone who acquires even the most refined of capacities by diligent practice and who is yet unable to give any coherent account of his or her success. We might well concede such an individual "expert judgment" concinnated by helpful hints over many trials and yet deny that he knows how to do what in fact he does superbly. The demand for an accountable know-how is often (and rightly) made of teachers. So much is implicit in the voice teacher's comment on his gifted student soprano: "She

understood, she knew instinctively what to do, but she never knew how she did it.">27

In other words, the demand for *accountable* know-how makes sense wherever a body of lore exists for training capacities and skills of one kind or another. We make note of it not only in our demands on teachers but whenever the ponderable lore either is ignored or remains imponderable to whomever can go on without it. Obviously, exceptional talent will often bypass whole phases of lore while just as often be nourished by it in ways that bear piecemeal analysis. The point is that the lore considered as a body of knowledge exists to be consulted as needed, so that unless one has a special interest in teaching or history, goodly portions of it are likely to be ignored or forgotten. Either way, the consequence is that one may know how (Type A) without knowing how in the compound sense (call it Type D).

Another way of looking at the matter is to note that a Type A capacity is usually the result of a selective grasp of traditional lore. Clearly this would not hold where no such tradition exists or for whatever reason goes unheeded. But where such a tradition is available, the sense of know-how that is constitutive of craftsmanship considered as a complete-as-can-be body of pracitcal knowledge, approximates closest to the combined capacities of Type D. In short, it is when we dwell on the means by which a particular result can be achieved that we invoke or tend to slip over to Type D know-how.

We encountered Type D know-how in our earlier discussion of the functional knowledge of the singing voice, knowledge expressible in either or both the languages of the ear or of physiology (see chapter 2). The relations among the Types was also in evidence there: because the craft of voice building, as contrasted with the art of singing, is a routine planned activity, one may know how (Type C) it is done — for instance, how Caruso achieved a particular vocal effect — without of course knowing how (Type D) to do it oneself. And, as mentioned, there are individuals who manage quite well (Type A) without knowing how in either the combined or propositional senses.

Though difficult to keep separate in practice, we may distinguish between understanding how to go on or know-how according to rule or planned procedure, and the understanding of "expert judgment" in Wittgenstein's sense of the term. Whether the latter be taken to refer to a momentary judgment based on imponderable evidence, or to an individual's ability overall to

make such judgments beyond the kith of convention, the afore-
mentioned difference in kinds of understanding corresponds to
the commonly invoked contrast between technical competency
and full mastery. Or rather, that contrast implies something like
the foregoing distinction.

It matters little that in the vernacular the terms 'understanding,'
'knowing how to go on,' and 'expert judgment' may also range
over the varieties of know-how distinguished above so long as
this reach beyond routine is acknowledged. In practice we seldom
fail to recognize the difference between the expert judgment of
a higher understanding and routine competency, the effects of
the former being often so evident: for example, when a senti-
mental ballad like *Macushla* is almost forcedly raised above
banality by the "artistry" — by which is meant the expert in-
tonation, diction, and phraseology — of a John McCormack.

It is sufficient, then, for a "technical" understanding of the
voice that one comprehend statements made in the language of
the ear, just as comprehending the language of physiology is
sufficient for a theoretical understanding. Such grasp of singing
— in fact an important dimension of its appreciation — is ac-
cessible to those who never could sing. For one who seriously
tries, however, understanding how to go on will usually, though
not always, depend on digesting bits and pieces of the tradi-
tional lore. Eventually, routine gives way to a rather different
grasp of imponderable, ineffable cues, sensations, vague or pre-
cise images, examplars, and subtleties of "feedback" effects that
lead on as they coalese into that form of refined understanding
Wittgenstein calls "expert judgment," where tips rather than
rules are more likely to make a difference.

How do the concepts of craft and skill plot against these dis-
tinctions? As noted before, partly out of convenience and partly
as a reflection of ordinary usage, craft herein is taken as co-
extensive with "technical understanding" construed not as any
one individual's formulable know-how but as the knowledge
available. Thus, to say "He knows his craft" *could* be to say that
he knows how (Type A), or less likely that he has knowledge
about craft (Type C), but paradigmatically refers to his com-
bined abilities to do and to account for what he does (Type D).
Note that I say "account for," not "explain"; for explanations
are limited to verbal versions, and we must allow for nonverbal
"showing" as well as "telling."

Craft aims to produce a specific result be it a physical pro-

duct or performing ability through the development of skills built up by practice. Craft ranges over the specifiable parts of skill including whatever is ponderable (codifiable) in expert judgment. Skill, however, being a broader concept, encompasses much more: from virtually any facility (such as skill at typing) acquired by practice to the imponderable varieties of expert judgment whether learnt by tips and cues supplied by another or in entirely idiosyncratic ways. By examining the ponderable results of a master craftsman's exercise of skill, it may be possible to discern his "method" and thus add yet another increment to the traditional lore. By finding an easier, more efficient, or pleasing way, such superior understanding may of course either further the progress of conventional know-how or destroy it completely. Craft, no less than art or science, is susceptible to revolution in substance or style.

5. *Words and Illustrations*

Though many a question goes begging in this rough sketch of the epistemological setting of craft and skill, it will perhaps suffice to indicate the varieties of knowledge and understanding aimed at through the interplay of language (and other symbols) and action at the moment of "trying to get it." Let us now consider some of the details, mentioned at the beginning of this chapter, of an individual's initiation into a lexicon of craft; in this instance, the singer's language of the ear as described in chapter 2.

There are two overriding questions to be dealt with here. First, how do we learn new words — or new usages of old words — especially ones that refer to or purport to explain recondite sensations, phenomena, or effects of one's own actions? Second, how do the circumstances of the learner of craft lore differ, if at all, from those of other learners of new words, say, a child struggling with its mother tongue, or a novice physicist with the jargon of quantum mechanics, or a field linguist with an undeciphered language?

As stated, both questions are slightly misleading in focusing attention on separate words. Ordinarily, we would consult a dictionary of English, of French (if it is a French word), or of a specialized subject, for the meanings of new words. For example, the best definition of "geosyncline" is likely to be found in a dictionary of geology, though it may also be found in the *O.E.D.* A glossary of terms is usually supplied in books on dance, sing-

ing, pottery, and the like. Still, lexical equivalents of the dancer's "lift" or the singer's "head voice" will often seem as inadequate as a definition of "red" as "the colour which appears at the lower or least refracted end of the spectrum."[28] This is because in the action-orientated context of craft skills one's concern is less with what particular words mean *as rendered in other words* than with what it is (the phenomena) they refer to. Indeed, while the phenomenon in question — a special quality of voice, the head voice, for instance — may admit of precise discrimination, the words used to label or describe it may vary considerably. The important thing is to be able to discriminate that sound from others, say, the chest voice, for which, as it happens, we have another term. Accordingly, such "technical" terms enter the novice's vocabulary not so much as separate words but either as one-word sentences or as parts of sentences the basic grammar of which is understood; for example, "Head voice!" or "That sound — the one you just made — is the head voice!"

The indexical character of such sentences might suggest that the answer to the first question above is "ostension" — that as verbal pointers, such terms as "head voice" are acquired solely by conditioned correlation of word and referent over repeated instances of their use in a variety of sentences. If not completely wrong, that answer is unsatisfactory for the tendency to confuse how a word gets its meaning with how its meaning is learned. Ostension may be thought of as a special case of denotation, or unidirectional reference, where understanding the "meaning" of the word requires direct acquaintance with its referent; which is to say, that such words — or such ostensive uses of words — are calibrated to objects, properties, or events in the perceptual present. But *which* objects, properties, events, or aspects thereof is not given by the simple act of pointing physically or verbally. In other words, it is a genuine question as to what can be distinctively pointed out. As Quine observes,

> In general, if a term is to be learned by induction from observed instances where it is applied, the instances have to resemble one another in two ways: they have to be enough alike from the learner's point of view, from occasion to occasion, to afford him a basis of similarity to generalize upon, and they have to be enough alike from simultaneous distinct points of view to enable the teacher and learner to share the

appropriate occasions.29

But such resemblances as form the basis of the ostensive use
of technical terms are not so much given as taken, or rather,
achieved, by the complementary processes of querying and of
matching and contrasting of stimuli. A typical exchange reflect-
ing such processes runs as follows: "Is that it?" "Yes, that's it
exactly!" Or, "No, it's this . . . as contrasted with what you did
which was this . . ." That samples and demonstrations play a
large role in teaching the extensions of the ostensive use of terms
is hardly logical news. What is of note, however, is that *criteria*
of resemblence (sufficient to mark something as an "instance")
are supplied by a teacher responding to students' queries by
affirming or denying that something in their common perceptual
present or recent past is an instance of whatever the label in
question names. Beyond that it is of paramount importance to
realize that the learning and use of the appropriate language on
these occasions is not just a matter of learning to attach a
verbal label to something grasped quite independently, but an
integral part of the grasping itself — like a novice painter dis-
covering all the different shades of "red."

To show the crucial contribution of "technical" talk to the
learning of skills, we have only to consider the symbol relations
involved in learning the ostensive usage of a single term such as
"head voice." While ostension is unidirectional reference from
symbol (in this instance a two-word term) to referent, such ref-
erence is learned by querying the samples and demonstrations
used to exemplify (that is, refer back to)30 the symbol being in-
troduced. ────────→ ←────────By learning when and what
to query in the examples, one advances en route to an under-
standing of what is significant about them: what to emulate,
avoid, or ignore. If talk about such notions as the head voice is
no substitute for even one plangent demonstration, so also the
demonstration may be pointless without some indication of what
to listen for. An expertly performed demonstration will not al-
ways speak for itself.

Analogues of this close interplay of language and sample/
demonstrations are not hard to find in the learning of virtually
any skill. A conspicuous feature of such interplay in nonverbal
skills (as contrasted, for instance, with learning color terms in a
foreign language) is that such sample/demonstrations used to
illustrate the proper use of a skill-term are first and foremost

aimed at illustrating largely unspoken — though perhaps de-
scribable — aspects of the skill itself. Unless one takes a purely
critical interest, as in the present discussion, one's concern is
less with what or how the *term* "head voice" means than with
achieving it and actively realizing its practical significance for the
voice overall. Hence the querying, far from ending once the ex-
tension of the new term is grasped, increases with the intention
of eliciting certain details and expanding the scope of the demon-
stration.

Though necessary to start things off and to make corrections,
words are quickly left behind with the consequence that refine-
ments in their usage seldom keep pace with the elaborate de-
velopments in the activities to which they refer. The result is the
familiar profusion of seemingly hopelessly vague technical terms
and metaphors enlisted more or less ad hoc as the occasion de-
mands. A second, more poignant consequence is that except for
some final achievements on canvas, in wood or stone, or record-
ed on film and disks, whole traditions of craftsmanship may be
lost and only painstakingly regained, as Husler and Rodd-
Marling's researches show, by lengthy scientific reconstruction.
Again, the analogues are many.

But to return to the topic at hand: Clearly, illustrations of
various kinds serve not only to exemplify the extensions of initial-
ly indexical bits of jargon but larger-scale descriptions and ex-
planations as well, the latter serving in turn to elicit the most
possible from the illustrations proffered. Accordingly, notwith-
standing the stress on pointed questions and leading examples,
new words about a craft or its constituent skills enter one's vo-
cabulary by much the same routes as any new words. Relatively
few of them are learned in isolation, in effect, as one-word
sentences. More often, they are learned in context or as "ab-
stractions" from various sentences in which they can occur.[31]
The method employed varies from one individual or word to
another. For example, it is likely that one's first inkling of the
meaning of "head voice" will come from hearing others talk
about vocal "registers" as breaking down into the "head,"
"chest," and "falsetto" voices. At first we may distinguish them
in the purely verbal way a blind man distinguishes amongst the
color words employed by sighted people.

Usually, prepositions, conjunctions, and other "syncategore-
matic" terms of language are learned in context by grammatical
analogy, that is, by extrapolating from the ways in which such

words as "of," "and," "such," and the like have turned up in the past. Even some substantives and verbs such as "ilk" and "bilk" will have been learned this way. And as Quine has observed, the same route seems plausible for abstract nouns and theoretical terms, "like 'molecule', which unlike 'red', 'square', and 'tile', do not refer to things that can be distinctively pointed out."[32] He further observes that such terms may also be inculcated by yet another method: description including every device of analogy, metaphor, simile, and extrapolation, not to mention literal definition. This is a particularly important "way in" for craft terms, besides ostension (and exemplification) and grammatical context; for, as we shall see shortly (chapter 4, section 9), words such as "head voice," unlike "positron" or "blue," may have both a theoretical *and* an observational significance.

6. *The Apprentice's Sorcery*

To sum up thus far, we are concerned with the role of specially adapted language in developing a "nose" for something. This was seen to involve the question of how descriptions, often expressed in sentence fragments or coded surrogates, are related by individuals to the very different things they describe; that is to say, how sentence-events get to be correlated with perceptual events.[33] This in turn was seen to involve a combination of sampling and querying under the very specific circumstances circumscribed, symptomatically, by the condition of craft set out in chapter 1. As well, such language is part of the circumstances, being mostly unintelligible apart from them, and reflective of one or another kind of know-how or understanding discussed earlier on.

Having given some indication of how technical jargon (in the sense defined in chapter 2) filters into one's vocabulary in the course of learning a skill, I wish now to return to the second question raised at the beginning of the preceding section: how do the conditions of such language absorption compare to first-language learning, the learning of a theoretical language (again as defined in chapter 2), or the learning of a second language. In other words, what differences, if any, are there in this regard between an apprentice and a child, or a fledgling scientist, or a field linguist?

The apprentice, or any cognitive adult, differs from a child in having acquired what the psychologists call a capacity for "formal operations,"[34] that is, the ability to variously symbolize objects and events and to deal with them indirectly (in their ab-

sence) as well as directly. Such a state of nominal adulthood comes down to the capacity to reflect critically on the passing scene, classifying and ordering things in terms of remote aims, temporal sequences, causes and their effects, and the like. The apprentice, we may assume, is a mature speaker of a mother tongue, which the child is not. Within such a framework the apprentice is receiving instruction and therefore capable of sophisticated queries impossible for the child. Essentially, the apprentice is struggling not with language as such but with a specialized extension of a language already mastered for general purposes. For him, a tailored jargon is a convenience, like any useful tool, that he can use to make over a part of his world, not the whole of it.

The part of the apprentice's world to be made over concerns his or her physical actions, their precise character and effects, again, as outlined symptomatically in chapter 1. Compared to the scientist, the apprentice aims not so much to explain his actions as to act on whatever explanations may serve to improve them. Therein, as we have seen, lies the principal, though not the sole, difference between the "language of the ear" and that of physiology.

In view of the discussion of the preceding section, it is useful to compare the situation of the apprentice with that of Quine's famous fictional linguist confronted with the word "Gavagai" which he suspects is the native word (or sentence) for "Rabbit" or "Lo, a rabbit" in a heretofore unknown language.[35] As a *Gedankenexperiment,* Quine's story bears considerably on our own and so deserves telling at some length.

In the extreme circumstances of possessing no kindred language and unaided by an interpreter, the linguist's task, according to Quine, is "The recovery of a man's current language from his currently observed responses. . . ."[36] Responses to what? To "present events that are conspicuous to the linguist and his informant"[37] such as a rabbit scurrying by. If, as that happens, the native should exclaim, "Gavagai!", one has a plausible candidate in the native tongue for "Rabbit" — but only plausible, since the same circumstances could just as well elicit the native equivalents (if such there be) of "Animal," "White," or "Rabbit." To disentangle these, the linguist would like to query different combinations of native responses and "stimulus situations";[38] but having only one apparent word-sound in his kit, the linguist is of

course in no position to put queries to the native, still less to receive answers from him. What, then, can the linguist do to put himself in a querying position?

First, he needs to discover the native signs of assent and dissent, of "Yes" and "No." These he attempts to elicit by himself uttering "Gavagai" in various circumstances, noticing, perhaps, that "Evet" and "Yok" crop up fairly regularly: "Evet" more often with "Gavagai" in the presence of rabbits, and "Yok" in their absence.[39] Armed with the hypothesis that "Evet" and "Yok" correspond to "Yes" and "No" respectively, the linguist then proceeds to "query" the native further with the aim of accumulating inductive evidence for translating "Gavagai" as "Rabbit" and not as something else. The idea is that the response "Evet" may be elicited to "Gavagai?" when prompted by a "stimulation" (Quine prefers to speak of stimulations rather than rabbits doing the prompting, to allow for possible counterfeits and different glimpses of the same rabbit)[40] that would prompt *us*, if asked, to assent to "Rabbit?" or, conversely, to dissent.

Certain subtleties in Quine's story are conveniently ignored here, but as he rightly observes,[41] virtually anything could upset the linguist's applecart at this early stage of his investigations. Moreover, even if things go smoothly, his translations of native terms will continue to exhibit a certain "indeterminancy" (like all hypotheses), insofar as the linguist can never be quite sure what the native is assenting to or dissenting from in the environment even if, after many trial queries, it is patently obvious that it must have *something* to do with rabbits. But what exactly? Rabbits-in-themselves? Rabbit movements? Rabbit parts? Or, as Davidson wryly suggests,[42] rabbit flies?

At about this point in his narrative, Quine introduces the notion of "stimulus meaning" as referring to whatever nonverbal stimulations prompt assent or dissent to queries of the form, "Gavagai?" This is Quine's invention, roughly by the argument[43] that a translated sentence shares meaning with its translation which in this case can amount to no more than certain prompting stimulations (rabbit glimpses and the like.) Ergo: stimulus meaning, a controversial notion the technicalities of which may thankfully be glossed over for the sake of expository simplicity. It need only be mentioned that stimulus meaning refers not to an *actual* identity of stimuli or stimulus synonymy between terms (thus begging the question of criteria of "sameness"), but to an ideal *limit* toward which the translator works "by significant ap-

proximation of stimulus meanings," weeding out such discrepancies as can be explained away as due to poor glimpses, surprise, or other interferences.[44]

As a species of meaning, stimulus meaning is most conspicuous in such sentences as "Gavagai!", "That's red," or "It hurts," which "command assent or dissent only if queried after an appropriate prompting stimulation."[45] Such sentences Quine calls "observation sentences," these forming a subcategory of "occasion sentences" which are similarly calibrated to the perceptual present. They differ principally in the degree to which "collateral information[46] enters into their verdicts. For example, "He's a bachelor" draws more heavily on "stored information" for its meaning than "A rabbit!" while "That's red" is even "less susceptible than "Rabbit" to the influences of intrusive information. . . ."[47] But even the stimulus meaning of "red" may fluctuate somewhat from one occasion to another depending on lighting conditions and what we know of them — so that, finally, we must settle for degrees of observationality construed as the "degree of constancy of stimulus meaning from speaker to speaker."[48] In other words, to describe a sentence as "highly observational" is to ascribe to it relatively low variation in its stimulus meaning — in the range of prompting stimulations — under the influence of collateral information.

The threat of such interference is nonetheless ubiquitous, though less on the observational end of the scale of occasion sentences. That this is so within a known language makes the situation even more precarious for the translator, particularly one who finds himself in the extreme circumstances that Quine imagines. The fact is that the aforementioned indeterminacy of translation is due to stimulus meanings, themselves hypothetical constructs, always being susceptible to the intrusions of collateral information such as that about the rabbit fly in the case of "Gavagai." While becoming fluent in the native tongue would reduce much of the static from such sources, it would never entirely eliminate it. Such in outline are the plot and some of the characters in Quine's Cinderella tale of meaning that never quite fits from one language to another.

How much of this story applies to the apprentice? There are some similarities. Like Quine's linguist, the apprentice discovers himself in somewhat alien perceptual/linguistic territory where, among other challenges, he tries to put together certain words with what he perceives. The language may range from single

terms and one-word sentences to much longer descriptions, and the phenomena from single mode (colors) or multimodal (rhythm, symmetry) properties to highly complex processes like musical phrasing or the tinting of prints. As it does to the linguist, the situation will often appear Janus-faced: to learn what to look for, the apprentice defers to the directions of a mentor (informant); but merely to follow such directions he must first determine what to look out for!

Practically, the circle is seldom so perfectly closed, because success in following one directive usually prompts further directives to be followed in other directions. Moreover, success when it comes is often the result of the apprentice's putting questions to his mentor about the latter's actions and use of language: "Is that it? No? Then this?" In other words, the apprentice, like the linguist, extricates himself from the bonds of circularity by mounting queries, one upon the other. Or better, he thereby converts a circle to a helix from description to phenomena and back (or conversely) not only to confirm his present grasp of things, but in an effort to get ahead.

Just at the point of "getting it," of understanding, the apprentice has the same advantage over the linguist as over the child in being a mature speaker of the language and hence able to ask what are unambiguously *questions,* even if they turn out to be ambiguous or wrong-headed questions. And, of course, the apprentice is in full possession of the conventional signs of assent and dissent, from words to nods. He is in a far better position to be taught and to learn, however casually or intensely he pursues the task.

We might characterize the difference in terms of the following two questions: Which among the discernible phenomena properly correlate with a putative observation sentence S in a generally unknown language L? — *versus* which among the discernible phenomena properly correlate with an evident observation sentence S in a generally known language L? In the one instance, the prime goal is recovery of a language from a correlation of phenomena, while in the other, it is the discovery of a phenomenon from descriptions rendered in a grammatically and semantically familiar language. The latter case is more like looking for a rabbit one knows (circumstantially) to be present than looking for a correspondence between two words ("Gavagai" and "Rabbit"), the stimulus meaning — or if you prefer, extension — of one of which is known.

From these two questions flow quite different quests that in Quinean terms might be characterized this way: For the linguist it is a search for an adequate translation of a native term by plotting its stimulus meaning against that of a term in the linguist's own language. For the apprentice, it is a search for the stimulus meaning of a recondite segment of a generally shared language. To avoid the controversy over meanings that are stimuli, I prefer the neutral term "instancing" to designate this logical face of first-hand experience. Thus one may know, again circumstantially, that something in the auditory present meets the description, "Head voice!", without yet having *instanced* it.

What this means is that one knows what the description denotes, its extension (a quality of voice); has understood the sentence, what it means; but still has not located the phenomenon of the head voice (its boundaries and distinctive sound). Since the phenomenon of the head voice — a compound of sound *and* sensation for the performer — grades almost imperceptibly into that of the chest voice at one extreme and into the falsetto at the other, it is enough, if someone can discriminate classic instances upon request, to say that he knows what it is subjectively, and, hence intersubjectively what the term means. This may take the form of his signaling its occurence in another singer's performance or himself demonstrating it, even if crudely. Such instancing, however accomplished, raises the question of the conditions of the intersubjectivity of "shared" perceptions of repeated phenomena in the context of what pedagogues are fond of calling "the method of show and tell." The next chapter examines those conditions along with the roles of description and demonstration, literal and metaphoric.

REFERENCES

CHAPTER 3

1. W. V. O. Quine, *Word and Object* (Cambridge: M.I.T. Press, 1964), p. 40ff.

2. On the notion of characters in a symbol system as classes of inscriptions, see Goodman, *LA*, p. 131ff.

3. Ludwig Wittgenstein, *Philosophical Investigations,* tr. G. E. M. Anscombe (Oxford: Blackwell, 1968), p. 60.

4. On the illocutionary force of locutionary acts, see J. L. Austin, *How To Do Things With Words,* 2nd ed. (Cambridge: Harvard University Press, 1962), pp. 98-108.

5. Wittgenstein, op. cit., p. 73.

6. Ibid., p. 61.

7. Quoted by Pleasants in *The Great Singers,* p. 331.

8. See Scheffler, *The Conditions of Knowledge.*

9. Cf. Nelson Goodman, *Ways of Worldmaking* (Indianapolis: Hackett, 1978), esp. chs. 1, 7, and 8.

10. Husler and Rodd-Marling, *Singing,* p. 59.

11. Wittgenstein, op. cit., p. 227.

12. Ibid.

13. Ibid., p. 228.

14. Ibid.

15. Ibid.

16. Ibid., p. 59.

17. Cf. Ryle, *The Concept of Mind,* p. 43, and Scheffler, op. cit., p. 14.

18. Ibid.

19. J. R. Martin, "On the Reduction of 'Knowing That' to 'Knowing How,'" in B. O. Smith and R. H. Ennis, eds., *Language and Concepts in Education* (Chicago: Rand McNally, 1961), p. 63.

20. See p. 49 above.

21. J. Hartland-Swann, "The Logical Status of 'Knowing That,' " *Analysis* 16, 1956, pp. 111-115.

22. Ryle, op. cit., ch. 2.

23. Hartland-Swann, op. cit., p. 111.

24. Martin, op. cit., p. 62.

25. Ibid., pp. 64-67.

26. Ibid., p. 65.

27. See p. 24 above.

28. *Oxford English Dictionary.*

29. Quine, op. cit., p. 7.

30. On exemplification as a subset of the converse of denotation, see Goodman, *LA*, pp. 58-59.

31. Quine, op. cit., p. 14.

32. Ibid.

33. Where sentence-events are particular utterances or inscriptions of a sentence.

34. See Jean Piaget, *The Construction of Reality in the Child* (New York: Ballantine Books, 1971).

35. Quine, op. cit., p. 29.

36. Ibid., p. 28.

37. Ibid., p. 29.

38. Ibid.

39. Ibid.

40. Ibid., p. 31.

41. Ibid., p. 30.

42. Ibid., p. 32.

43. Ibid.

44. Ibid.
45. Ibid., pp. 35-36.
46. Ibid., p. 41.
47. Ibid., p. 42.
48. Ibid., p. 43.

To be intelligible is to be found out.

Oscar Wilde

4 *Languages of Craft* (II)

1. *Through a Description Intersubjectively*

Discussion of the languages of craft thus far has stressed the overall role of technical jargon as a way of conceptualizing aspects of skill and craftsmanship and as a mnemonic adjunct to criticism and practice. Along with ostension, exemplification, and grammatical analogy, description was mentioned as an equally powerful means of inculcating, by elucidating, a specialized terminology (chapter 3, section 4) By description is *not* meant a synonymous phrase or definition, but a statement or series of statements that clarify — usually by analogy or simile — the use of a term. This use of description to *suggest* is perhaps more apparent, initially, in theoretical contexts where there is nothing to point to or hold up as a sample of "electron" or "valence." As Quine observes, "What makes insensible things intelligibly describable is analogy, notably the special form of analogy known as extrapolation."[1] Thus we get across the idea of a molecule as "smaller than anything seen"[2] by extrapolating from the observable contrast between a gnat and a mote of dust.

However, the results of suggestive description are generally quite different as a means of concept formation for insensible as opposed to sensible things. By extrapolating from things with which we are sensibly acquainted we are likely to arrive at only fuzzy, first conceptions of insensible things — for example, from dust motes to molecules or microbes — whereas it is by just such means that we may be led to an accurate-as-can-be "final" conception of other sensible things. For instance, the voice teacher's well-worn metaphor of the "inner smile" has a direct, kinesthetic correlate in the experience of the singer. Similarly, the low larynx position and expanded pharynx acoustically necessary for singing is a close cousin in sensation of the yawn reflex, particularly in the upper or "covered" part of the singer's range, which, incidentally, actually feels like a yawn that has somehow been "covered" or "capped" over. This is to say that where experiences are of a type sharable by us under the aegis of some description of what they are, restricted, specified likenesses are among the major aids to their access.

Where a sort of experience is accessible, or judged to be so, comparisons and likenesses both literal and metaphorical may

take one from complete unawareness of the target state to the brink, and over, of first-hand experience. Though other routes besides suggestive description are possible, the destination is the same: the "instancing" (in perception or by demonstration) of something heretofore elusive. In other words, a conception of what something is *like* grades into an awareness of what it *is*, depending upon what qualifies under the circumstances as first-hand experience. That will vary as much with alternative construals of an experience as with its actual or presumed accessibility; that is, with descriptions of an experience as with the experience itself.

For example, one may never have been in the slums of Hong Kong, though it is possible to have a fair conception of what it is like from having been in the slums of Rio de Janeiro. If all that is wanted is an experience of what it is (not merely "like") to visit a mountainous, urban slum, then having been in either place would suffice. By the same token, if the description is narrowed to "what it is to live in a mountainous, urban slum," then obviously a tourist visit to either place would not count *as* such an experience, though it may well enable one to know what it is like. Since both aspects and boundaries of experiences will vary with descriptions, access to them will also vary even within the range of what we could normally be expected to be able to experience. Where, for whatever reason, that expectation begins to wane, as for example in considering the experiences of other species, we tend to talk of "alien" experiences. The limitation on alien experiences, say, that of bats, is that even in the face of indirect evidence that such experiences exist, under no description would anything qualify as an instance of bat-consciousness for us.[3]

Certainly, any experience may be construed as alien if not one's own or "private" experience. I cannot feel *your* toothache, though the feeling of toothache is sharable provided we allow for what I shall call "event-replicas" consisting here of multiple toothache-events occurring in different persons and correlated with toothache-descriptions. That, at any rate, is the literally *common* sense of the situation. To be sure, there are different types and intensities of toothache which may be distinguished, but these represent describable refinements that may or may not disqualify a given toothache from a given description — just as we may say, "That isn't really the head voice, it's more falsetto." Hence, what counts as an event-replica, or more simply, the

"same" thing, phenomenon, or experience, is partly determined by which aspects of an accessible event one chooses to stress or pick out from among the innumerable ways it may be construed.4 And since with language we are dealing with a semantically dense symbol system,5 we may be as refined in our descriptions as we are in our perceptions of pain, or voices, or anything else.

2. *Through a Quale Privately*

In the context we are considering, a sense of rapport between Master and Apprentice, of being on the same "wavelength," mostly comes down to an expanding, shared understanding rooted in shared perceptions. But in what sense shared? Surely, it is not just the talk but the experiences and insights that are shared. If it is clear that suggestive description (along with other forms of symbolization) plays a large part in conceptualizing the perceptual flow — in directing selective attention to its aspects — it remains unclear, at least incomplete, how extrapolation, metaphor, and simile promote the intersubjectivity of the flow. How. in other words, do leading statements lead different people to the same thing, The quick answer is, In the same way they lead the same person to the same thing. But that requires some spelling out; for, as the previous chapter should have made plain, it is seldom obvious what constitutes the "same" thing.

What I have loosely dubbed "event-replicas" needs some filling in if it is to serve as part of the analysans of sameness. Event-replicas encompass both "properties" and their "qualia" on the special usages of these terms given them by Goodman in *The Structure of Appearance*.6 Goodman's distinction is itself a theoretical extrapolation from the ambiguity of ordinary language property ascriptions as between how they appear to us and what they are. Thus to say that something looks, feels, sounds, or tastes in a certain way is to describe a once-only "presented quality" or quale — a look-, feel-, sound-, or taste-quality of the thing presented. Whereas, to say that something *is* green, smooth, a B♭ pitch, or bitter, is "to make a more complex statement concerning the . . . qualities exhibited by *various* presentations of the thing."7

On this rubric, what it means to experience something under the aegis of a description of what it is amounts to ascribing properties to the thing in question; and to do that is, in Goodman's words, ". . . to affirm that the qualia it presents under

different conditions conform to some more or less fully pre-
scribed pattern."8 Such prescribed patterns may relate, for ex-
ample, the spatially diverse parts of a whole table or the temporal-
ly diverse soundings of pitches in a scale. This allows for some
degree of variation of appearances from one observer, time, or
place, to another — so that while an optimum standard might
require, if only ideally, the matching of qualia of, say, hues or
pitches, considerable variation may accrue to the "normal con-
ditions" of appearance of things observed from different per-
spectives, as when we allow for different scalene projections of
the "same" physical square.9 Similarly, singer and coach hear
the same voice, the one from "within," the other from "without."

Without trying to resolve the puzzle of our knowledge of
Other Minds, how does the aforementioned distinction between
properties and their qualia explain, or better, accommodate the
nagging "privacy" of first-person perceptions? While I cannot
feel your toothache, neither do I experience your hearing, nor
you mine, of the (presumably) same B♭ pitch we both hear.
That fact alone suggests that the line between private and public
aspects of perception applies to all phenomena, not just to
other minds, and fails to correspond to putative differences be-
tween our access to minds *versus* bodies. For while the privacy
of your toothache leaves me without access to your qualia of
toothache, the "publicity" of beeswax and B♭'s does not re-
quire either of us to have access to the other's qualia of beeswax
and B♭'s, nor even to make direct comparisons with our own
past qualia of beeswax and B♭'s. Given the fallibility and selec-
tivity of memory, and the power of the social act of description
to shape perception, it is a genuine question whether *I* have much
of an edge over *Us* to determine that indeed something before me
is the same as previously or differently observed.

Neither is the difference between private and public con-
formable to that between phenomenalistic and physicalistic
descriptions of things;10 for we may both have access to the
same blue blur or the same blue bird. The once-only quale pre-
sentation of a blue blur-sighting or blue bird-sighting is as private
as the blur or the bird is public. The difference, rather, is
between private, nonrepeatable qualia presentations and public,
repeatable properties. That is the gap breached by the largely
phenomenalistic "language of the ear," in other words, that be-
tween a purely subjective and an intersubjective hearing of one's
own voice. Incidentally, that is one reason why singing is such a

good case study for our purposes, because it focuses attention on the difficulties involved in achieving a more public perspective on one's own performance — just the opposite of a casual solipsism to the effect, "I know what I'm doing (hearing, seeing, feeling), it's the others I'm worried about." Our apprentice singer will perhaps seldom (justly) be so confident about himself however accurate his judgment of Other Voices.

All this suggests that the line dividing the subjective from the intersubjective in perception corresponds less to the difference between private qualia and public properties than to the difference between those *properties,* "internal" or "external," that are recondite and those that are salient. The pain of toothache is at least as salient as a blue bird, while a "public" phenomenon such as the hidden figure in a picture puzzle may prove extremely difficult of detection. Hence, initially subjective properties — where by "property" is meant whatever may comply with a proper description — may become intersubjective in a way ruled out for unique, private, qualia-presentations by which, in turn, is meant the once-only glimpses, hearings, or other appearances *of* something.

Whether in having access to our own private qualia we thereby have access to the same property as before, or as someone else, depends heavily on the accuracy and refinement of our property *decrees,*11 statements declaring, "It's this!" or "It's that!", decrees which live under constant threat of revision. For example, another sighting may cause me to change my decision from "red" to "burgundy" to describe the color of a friend's tie. Moreover, the question of the life span of our property decrees observes the same general conditions for all phenomena. In Goodman's words, "we favour the more 'natural' decree, the one best supported by an instinctive feeling of hitting the mark, as when we select a remembered colour. In the second place, we favour the decree that makes necessary the least adjustment in the body of already accepted decrees."12 Unless my friend changed ties while my back was turned, it is more plausible to assume that I misjudged its color the first time.

Beyond these considerations, the problem of decreeing things the same is complicated where allowance must be made for special distortions exceeding the "normal" limits of optimal viewing, hearing, tasting; for example, if I happen to be wearing dark glasses, or trying to hear the timbre of my own voice or taste the sweetness of a Sauterne after a chocolate bar. "Red

or burgundy?" is more difficult to decide through a glass darkly, though not impossible if we learn somehow to "compensate" for the interference of the spectacles while continuing to wear them.

One kind of compensation is *normalization,* as when we "correct" for the distortion of pictures viewed from an acute angle, for example, from an outside aisle seat at the cinema. A photograph taken from that same vantage will show a distortion we quickly cease to experience. Another kind of compensation is *correlation,* as when we try to match up our consistently "abnormal" perspective with the judgments of those enjoying the preferred, by some standard, "objective" or "normal" perspective. This requires an individual to correlate one's own *intra*subjective conclusions with the *inter*subjective conclusions of two or more observers in the privileged, normal position.

Correlative compensation is a distinctive feature of many performing skills in art, work, and athletics, and an indispensable form of judgment to be cultivated where self-observation is concerned. In that regard, we are not in a position to remove the distorting lenses of our bodies or change seats for a better view without thereby giving up the action itself. For example, *the* overarching problem of vocal perception, in the act of singing (or speaking, for that matter), is trying to correlate one's intrasubjective judgments (when it sounds the same or right to me) with what two or more other observers would intersubjectively agree it "really" sounds like.

Thus the intersubjectivity of coach and singer is not that of two nonperforming listeners (though a recording machine allows that *ex post facto*), but a more complicated intersubjective judgment involving correlative compensation for the unavoidable difference between hearing from "within" and from "without." Stop-action photography and recording machines may enable one to examine at leisure one's own performance, to form "objective" assessments of results achieved — in effect, to reduce the effects of perceptual obstacles — but ultimately one acts out of a judgment that combines correlative compensation with received "objective" standards. However it is achieved, intersubjective agreement does not in any case demand identity of point of view, still less the sharing of sensory impingements, but rather, the identification of the *desideratum.*

To sum up these technicalities: to experience the same thing as before or as someone else — to grasp first-hand what it is — involves property ascriptions under qualia control where the con-

trol finally is shared with the language used to make such ascriptions. The circle of control is benign, logically speaking, since one is gradually initiated into the language and its field of reference (in this case the singer's jargon), as it were, trading off qualia for such properties as "head voice," "chest voice," and the like, in a staggered progress until one "gets it." When one has gotten it, can demonstrate, point to, or otherwise discriminate the phenomenon in question (what earlier I called "instancing"), the foundations in shared perception are laid for the further growth of know-how and the eventual achievement of active understanding.

3. *Sameness and Suggestion*

A few words remain to be said about replicas-of-an-event or samenesses, the first word being that though they are multiple and repeatable, they behave differently from the ordinary complaints of general terms. The complaints of the word "man," for example, while belonging to the same class, are not normally considered as so many instances of the same man (unless one goes in for some radical form of essentialism); so that to be a man does not require that one be a true copy or replica of every other man — whereas, to be an event-replica is to be an instance of the same event and equivalent for some practical or theoretical purpose to every other instance of that event. Certainly, this does not preclude treating each and every man as so many instances (samples) of "man." The point is that replication comes into play where the question of "sameness" is raised for whatever reason or purpose. Thus do we speak of different persons performing the same experiment or making the same observation at the same or different times.

Ideally, a class of event-replicas, such as repeated soundings of B♭ on a piano, is crisply categorical so that a particular type of event is singled out — in a word, segregated from other adjacent or physically overlapping events — as pitch from the timbre and duration of sounds, for example. Where a phenomenon is thus set off from others, we may under some circumstances come to think of it as a "target" experience or phenomenon, whether as means or as an end, for someone trying to achieve it. Target states may range from particular sensations or other minutiae to large-scale controlling conceptions, say, of phraseology in musical interpretation or directives of the "keep your eye on the ball" vintage. Whether thought to be necessary or close to suf-

ficient for a successful performance of some kind, target states are part of what is meant by heeding what one is doing, of keeping something essential in mind.

Complications arise, certainly, from limitations of one's discriminative ability but also from the fact that even where the target phenomenon is clearly demarcated, the language with which we describe it usually will not be. With rare exception, we approach target experiences within descriptive rather than notational symbol systems (like a musical score or the Dewey Decimal filing system), which means that we must allow not just for some redundancy — the singer's inner "smile," "grimace," or "snarl" — but for levels of generality, vagueness, and ambiguity as well. Whatever the event in question, it will likely correspond to several proper descriptions amounting to subtly different characterizations even where the class to which it belongs is exactly delimited. The singer's "grip" on the voice, like the golfer's on his club, to mention only two small examples, may generate an explosion of detailed commentary in their respective realms of expertise.

Unlike scientific contexts where a precise definition is most likely to clear the air of confusion, in procedural contexts — especially those involving motor action — precision understanding accrues more to convergence on the same thing of a variety of suggestive viewpoints. Suggestions of what? Of what it is, first hand; how it feels, looks, tastes; how it works; what it will do for you; its results or effects; its overall place in a craft or skill; in short, suggested answers to the questions, What is it that I am trying to do? and Why am I doing this? Definitions and notational devices are peculiarly anemic for such purposes. Consequently, what is thereby sacrificed in the way of fixed precision of meaning and of reference and recoverability as between terms and phenomena — is compensated for by the versatility of our descriptions corresponding to refinements in our discriminations. Indeed, premature resort to technical jargon and notations in advance of building secure analogical bridges can initially hinder as much as it may later help one's effort to "locate" the target phenomenon, be it the hidden fifth in a musical progression or the hidden fault in one's execution of it. So much seems obvious.

But is there not a pardox in this? On the one hand I have argued that technical jargon facilitates the growth of skill from the very beginning by enabling one to better conceptualize the perceptual flow and, on the other, that it frequently gets in the

way. Psychologically and practically, the "paradox" resolves to a problem of timing: of realizing just when to say what to whom. Philosophically, the paradox is that of technical discourse that obscures the technicalities. Happily, it often happens with task-orientated uses of language that the jargon itself solves the problem by supplying the novice with an apt metaphor having simultaneous literal meaning for those in the know — a linguistic halfway house with wide, metaphoric entrances and narrow literal exits.

The significance of all this comes down to two broad observations: first, that the same set of terms may function both metaphorically and literally with respect to the same field of reference; and second, that literalness and intersubjectivity co-vary with increasing observationality of such terms. On the first point, it was noted earlier that suggestive description is one way of elucidating what a technical term means. By the same token, the term itself may suggestively describe the phenomenon it designates. Ultimately, it is the phenomenon as experienced first-hand that constitutes the literal, ostensive meaning of the term. In the meantime the term may function powerfully as a metaphor within a family of metaphors to direct one's attention toward the target state. The runner's "lift," the dancer's "carving" of space, and the singer's "support" are all lively (if initially vague) metaphors that eventually *achieve* the status of technical terms through becoming "frozen" and near literal in meaning.[13] Learning the appropriate language is thus a *rite de passage,* part of the progressive "funnelling" of the apprentice's attention by myriad hints and cues, some given, others taken, some symbolic, others not, of greater or lesser detail and effectiveness.

On the second point, the idea is that a metaphor or suggestive description becomes increasingly literal, and therefore strictly technical through becoming increasingly observational. For example, the singer's metaphors of placement and vocal registers are especially susceptible to the influence of collateral information on first encounter. Yet by that very encounter (among other encouragements) one is drawn along a vestibule toward highly observational usages of those same terms, toward a phase of usage in which such terms as "head voice," "messa di voce," and the like are mostly stimulus-meaningful and rather easily queried as to the accuracy of their application. Thus as segments of occasion sentences or one-word observation sentences they typically exceed "Gavagai" while falling somewhat short of "red" on the

scale of intersubjectivity. In that respect, each term or family of terms would have to be examined *in situ* as used by its "native" speakers to determine its degree of observationality. Overall, we may say that from the standpoint of the procedural jargon spoken, the passage from novice to initiate is marked by a gradual shift from suggestive, metaphoric uses of certain key terms to near literal, observational usages we are accustomed to call "technical." In short, initially open-handed metaphors close fist on particular phenomena. Following that achievement, if only at the level of talking about things, it is both appropriate and convenient to resort to the various shorthand and coded devices for communication and keeping vital matters in mind (mentioned at the beginning of chapter 3).

4. *Following the Rules*

Most of the actions involved in skilled procedures are what philosophers from Wittgenstein onward describe as "rule governed" or "rule following."[14] Certainly one characteristic use of the language growing up around established skills is to formulate rules and procedures to follow. What it means to follow a rule is the subject of much philosophical discussion mostly centering around moral principles or casuistry and therefore somewhat afield of, even if distantly kindred to, present concerns. An exception is Max Black's four-part classification of actions following rules[15] which cuts across several of the distinctions thus far drawn in a way that illuminates the different roles played by an entrenched technical jargon.

According to Black, an action is *rule invoking* if it follows a set of explicit, fully articulated procedures or steps as in a recipe, any one of which could be invoked to explain or justify what one is up to at any given moment while following them. In such cases, one is fully aware of the rules just as they are given in the cookbook or Handbook of Qualitative Analysis. Exercises, recipes, and regulations intended to build muscles or make fruitcake, to control traffic or run a committee, come readily to mind. A set of directions and the will to follow them is all that is required.

An action is *rule-accepting* if a rule could be formulated that exactly describes what I am doing even if I am not consciously following it. Thus, if I am overheard to count, *"One,* two; *one,* two . . ."* someone might say, "You are counting that passage in 2/4 meter: two beats to the measure, a quarter note gets one

beat." "Why, yes," I might reply, unless I happened to be counting in 2/2 time. Though Black does not say so, it is crucial to accepting a rule properly that the conditions of its rejection be also clear. By the same token, it is possible to reject the action once the "rule" is made clear in such a diagnostic comment as the following: "It is as if you try to compensate for lack of pleasing timbre with sheer volume." Or more simply, "You took your eye off the ball." That is no rule but an explanation of failure via announcement of a violation of a rule. One accepts the explanation because one accepts the rule, "Keep your eye on the ball," as getting better results.

Rule-covered action occurs where an explanation is given in terms that could not be followed.[16] Polanyi's example (see p. 49) of a physical explanation of how one maintains balance on a bicycle, using such terms as "rate of curvature" and "angle of unbalance," cites a "rule" that covers without directing action. Similarly, many of the physiological explanations of vocal maneuvers described in chapter 2 would fall into this category. At best, their influence is indirect, resulting, perhaps, in revisions of practical directives or confirmation of others but of no immediate[17] self-critical value to the agent.

Finally, there is *rule-guided* action — virtually synonymous with *understanding,* a procedure in the sense of chapter 3 — where, in lieu of an explicit *list,* one finds only "tips" and "cues" as well as various images affecting, in Black's words, a kind of "phenomenological compression" of vast amounts of detail.[18] A distinguishing feature of this "assimilated" level of action is an ease and fluency of execution conspicuously absent from the "jerky" spectacle of consulting rules one by one. What private, synoptic shorthand as one devises for guidance and rendering down to essentials is "appropriately articulated by non-verbal symbolism."[19] Though intuitively transformed and ideo-syncratic, such "condensations," Black urges, are "not 'private' in the philosopher's technical sense of unintelligibility in principle to another."[20] Indeed, they are not: for it is just such mnemonic, controlling devices as constitute the "tips" and "cues" that one may offer another to guide the exercise of high skill. Wittgenstein places such subtle hints beyond the reach of rules and formulae, whereas Black views them as simplified, though amazingly versatile, *summaries* of rules, the means whereby "*the* rule" becomes "*my* rule" in a fluid performance.[21] Both acknowledge, while I have stressed, their role in communicating

about the subtleties of skill. A properly balanced view acknowledges all these possibilities.

Between the extremes of blind mastery (rule-covered behavior) and slavish adherence to precept (rule-invoking behavior), Black discerns the relative ease of implicit conformity to rule (rule-accepting behavior) and the "free-flowing" action without apparent calculation of trained virtuosity (rule-guided behavior). Arranged thus on a continuum, Black's types of rule-governed action suggest that there are limitations on the articulation of rules beyond those arising from an inability to put things into words or the initial obscurity of the language mentioned earlier.

Consider the following situation. A standard tax form instructs us to "enter all taxable income." The form then supplies rules for determining what is taxable income. We can easily imagine further rules for interpreting the rules for determining taxable income, and so on indefinitely. What stops the regress of rules? In a word, unintelligibility. "The chain of rules will quickly terminate, for want of an adequate vocabulary. The nearer we come to what is readily *seen* by an apt learner, the harder it becomes to articulate the governing rule and a point is soon reached at which the effort of attending to the verbal formula positively interferes with the primary performance."[22] This is not the unintelligibility of misuse, mistiming, or first encounter with a new terminology, but of distraction. It is a case of language outstripping its descriptive usefulness almost to the point of trying to *reproduce* the prescribed behavior. "Of course," Black remarks, "sensible men soon abandon *saying* in favour of *showing.*"[23] However, as I hope to show below (section 6), abandoning descriptions and rules for demonstrations and samples is less a jettisoning of symbols than a shift in their emphasis or "direction."

Since following rules and making sense of demonstrations must themselves be learned, a "foundation of primitive habits of response" (rule-covered behaviour) is presupposed, so that "The ideal cycle, indefinitely repeated, will be from 'rule-covering behaviour' to 'rule-invoking behaviour' and then to 'rule-accepting behaviour' and 'rule-guided behaviour.' "[24] So the full cycle of development from novice to virtuoso takes the form of training that is symbolically mediated even if, as must happen, there comes a time for casting explicit rules aside.

5. *Reasoning by the Rules*

Conspicuous by its absence from Black's account of rule-governed action in procedural contexts is examination of how we reason using rules. As my interpolated comment about "violations" hinted (p. 95), we are accustomed not merely to accept or obey rules but to use them critically. We *resort* to rules, among other reasons, to compare and contrast our successes with our failures in terms of what we believe to be their underlying causes (if we have confidence in the rules). Black approaches the topic twice; once when he observes that the "credentials" of rules ultimately are cognitive, even if momentarily backed by personal authority; are rooted in the nature of things such that the difference between a rule and a "principle" is largely a matter of grammatical mood.25 And again, in a footnote, he avers that "Verbal articulation will *change* the performance, in subtle or massive ways. Indeed its main point will often be to correct and to improve the performance."26 But if the rules are often mini-principles, it is not just a matter of following orders but of understanding the criticism implied in their "violation" and of making inferences from causes to their effects and back again.

A simple example such as "You took your eye off the ball" is an isolated instance of "diagnostic" reasoning by reference to a procedural rule, but fails to capture the interconnectedness — the principle-like nature — of many such rules expressible in a jargon that has achieved technical status, that is, has begun to be used in a mostly literal way relative to its field of reference. As a larger-scale example, the singer's talk about exercises and "technique" gives a better idea.

Let us quickly review what such talk is about. Vocal exercises, construed as rules, are designed to strengthen organic responses, perfect vocal registration, and train the ear.27 The mature integration of these elements in action *is* singing skill, while knowledge of such matters, of what will and how to strengthen, perfect, and train, is the craft of voice building. Devoid of such knowledge, exercises are useless, their proper execution, aims, effects, and the like remaining obscure. The language of singing spans these practical, as well as artistic considerations, focusing most generally on vocal registers and breaks, tonal quality (timbre), resonance, and respiration (support); or more specifically, on the functional effects of certain pitch and intensity patterns that the student of singing learns to discriminate and correlate

with certain physical sensations. That, in sum, is the "language of the ear."

Though rapsodically metaphysical at first glance, such talk is actually perceptual, phenomenal, and *sub*physical in the sense of being prior to any physical (rule-covering) explanation. Except for explicit (rule-invoking) exercises, most such discourse is of the rule-accepting kind whereby one sensation is *e*voked to "explain" another: "See how that sound feels? Isn't that easier? Can you feel it forward in the head?" The coach's assent to "forward in the head," as a sensational report, is of course indirect, based on its known correlation with what he hears. (He may easily verify the induction by producing the designated sound himself.) Depending on how much physiology he knows, the coach may also infer a rule-covering explanation from the co-variance of sound and physical sensation as follows: If (a) *that* sound, then (b) *that* feeling (physical sensation), and (c) *that* physiological function. For example, we know what the falsetto voice sounds and feels like by contrast with a "full-throated" chest voice, and that it results from the independent vibration of the outer longitudinal lining of the vocal folds. We know also (in the rule-covering sense) that it is only as the outer lining and *vocalis* muscles or tensors are brought into synchronous vibration that the break between falsetto and chest voices, typical of the yodeler, for instance, can be eliminated.

While knowing (c) may aid one's broader understanding of the voice, we apply the rules (exercises) and give advice in terms of the co-variance of (a) and (b). The language, though not the inductive correlations represented in (a) and (b), may be rather loose, especially to begin with. Indeed, such language must remain versatile and suggestive to have effect. For example, the coach may attempt to alter the sound by attacking the feeling with a metaphor: "Round the back of the throat" (has the effect of raising the soft palate); or he may try to alter the function (c) by addressing sound and feeling simultaneously with a "placement" metaphor ("Place the tone forward so that you both feel and hear it there.") and thereby improve physiological function through "the feel of it." Or, finally, he may try to alter the physical sensation by addressing the sound with a suggestion to make it "brighter" or "darker."

Nearly any complex skill or craft has a similar domain of sensation, perception, and special effects over which range the terms of its jargon, however variable, fragmentary, or confusing

its descriptions may appear at first blush. As mentioned earlier, the prime value of such talk lies in its utility, in directing and communicating about action, rather than its strict consistency, coherence, or capacity for extended arguments or explanations. Explanations, like descriptions, that exceed the limits of useful "telling" quickly become unintelligible or, at best, they become irrelevant. Certainly, the utility and communicative power of any language, however much "action-oriented" or intuitively suggestive, requires that *some* standards of coherence, of consistent use of terms, and of inference be observed if its explanations and directives are to be of any pedagogic or critical value. However, the organization and structure one seeks is in the activity itself, so that, paradoxically, the language may become more fragmentary as it becomes more literal at higher levels of rule-guided action.

6. *Showing and Telling*

Where telling leaves off, showing tends to take over. Indeed, much of the "telling" takes the form of cueing a particular salience. By cueing a salience I mean indicating when to look for what in the demonstration. "The" demonstration may of course consist of several illustrative actions or a single action illustrating several different aspects. Each action or aspect may have its appropriate cue and covering explanation where enough is known both practically and scientifically to correlate the two: again, the "language of the ear" construed as a "heard physiology." (See p. 35.) Or take the action of throwing a ball. To increase the accuracy and speed of the throw, one might be advised to bend the elbow through the middle phase of the throwing action. That the advice proffered in the cue-expression works can be seen from a demonstration or by trying it oneself. The covering (kineseological) explanation, on the other hand, would refer to the shorter lever (elbow to hand) being easier to move and control while simultaneously increasing the angular velocity.[28]

From the standpoint of the learner, the demonstration is *of* whatever is described in the cue-expression, the explicitly invoked rule, rather than the covering physical explanation. With respect to the same demonstration, that situation is reversed for the student of kineseology. Whether based on knowledge of practical results of physical principles or efficiency or both, the coach's task is to "translate" such results and covering rules into cue-expressions to be invoked at the appropriate mo-

ment in either the demonstration or the action as attempted first-hand. Whatever limitations of knowledge or experience beset such an undertaking, nothing in principle is mysterious about it, until one asks this question: what exactly *is* showing? What logically is the difference between simply doing and showing? When does an action become a demonstration? And when it does, what is the nature of the "shift" from telling and describing to showing and demonstrating?

It will not do simply to say that the action "speaks for itself" if only because the nature of such speaking is to be contrasted with all the talk that has gone before. It is at least another kind of speaking and more likely (unless it be a demonstration of speaking) no speech at all. Bending the elbow in mid-throw clearly describes a demonstrable action. To that extent, the description refers to, in the sense of denotes, that action. But a demonstration of that same action does not describe it. Description is a function of language. Rather, the demonstration would seem to refer back to the description, to exemplify it, as well as to all other actions to which that description properly applies. If so, then the demonstration behaves exactly like a tailor's swatch, as a sample of something.29

What the demonstration exemplifies (is a sample of) is delimited by the description currently in force; that is to say, whatever description it is *taken* to exemplify; bending the elbow just so is not a dance movement (though it might be) but a throwing motion. Thus it would appear that a demonstration is a case of selective reference, of symbolization by an instance, so to speak, where the selection is made by a description. The description need not be complete in every detail (indeed it could not be); it need only properly apply sufficient to pick out the sample which in turn supplies the relevant detail. Further talk may or may not obscure matters, depending upon the circumstances, for example, whether something important in the demonstration has been missed. A demonstration is thus worth a thousand words provided it is clear in principle what such thousand words would be about.

We may say, then, that doing becomes showing when the action in question functions referentially, symbolically, to exemplify certain of its aspects. For the doing to be an "instance" of some relevant kind (see p. 80) requires only that it be properly labeled, that it possess the properties ascribed to it. For an instance properly identified to be a sample or demonstration, how-

ever, requires that it refer besides being referred to — that it be a "showing" as well as a "doing." Now as already noted, demonstrations are not illustrative merely of verbal descriptions, however subtle, discriminating, or helpful such descriptions may be in directing our attention. But if the original label is verbal, and exemplification is a subset of the converse of denotation by a label,[30] are we not then by default limited to illustrating verbal versions? Fortunately, no. As Goodman observes, "the label a movement [for example] exemplifies may be itself; such a movement, having no antecedent denotation, takes on the duties of a label denoting certain actions including itself. Here, as often elsewhere in the arts, the vocabulary evolves along with what it is used to convey."[31]

In that event — and the point here is a crucial one — the term "vocabulary" may be taken literally or metaphorically to refer to either an evolution of terms (words) or of nonverbal symbols. That is to say, the "shift" involved in switching from telling to showing may not only be in the direction of reference (back from the denotatum to the label in force) but in the labels[32] themselves: from descriptions exemplified by actions to actions that are self-referential. Just as the tailor's swatch is a sample of colors and textures for which we may or may not have names, a demonstration is an action-sample of aspects of a performance that may or may not elude description. Generally, we are able to describe, exactly or crudely, what we manage to discriminate; but what we manage to discriminate at any given juncture may be aided by a sapient word or a salient sample. So it is really a question of what labels — verbal or nonverbal — are in force that decides what a demonstration is *of*; and that is as much a matter of what, besides being an instance, an action, object, or event *does* referentially to draw attention to itself.

Samples and demonstrations mark an expansion of the "vocabulary" of craft altogether beyond technical jargon and description to encompass aspects of skilled performances that "speak for themselves" by not speaking at all. Yet it remains that a demonstration is as much *about* what one is trying to do (or communicate) as any description; and if we frequently abandon words for illustrative actions, it is seldom for long as we continue inevitably to talk with better understanding of what we do. In the sense of being about something, showing and telling, however different in other respects, are both forms of reference, of symbolization facilitating cognition and communication in many

contexts including, certainly, craft.

7. *Ways of Showing*

Demonstrations are not unequivocal in their aims, scope, or details. Getting the point of a demonstration can be as difficult as getting the point of a long description or set of verbal instructions; and a single word, gesture, or other cue may on occasion be worth a thousand repetitions. Orthogonal to the issue of denoting (cueing) a salience by verbal or nonverbal labels is the question of certain typical ways of showing and the restrictions upon interpretation imposed by them. That recalls also a question raised toward the beginning of chapter 3 (p. 61), namely, whether, given that an exaggerated demonstration can be used to make a literal point, it makes sense to speak of literal and metaphoric demonstrations as well as descriptions.

Common sense recognizes many ways of showing by examples, three of which stand out, if ambiguously, overall. One is that of the perfect replica or "ideal," an *exemplar*. Another is the *sample* or typical instance. A third is that of a *model* taken as a scaled down (or up) design of structure or pattern.[33] Obviously, these are not as given distinct notions, since a sample of gold might well be exemplary and "model" has another use virtually synonymous with "ideal" or "exemplar." But these will do for a start.

With the exception of a vast literature on scientific and logico-mathematical models, philosophers until recently[34] showed little interest in ways of showing. Anita Silvers has lately suggested an analysis of exemplars, samples, and models along lines congenial to the exemplificational approach taken herein.[35] Silvers begins by indicating how differently exemplification operates according to "instructional situations."[36] For example, if the task is to show someone how to make a bed, one does it as perfectly as possible in order to provide the learner with "an exemplar, an ideal toward which to strive."[37] If the task is to show someone how to weed, one selects several samples of weeds and plants under cultivation rather than the single best specimens of each discoverable in the patch. "The point of the activity is to pick out all the plants relevantly similar to the example, not merely those most closely resembling the ideal weed."[38] Finally, if the task is to teach, say, a child how to iron, one might resort to a toy iron, one small and light enough for the child to handle. (One is reminded of the many instances where musical prodigies have been supplied with miniature instruments on which to per-

form.) Such "toys" are models incorporating features relevant to instructional purposes while excluding those that would interfere. They are neither typical instances nor exemplars.

Silvers further illustrates the differences among exemplars, samples, and models with a comment on two instances of mistaken exemplification imagined by Goodman. "In one of his discussions of exemplification, Goodman[39] creates a heroine, Mrs. Mary Tricias, who presents a tailor's swatch to her draper and orders cloth 'Just like this!' She receives several hundred two-by-three inch pieces of cloth. When she presents a chocolate cupcake to her baker and orders enough for fifty people 'Just like this!', she receives a single giant chocolate cake. Obviously, her draper mistook a sample for an exemplar, and her baker thought that a sample was a model."[40]

Whatever the ease or difficulty of sorting among them, there clearly are differences among the ways of showing described. But how are they to be theoretically characterized in terms of exemplification? Silver's answer is that "Neither models nor samples possess all the features of their referents, while exemplars must possess all the features of their referents." And again, "When examples operate as models or as samples, members of their compliance classes should be expected not to possess all of the signifying features of the examples. In contrast, the members of an exemplar's compliance class should be expected to possess all of the signifying features of the example. Thus an example might qualify as a satisfactory model but as a very poor exemplar."[41]

Silver's reply to the aforementioned question requires some amplification and minor qualification if certain misunderstandings and omissions are to be avoided. In the first place, note that Silvers speaks of exemplars possessing all of the *signifying* features of the examples. It should be clear that no example exemplifies all its properties if only because there will always be an indefinite number of them, many of them quite irrelevant. Indeed, to do so (if it were possible) would disqualify the example as an exemplar: if Pavarotti's rendition of the aria, "Recondita Armonia," is exemplary, it is not because the available example is a recording or was performed on a certain date. An exemplar exemplifies not so many more properties as certain properties more perfectly. Exemplars closely conform (and perhaps more completely, hence, the suggestion of "more" properties) to an ideal of some sort. But to exemplify all the requisites of the *ideal* is not the same as exemplifying all the properties of the example.

In short, status as an exemplar is not a question of how many, still less of all, properties of an example being exemplified, but of those selected, how *well* they are exemplified.

But if it is a question mainly of "how well" and not "how many," one should not *always* expect the members of an exemplar's compliance class to possess "all the signifying features of the example"[42] as Silvers asserts. To suppose so closes off the contingency that particular exemplars may (however closely) only approximate to some preconceived or "open-ended" ideal. Or at least, it is to restrict the term to those exemplars which in themselves *establish* an ideal. There are of course many such: the printmaker's *bon à tirer* stands as an unimpeachable exemplar for all other prints in an edition, rather like the Standard Yard or Greenwich Mean Time. Still, in practice we also allow for degrees of perfection (grammaticality notwithstanding) for different or successive approximations to an ideal. Pavarotti's version of "Recondita Armonia" is no less exemplary for failing to be absolutely perfect. Like many exemplary achievements, it points suggestively in new directions, to things yet unrealized.

The difference, then, between suggestive exemplars and samples is one of degree with respect to "how well." We select several samples of a particular weed, for instance, precisely because so few of them are exemplary — would not likely match the illustration in the Handbook of Weeds. Severally, they are representative examples in the sense of re-presentations of what one actually finds, namely, an uneven distribution of characteristic features. So Silvers is correct to say of such samples that members of their compliance classes (one or another of a particular kind of weed) should be expected not to possess all the signifying features of the examples. By the same token, however, neither should any particular *example* be expected to possess all the signifying features of all the examples, notwithstanding the occasional "textbook" weed *in re*. That is the other side of the coin.

Yet one should not be led on that account to think that samples compared to exemplars are *bad* examples. On the contrary, the picture-perfect weed can be deceptive for being too unworldly and possibly a "bad" example of what one is more likely to find in the patch. This is merely to underscore the fact that what makes a sample "good" or "bad" is the relative efficiency with which it serves its cognitive purpose: whether that of inducing correct identification over variable instances or of individual exemplary instances. Given a distinction between constitutive and

suggestive exemplars — those which establish versus those which approximate to an ideal — there appears to be nothing to *prevent* a sample from being an exemplar of either sort, as witnessed by the occasional perfect weed, even if most are not.

Interestingly, one of the meanings for "model" given in the *Oxford English Dictionary* is that of "perfect exemplar." Now how does that square with the notion that models are somehow unreal as suggested by Silvers' example of the toy iron? Well, how are they unreal? Generally, we think of models as differing from the real thing in scale, weight, materials, or function. The clay "mock-up" of a car, though constructed to exact size and shape, exemplifies neither the materials nor the overall function of a car. It is a perfect exemplar of the former though not of the latter properties. On the other hand, except for scale, a model may be more exemplary, say, of the "classic" clipper ship than any of the surviving examples. (The *Cutty Sark*, I understand, is a bit of a hybrid as clipper ships went.) There is of course a difference between being an exemplary car or clipper ship and being an exemplary model of a car or clipper ship. Being real — not a model — is implied by the former but not by the latter.

What does it mean to say that models are unreal? For whatever reasons we say it, the suggestion is that a model car is not *literally* a car even if it literally possesses to an exemplary degree some of the properties of a car; whereas samples and exemplars of cars are literally cars. We might say that the model car is a car metaphorically, possesses the property of being a car metaphorically, and, therefore, metaphorically exemplifies being a car. Or more specifically, the model car metaphorically exemplifies labels that apply literally to real cars; all because even working models, however exactly reproduced to scale, are not the real thing. To the objection that in a Liliputian world just the opposite would be true, one might reply that to claim that model status co-varies with being a metaphoric and not a literal sample43 says nothing about what changes in circumstances or other alterations would convert a working model, facsimile, or mock-up into the real thing.

Though models can and do on occasion function in this way, such an account of them is far too narrow, for not every model is a metaphorical sample and conversely. An architectural model used to indicate the layout, proportions, and materials of a building is neither a metaphor nor a sample of those features. Furthermore, the proposal that models are necessarily or even usually

metaphoric samples obscures their primary function, and funda-
mental difference from samples, as nonverbal *labels* literally de-
noting the real thing. Commenting on the main function of mod-
els, Goodman says, "Unlike samples . . . models are denotative;
unlike descriptions, they are nonverbal. Models of this sort are
in effect diagrams, often in more than two dimensions and with
working parts; or in other words, diagrams are flat and static
models."44 Accordingly, it might be more accurate to place toy
irons with miniature violins and flight trainers in the category of
simulations (approximations) of the real thing, rather than mod-
els. As simulations, they may exemplify literally or metaphorical-
ly certain physical features, functions, and uses of the real thing.
As models, they serve more to take the measure quantitatively or
qualitatively of the real thing — all of which argues for "ways of
showing" to include nonverbal labels as well as samples —
symbols that denote as well as exemplify without describing.

8. *Showing by Overemphasis*45
Earlier I spoke of suggestive descriptions, then of suggestive
exemplars, to which may be added suggestive demonstrations by
which I mean exaggerations or action-caricatures intended to
make a point: the sort of "over doing" that makes something
salient. If simulations as nonsamples approach a norm while
excluding for convenience certain features of the real thing,
exaggerations as samples of the real thing exceed a norm (by
over- or underdoing) and for much the same purpose: to make
something plainer, clearer, easier to grasp, or to do. As a species
of overemphasis, suggestive demonstrations are the nonverbal
analogues of hyperbole and understatement — something over-
or underdone as contrasted with something over- or under-
stated. 46
Typical examples of over- or under-emphasis both diagnostic
and prescriptive would include the following: a gandy dancer
swings his sledge high overhead with legs held straight and to-
gether to show the greenhorn how not to hit the spike; the stage
director interrupts an actor's scene with a garbled version of the
lines to show a fault of diction; or "spits out" the lines to empha-
size the consonants; or "plays down" a scene to curb a tendency
to overacting; similarly, the singing coach reproduces a phrase
in a stilted voice to show a lack of expression; or melodramatizes
it in an effort to "draw out" the singer; and so on indefinitely for
dozens of tasks in every walk and way of life.

Frequently and revealingly, such demonstrations are followed
be statements to the effect, "That is what you (should) do;
well, not exactly, of course, but . . ." The qualification is notably
absent in the case of demonstrations that are exemplars or literal
samples (including imitations of errors). Where added, it ac-
knowledges the demonstration as being over- or underdone rela-
tive to what one actually did or tried to do.

Of what, then, is the demonstration a sample? What properties
does it exemplify? Surely not, as with ordinary samples, its own
literal properties, for they exaggerate the literal properties of the
object, action, or event referred to. Rather, exaggerations meta-
phorically exemplify certain literal labels, verbal or nonverbal,
of a referent while also metaphorically denoting that referent, or
referents if more than one. In other words, suggestive demonstra-
tion or exaggeration is the *exemplificational* analogue of hyper-
bole and understatement. Logically, there appears to be no dif-
ference except that of perspective: whether one looks at a situa-
tion in terms of labels skewed with respect to their referents or
referents skewed with respect to their labels.

Nonetheless, such "felt" or perspectival difference counts for
a great deal psychologically in terms of how certain features are
brought forth or made salient. It is as if one produced a gro-
tesquely tasteless hat to show how a mildly tasteless hat is
tasteless. This is hardly a mistake — producing the wrong re-
ferent for the right label — but a deliberate choice of a re-
ferent from the range of "grotesquely tasteless hats" to sharpen
our discrimination of mildly tasteless hats; it is just as if one
were to *under*state, with the same intention, the tastelessness of
the same grotesque hat. In general, from the standpoint of the
exemplifier, over-exemplification corresponds to understatement
and under-exemplification to overstatement.

Given this perspectival difference, it is tempting to speak of
two kinds of metaphoric exemplification historically explained as
involving either a metaphoric transfer of labels or, so to speak,
a transfer of exemplifiers. However, since either way the relation-
ship is logically equivalent, it is not so important which element
has been transferred as that the relationship between them has
been transformed. In turn, the perspectival difference corres-
ponds to whatever changes the relationship, and that can happen
many different ways depending on the topic of discussion and
what one focuses on.

On the one hand, if it is talk about an object A, then it is

the label that is exaggerated. On the other, if the talk is about certain characteristics of *A*, then for the purpose of bringing out those characteristics the example given may be exaggerated. Though psychologically real and pedagogically crucial, such historical facts do not explain the logical relationship or the nature of its transformation. Still, it is interesting to speculate whether and how this felt difference pairs with other metaphors not exhibiting the exemplificational asymmetry of exaggerations.

Suppose a term transferred from its home realm and applied metaphorically as in "That lake is a sapphire."[47] If the lake thus denoted is taken to exemplify "sapphire," we have a classic case of metaphoric exemplification without exaggeration. Suppose further that someone fails to understand the metaphoric use of the term "sapphire," and I point to the lake to illustrate that *sort* of application of the term. A violet in sunlight might have done as well to make the point. The emphasis here seems to be on the transfer of exemplifiers relative to a term. On the other hand, suppose that the question concerns the sort of lake it is or which among all jewels it best exemplifies. The reply, "A sapphire!" would seem to emphasize the transfer of an appropriate term. The difference emerges in relation to the context of discussion, where the emphasis lies depending on which question one asks. Since no transfer of the relevant kind is involved in literal exemplification (including that of ambiguous terms), the issue of perspectival or contextural emphasis on the transfer of labels or exemplifiers does not arise.

Though perhaps most conspicuous in the exemplificational analogues of hyperbole and litotes, the phenomenon of differential transfer would appear to be quite general to cases of metaphoric exemplification, whether verbal or nonverbal. If so, then we should have to add a contextual addendum to the theory of exemplification, namely, the perspectival difference between the transfer of labels versus exemplifiers within a logically equivalent relation, an addendum which illumines the changes in such relationships (though not, as such, their logical patterns of reference) and their instructional uses as well, especially in the highly metaphoric languages of craft.

Finally, it may be wondered why, throughout this account of the ways of showing, that virtually nothing has been said about imitation. Yet it should be clear by now that imitation, like sameness, resemblance, or similarity, explains less than it needs to be explained. Imitation may be partial or wholesale, master-

ful or slavish, but it is always in certain respects, so that criteria are required to specify what should be or is being imitated. In lieu of such criteria articulated or assumed, imposed or induced, it is anybody's guess how one thing, performance, or person imitates another. For sure, the reader will have guessed my heading on this topic: to imitate is to exemplify, to act with reference to an exemplar, sample, or model with the intent to replicate within specified limits.

While not every case of exemplification is imitation, imitation as an activity — the deliberate attempt to replicate an object, action, or event — is perhaps most readily understood as the effort to exemplify to whatever degree such objects, actions, or events. Of course, there may be instances of "unconscious" or involuntary imitation, say of accent or gesture, in which cases the exemplification is unintentional but not for that reason any less referential to the norms by which such instances are detected. Then, too, we speak of cut glass as imitating diamond, but only as the former is taken to exemplify some of the visible properties of diamond. As a species of exemplification, imitation may also be literal or metaphoric depending upon the labels exemplified; whether, for instance, in singing one seeks to imitate the sound of an "open throat" or an inspanned pharynx. This suggests a special role for the imagination, linked to exemplification, in imitative action — particularly in regard to the construction and interpretation of exemplars and samples, a topic to which we shall return in due course.

9. *Explanations Beyond the Pale*

It would be remiss to leave off the topic of the languages of craft and skill without some further consideration of their explanatory uses. So far emphasis has been on the uses of specialized jargons of the action-oriented kind to sharpen and induce discrimination, direct and describe behaviour, and, in general, to conceptualize alike one's own or another's achievements and failures. Relative to these uses, three characteristics of such language emerged dominant: its often fragmentary, metaphoric suggestiveness; its mainly associative patterns of inference or explanation; and its phenomenalistic bias or relatively high degree of observationality of its terms. What happens when such language exceeds its mandate, so to speak, when it reaches beyond the perceptual here and now, patterns of action, and their immediate results, to try to explain things in a more general,

theoretical way?

Predictably, the outcome is conceptual confusion and an alienation of language fully deserving of the Old French *jargoun* — the kind of verbiage that can give a good technical metaphor a bad name. This is not of course to deny the commonplace adoption for theoretical purposes of terms borrowed from the marketplace: 'work,' 'force,' 'mass,' 'energy,' to mention only a physical few. Nor is it to underrate the often complementary uses of technical and theoretical discourse when focused on the same subject, as illustrated in chapter 2. Still less is it to broach some sort of thought-action dichotomy when, in fact, the thrust of this entire discussion has been in the opposite direction, to show the thoughtfulness of even the most humble of skilled acts. Rather, the idea is to illuminate the admittedly vague boundaries of a form of discourse forged on the anvil of experience by showing what happens when it is driven to do the kindred but different job of theoretical explanation.

Grammatically, in the present context, 'to explain' is ambiguous among explaining *how* (e.g., to "support" the falsetto voice); explaining *why* (e.g., support eliminates "breaks" in the singing voice); and explaining *that* (e.g., support is primarily a muscular, not a respiratory, phenomenon). Relative to the earlier distinction between understanding and knowledge of the propositional kind (see chapter 3, section 2), explanations why represent a common ground where the reasons given may be technical *or* scientific, depending on one's interests, and where understanding and knowledge display their strongest mutual bearing as shown in chapter 2. Indeed, we might think of such explanations as strung along a Practice-Theory continuum marked less by a dichotomous confrontation of the two than by a subtle shift in the character of the explanations given and of the language in which they are expressed. Ideally, the traffic is free and two-way.

At the practice end of the spectrum one finds a high population of observation sentences differing mainly in the vagueness of their stimulus meanings, rather than collateral (lexical) information, though exhibiting, nonetheless, a fairly regular intersubjective agreement (or stimulus synonymy, in Quinean terms). Such fluctuations of terms and their extensions as one encounters here take place within tolerable limits mostly set by traditional, entrenched usage. Further along the spectrum, usually in the vicinity of explanations why, where increasing amounts of collateral information intrude on the consistent usage of terms,

there begins the shift from the action-oriented language required to *do* something to the sorts of explanations why and that, that draw down the canopy of "theory."

Confusion arises when this happens to a single term; when, for instance, there is disagreement over what the singer's "support" is physically: whether it is a muscular or respiratory phenomenon — *not* what it feels like. The felt experience of support *is* its stimulus meaning, which is why, incidentally, certain techniques that disagree in theory may yet agree in practice.

Normally, collateral information produces discrepancies in the stimulus meaning of observation sentences, making them less observational; for example, "That is red" versus "He is a bachelor."[48] In lore, however, we are dealing with terms and sentences that by and large retain their observational usages while varying widely along other lexical planes, becoming, as it were, bi-focal. A good example of the sort of disagreements that can thus arise is the traditional controversy among singers over the "reality" of vocal registers. The question is a peculiar one, and it is instructive to see how it arises.

Generally, the question arises out of more elaborate attempts to explain than those articulated connections or associations which aim solely to heighten discrimination, improve practice habits, or to get something better out of the singer's throat. On the one hand, the most widely accepted observational usage of "registers" or "registration" refers to the distinctive vibratory and sound sensations designated chest voice, head voice, and falsetto, respectively. On the other, there is the *hypothesis* to the effect that the singing voice consists of three separate voices that require to be blended together so as to appear "seamless."

For C. L. Reid, for instance, a "theory of registers" explains many vocal phenomena including the errors of nineteenth-century "resonance" techniques: ". . . few seemed to remember that the sensations of vibration felt in the head or in the chest [the foci, incidentally, of "placement" techniques] were *due to* registration."[49] For Husler and Rodd-Marling, however, vocal registers are among the very phenomena to be explained, whereas Reid attributes the vibratory sensations of placement to (as if caused by) registration. In other words, on Husler and Rodd-Marling's usage, registration refers to no more than the set of vibratory and sound sensations called chest voice, head voice, and falsetto.[50]

Accordingly, they would likely argue that Reid overlooks, in

his haste to reify registers, the fact that the sensations of registration are themselves "due to" certain phonaesthenic operations of the involuntary musculature of the larynx and pharynx, to be explained in quite different terms. It would even appear that Reid's idea of "functional singing" (on which the three parties seem agreed) presupposes another kind of explanation, since registration is counted among the most conspicuous *experienced* phenomena utilized as a means to functional (nonphonaesthenic) control. That is, registers are on the same phenomenal plane as "placement" — pitch-intensity patterns, and the like — the whole being encompassed by the language of the ear. However one looks at this issue practically or scientifically, the fact remains that reification, under the drive to formulate explanatory hypotheses of a general nature, is a constant hazard.

Certainly, complaints about the jargons of some arts, sports, and crafts will justifiably cite the plethora of "theories" and "explanations" couched in seemingly inscrutable language. Scrutability is relative, however, in this instance, to the special activities and purposes around and for which such language was originally devised, often over centuries and passed on from master to apprentice for several generations.[51] To cast such talk aside wholesale, ignoring its proper role because of its failure at another, is but the opposite manifestation of that linguophobia which, no more absurdly, criticizes a chemical analysis for failing to be a recipe or to convey the taste of the soup.

REFERENCES

CHAPTER 4

1. Quine, *Word and Object,* p. 14

2. Ibid.

3. Cf. Thomas Nagel, "What is it Like to be a Bat?" *The Philosophical Review* 83, 1974, pp. 435-450.

4. See Nelson Goodman, "The Way the World Is," *Review of Metaphysics* 14, 1960, pp. 48-56; reprinted in Nelson Goodman, *Problems and Projects* (Indianapolis: Hackett, 1972).

5. On semantic density and related concepts in the analysis of symbol systems, see Nelson Goodman, *LA*, esp. ch. 4.

6. Nelson Goodman, *The Structure of Appearance,* 3rd ed. (Boston: D. Reidel, 1977), esp. ch. 4: hereinafter cited as *SA*.

7. Ibid., p. 130; italics mine.

8. Ibid., p. 132.

9. Ibid., p. 131.

10. Cf. ibid., p. 140.

11. On decrees and their immunity to direct test but vulnerability to cancellation, see ibid., pp. 134-135.

12. Ibid., p. 135.

13. A frozen metaphor is banal at best and well en route to becoming literal, and, therefore, merely ambiguous on its two uses. See Goodman, *LA*, pp. 68-71.

14. Wittgenstein, *Philosophical Investigations,* pp. 80-81.

15. Max Black, "Rules and Routines," in R. S. Peters (ed.), *The Concept of Education* (London: Routledge & Kegan Paul, 1967).

16. It seems that rule-accepting and rule-covered actions are not necessarily distinct, since a covering rule that exactly describes what one is doing is therefore also rule-accepting. However, the idea of a rule that "could be followed" is ambiguous between (a) one that the actor could appeal to as sufficient to *direct* or *control* performance (rule-accepting); and (b) one that properly *describes* or *explains* his performance (rule-covered). Clearly, the one kind of rule does not entail the other. If that is enough to distinguish the two *categories* of rule-following action, it can still happen in practice that a particular *rule* may fall into either or both categories. For a given rule, that circumstance will vary from time to time and person to person. In short, the categories appear to be disjoint but not differentiated. This would seem a sensible allowance, though whether that was Black's intention is difficult to tell.

17. Black says of "no value" (op. cit., p. 99); but that, obviously, is wrong as attested by Husler and Rodd-Marling's researches and by recent advances in sport and dance physiology too numerous to list. Another difficulty here is that rule-accepting and rule-covered actions are not necessarily distinct, i.e., a rule-covered action also exactly describes what one is doing and therefore may also be rule-accepting. However, talk of a rule that *could* be followed is ambiguous between one that *is* followed and one that can be *appealed to,* so to say, in the first person, as effective to direct or improve performance. This will of course vary from one person to another and from time to time, but the proviso is sufficient to keep the two categories of rule-following action distinct — which, incidentally, seems to be Black's intention. I owe this query to Israel Scheffler.

18. Black, ibid., p. 100.

19. Ibid., p. 101.

20. Ibid., p. 100.

21. Ibid., p. 101.

22. Ibid.

23. Ibid., p. 102.

24. Ibid.

25. Ibid., p. 96.

26. Ibid., p. 104.

27. Reid, "Functional Vocal Training," p. 37.

28. I owe this example to Douglas Lare.

29. On the logic of samples and labels, see Goodman, *LA,* pp. 57-67.

30. Ibid., p. 59.

31. Ibid., p. 65.

32. On Goodman's view, a predicate or description is a label in a linguistic symbol system; see ibid., p. 57.

33. Cf. *Oxford English Dictionary* on these and many other typical uses.

34. Largely in response to Goodman's theory of exemplification, op. cit., pp. 52-57.

35. Anita Silvers, "Show and Tell: The Arts, Cognition, and Basic Modes of Referring," in S. S. Madeja (ed.), *The Arts, Cognition, and Basic Skills* (St. Louis: CEMREL, 1978).

36. Ibid., p. 38.

37. Ibid.

38. Ibid.

39. Goodman, "When is Art?" p. 15.

40. Silvers, op. cit., p. 39.

41. Ibid., pp. 38-39.

42. Ibid.

43. By metaphoric sample is meant one that exemplifies metaphorically, whereas a literal sample exemplifies literally. Both are literally samples.

44. Goodman, *LA*, pp. 172-173.

45. This section owes much to a conversation with Nelson Goodman.

46. Cf. Goodman, *LA*, pp. 81-83.

47. The example is Goodman's, though I am uncertain whether our interpretations of it would tally.

48. Quine, *Word and Object*, p. 37.

49. Reid, op. cit., p. 38; italics mine.

50. Husler and Rodd-Marling, op. cit., pp. 57-66. Some writers and teachers distinguish several more such "voices" or subsets of the basic three.

51. By contrast, *gratuitous* jargon of the kind rife in education, politics, and advertising (see chapter 2, section 6) is mostly euphemistic and serves *no* useful purpose.

Sometimes I see it and then paint it. Other times I paint it and then see it. Both are impure situations and I prefer neither.

Jasper Johns

5 *Craft, Creativity, and Imagination*

1. *The Creativity Paradox*

What have target shooting and academic art in common?[1] Besides taking pot shots at the done thing, both are splendid examples of rule-following behavior, of adhering to precept in order to achieve a preconceived result. Moreover, and on that account, neither displays much in the way of creativity or imagination. If one hits the target consistently, one is a good, even excellent, but not creative shot; and "academic" applied to art is the very antithesis of creative imagination in art. We applaud the sharpshooter and denigrate the copyist for the same reason: they are stereotypically good at what they do. We expect the sharpshooter to hit a given target, whereas we expect the creative artist to aim for new targets of his own making. Philosophic opinion diverges at the point of trying to say why we are agreed on these judgments.

Being imaginative is one way of being creative, though a lack of imagination is but one way of being uncreative. The mere presence of imagination is neither necessary nor sufficient for creativity, however, as attested by the fact that creativity can be hobbled by a "limited" imagination; and, of course, an unlimited imagination might only amount to chaos. Still, it would seem that creativity implies *some* kind of imagination, though beyond partially synonymous usages of the two terms, it is difficult in the extreme to say what that kind would be. In all likelihood, there is no one kind of imagination indicative of creativity, and even to pursue the issue in this manner is logically Quixotic. The sharpshooter does not become creative for all his imagings of the steps to be followed that lead to a bull's-eye, nor does a painter cease to be creative for not imagining the final form of his painting.

Far from it! The weight of recent philosophic opinion is on the side of the view that such "preconception" of final outcomes is incompatible with creativity and sufficient reason for denying it anywhere. For Collingwood, for instance, such making in accord with preconception is "fabrication" or technical skill, whereas "To create something means to make it nontechnically, but yet consciously and voluntarily."[2] Works of art, for example, "are not made as means to an end; they are not made according to

117

any preconcieved plan. . . . Yet they are made deliberately and responsibly, by people who know what they are doing, even though they do not know in advance what is going to come of it."[3] More recently, Vincent Tomas in a much quoted passage has said, "To create is to originate. And it follows from this that prior to creation the creator does not forsee what will result from it."[4]

The first half of this chapter challenges this view as it applies to art generally, while allowing it for craft. In other words, I will argue that not all creativity in art is of the "unforeseen" variety, but that predominately problem-solving activities, including craft, commonly exhibit such creativity within and without the arts. Without exception,[5] philosophic comparisons of art and craft from Collingwood onward have denied creativity to craft mainly on grounds that its aims and products are fully preconceived, thus leaving little if any scope for the imagination. Since it is a question of making room for the imagination, the issue of creativity commands out attention first.

From a logical point of view, the issue of creativity concerns (at least) the grounds for ascribing or denying creativity, in whatever sense of the term, to either the works or achievements of artists and artisans on the one hand, or to the work or activities of such individuals on the other. The root problem centers on the active verb, "to create," or "creative process," which Beardsley describes as "that stretch of mental and physical activity between the incept and the final touch — between the thought 'I may be on to something here' and the thought 'It is finished.' "[6] The philosophical question is not so much what goes on psychologically in this interval as what makes such goings on "creative." When, under what conditions, are we permitted to describe them as such? Inasmuch as the interval is not empty but directed, in Collingwood's words, "by people who know what they are doing, even though they do not know in advance what is going to come of it,"[7] there is an element of "control" to be reconciled with the "unforeseen." And therein lies the creativity paradox: that the artist both knows and does not know what he is up to, that he directs without foresight or preconception. Maitland spells it out for us:

> To foresee the results of creative work is a logical
> impossibility given this view: if the artist has a clear
> idea of the results toward which he is aiming, then

either he is not engaged in creative work, or the clear
idea is itself the final result of a creative act that has
already occurred. Yet, in some way, the artist must
know what he is about and where he is heading.
Otherwise, he would be unable to make aesthetically
discriminating or relevant choices or to correct his
mistakes.8

Collingwood's solution is to convert the control into a process
of discovery and clarification of emotions we-know-not-what-
nor-whence. "If artists only find out what their emotions are in
the course of finding out how to express them, they cannot begin
the work of expression by deciding what emotion to express."9
But who is to say that artists only find out, James-Lange style,
what their emotions are by first expressing them? And if that
were the case, how should we ever be sure that the emotions
finally expressed are the same as those we started with? And
why, after all, should they be the same? As Beardsley observes,
the whole idea of art works as *clarifying* the artist's emotions is
obscure at best and absurd when applied to the grandiose
musical expressions of a Bruckner or a Mahler.10 Admittedly,
there is some truth in the control-as-discovery thesis — artists
do sometimes clarify or discover their emotions by expressing
them — but as an account of the control involved in creative
activity, it falls short by less than half.

The control in question is a matter of knowing where one is
heading and how to correct mistakes in getting there. As a sub-
scriber to the Unforeseen Theory of Creativity,11 Tomas elects
to suppress the heading in favor of correcting mistakes. This results
in some awkwardness for the artist: deprived of a prime reason
why something is a mistake, he becomes a blind seer of his own
errors, inwardly goaded by an "inspiration"-he-knows-not-
whither. "Whenever the artist goes wrong, he feels himself kicked,
and tries another way which he surmises, trusts, or hopes, will
not be followed by a kick. What is kicking him is 'inspiration',
which is already there."12 The artist, locked into a kind of aes-
thetic blindman's buff, looks not at the work in progress, still
less at his ultimate goals (for then he should be uncreative!), but
at his mistake-signalling inner twinges. As Maitland correctly
observes, this situation makes creativity impossible by ruling out
reasons for change related to works: "Critical control must be
understood in terms of the object of creativity, not in terms of

feelings disconnected from their objects."13 Clearly, theories of
control we-know-not-what-nor-whence-nor-whither are themselves
much too paradoxical to offer any way out of the creativity
paradox.

2. *Creating and Creativity*

Control without aim or reason is more like no control at all,
and were it not for the Unforeseen Theory of Creativity, no doubt
a more robust conception of control would be substituted in its
place. And certainly there is little *empirical* support for the Un-
foreseen Theory of Creativity if such statements as that of Jasper
Johns in the frontispiece to this chapter are taken seriously.
Rather, the connection between creativity and the unforeseeable is
thought to be a logical one, that creativity implies the absence of
preconception, that one cannot foresee the results of one's own
creative acts. Plainly, the claim is overstated, its apparent strength
deriving from an equivocal use of "foresee." For even if it be
argued that one never *knows* what one will do in advance of
doing it, one may yet *intend* in greater or lesser detail to do this
or that and know one's intention perfectly well. Only that is re-
quired to "foresee" what one undertakes to create; not a pre-
diction, or clairvoyance, still less full knowledge of results. So
much is philosophically well-trod ground.

What, then, underlies the Unforeseen Theory of Creativity?
Two things, it would appear: First is the view that creativity is
an isolable, psychological concept; and second is an overdrawn
analogy with problem-solving. On the first point, consider some-
one who says, "I am painting." "So I see," might well be the
reply. But if he or she had said, "I am creating," we could well
ask, "How can you be sure?" His painting may be more in the
way of creating a nuisance than anything creative. Creating does
not imply creative. Why is that? Because, "creating" may only
imply something like efficient causality — responsibility for the
making — whereas "creative" occurs in judgments of results
achieved; so that one who produces a creative result must have
been engaged in *something* en route deserving of the description
"creative process." But that could be anything, including, of
course, painting. One does not paint *and* create in the way that
one may paint and fidget at the same time. Rather, one creates
by painting, composing, or performing, which is to say that the
latter are isolable activities corresponding to the verbs "paint,"
"compose," "perform" and quite unlike creating which is not an

isolable activity corresponding to the verb "create."[14] There is
no specifiable process such that "X is a creative work" entails
"Process P has occurred."[15] In judging a work to be creative, we
are not thereby saying anything about the psychology of the
creator except possibly that whatever he did or experienced had a
creative outcome. As Kennick remarks, "To be sure, if a work
of art is creative, then its artist is creative. But this is an empty
or uninformative tautology. If Jones' swimming is graceful, then
Jones is a graceful swimmer. Antecedent and consequent say the
same thing."[16] This is good news for psychologists whose theories
of creativity explore the contingent relations between certain
states or habits of mind and acknowledged creative achieve-
ments.

Notwithstanding the fact that "create" is not a "psychological
verb"[17] in the way that "to reason," "to dream," or "to imagine"
are sometimes thought to name distinguishable kinds of mental
act or episode, it seems rather overstated to assert, as Kennick
does, that "The concept of creativity is not a psychological con-
cept."[18] Granted that we can determine the originality or crea-
tivity of works independently of any knowledge about the psy-
chology of creativity, still, "creativity" is asserted or denied of
such processes, not always recursively or tautologously, but in
such manner as to impose certain restrictions themselves in-
dependent of judgments of final outcomes. That is the other side
of the coin that creating does not imply creativity; that is, crea-
tive process may have its conditions even if they neither entail
creative results nor single out any one process as being the unique-
ly creative kind. (See section 4.)

The Unforeseen Theory of Creativity is just such an attempt
to stake out what appears to be a necessary condition of creative
processes whatever they are or should turn out to be. Whether
one agrees with the Theory — which I do not — it is an at-
tempt to set conditions on that interval of intentional (physical
or mental) activity between incept and final touch. In other
words, the creativity paradox is not eliminated, even if partially
aleivated, by establishing that "create" is not always or primarily
a mental-process verb. As a description of mental or physical
processes, "creative" may yet involve criteria significantly ap-
plicable to activities and different from those by which we judge
the creativity of their outcomes.[19] This brings us to the second
basis of the Theory: the idea that creativity in art or elsewhere
is a species of problem-solving.

As delimiting a logical restriction on what shall count as creative problem-solving, the Unforeseen Theory of Creativity appears unobjectionable. It amounts to the view, in Maitland's words, that

> If the aim of a creative endeavor is the solution of a certain problem, to foresee the solution to the problem before solving the problem (not just to foresee or predict *that* one will solve it) is indeed contradictory. For, to foresee the solution of a problem is after all to have the solution of the problem. Those theorists, then, who view foreknowledge in creativity as a logical impossibility are correct only to the extent that a creative endeavor involves creative problem solving.20

Thus, for example, John Dewey speaks of the artist as "born an experimenter" much as any scientist without which trait he is doomed to be a mere "academician."21 "The artist," he maintains, "is compelled to be an experimenter because he has to express an intensely individualized experience through means and materials that belong to the common and public world. This *problem* cannot be solved once for all. It is met in every new work undertaken."22 More recently, D. W. Ecker describes artistic creativity as "qualitative problem-solving" not necessarily verbal or propositional in form but taking place "in the artist's medium."23 So, for instance, a painter may use a cool green to cause a place to recede.24 That, then, is his solution to the problem of how to get the plane to recede.

Plainly, whatever else might be said at this point, the Unforeseen Theory of Creativity presupposes a fabrication theory of art; or, what amounts to the same thing, a conception of creativity that is restricted to that much of art which is fabrication or craft. Ironically, what began as a theory of artistic creativity turns out on closer inspection to be better suited to craft construed broadly as traditional, yet revisible, problem-solving lore.

Complex crafts such as voice building, boat building, or glass working are, as we have seen, subject to intrusions of new information from practical and theoretical sources. A change of tools, of techniques, or of procedures may well be the result of creative endeavor at problem solving within the traditional mold. To deny as much is to fail to give the craftsman his due,

besides confusing productive rules and routines with the "canned reactions" of conditioned response. On the whole, it is the craftsman within and without the arts who comes closest to being a qualitative problem-solver.

3. *Creative Performance*

Ironically too, for those who would defend the Unforeseen Theory of Creativity for art generally, *creative* problem-solving emerges as a relatively rare thing in the context of the prescribed rules and routines of an established craft. It happens, yes, but not nearly often enough to satisfy the demands of ubiquitous creativity in art. It might be countered that craft, especially in art, involves a constant "creative adjustment" to changing conditions, materials, styles, and expressive demands. And so it does, but then the "unforeseen" purchases a most attenuated sense of creativity, one that would make virtually any perception — for instance, my first somber look at the ceiling in the morning — a creative act. Doubtless there is something to be said for creative adjustment of received *knowledge* to changing circumstances, but more that illuminates craft than art as such except as the latter requires craft. (See chapter 6, section 5.)

Besides the counterintuitive suggestion that to be creative, artistic endeavour must always somehow be a "problem,"25 there are other difficulties with the Unforeseen Theory. For example, we should be loath to brand "uncreative," say, the paintings of Jasper Johns on those occasions where he saw the subject and then painted it and "creative" only where he painted it and then saw it — though, in fact, that is exactly the position Collingwood takes. (See pp. 118-119.) And conversely, where we judge the artist's activity recursively, by the creativity of his achievements, we should be courting contradiction were it later to emerge that the work in question was "preconceived" and therefore the creative product of uncreative effort. In short, the distinction, however drawn, between creative and uncreative process cuts across the difference between those cases where results are foreseen and those where they are not. And if that is so, then foreknowledge, except as it accrues to instances of problem-solving, is incidental to creativity in art.

Beyond that, it is worth repeating that the kind of forehavings or preconception required for critical control amounts neither to foreknowledge of what has not yet happened or been conceived, nor to slavish adherence to precept and habitual response.

Rather, as Dewey observes, "The artist embodies in himself the attitude of the perceiver while he works" such that if he fails to "perfect a new vision in his process of doing, he acts mechanically and repeats some old model fixed like a blueprint in his mind."26 Such vision is less foreknowledge than foresight, indeed a compound of hindsight and anticipation that we are accustomed to grace with the term "imagination." More on that later.

If creativity and control are not so incompatible as suggested by the paradox of creativity or its companion piece, the Unforeseen Theory of Creativity, still we are not much clearer as to the nature of creative process or the general conditions thereof. Perhaps, after all, there aren't any; but some general characterization at least ought to be possible for whatever is not crafty about art. Most attempts to deal with the question separate creative process from creative results except where the former is trivially inferred from the latter. An alternate tack would be to bring them closer together by extrapolating in the opposite direction, from creative process to creative results; that is, to view the creativity of art works as a kind of performance function.

Dewey broaches such an idea in *Art as Experience* when he says, "It is no linguistic accident that 'building', 'construction', 'work', designate both a process and its finished product. Without the meaning of the verb that of the noun remains blank."27 Among recent writers, Jeffrey Maitland takes the full step with his notion of "creative performance" developed by analogy with performative utterance construed as "the doing of something rather than merely the saying of something . . . the public exhibition of intent fused with the act of speaking"28 as in declarations of war, peace, welcomings, or the making of promises. Similarly, the work of art, where successful, is not merely "the application of paint and the solution of a problem," but two further things: "the exhibition of the way of doing things" and (assuming success) "the achievement of creative performance as the work of art."29 In other words, works of art *do* something: they perform well or poorly, creatively or uncreatively and thus have a "performative presence" quite like that of performing artists who, incidentally, typically know in advance what the work is irrespective of their inspired, innocuous, or insipid performances of it.

Despite some awkwardness of wording, it is reasonably clear what Maitland has in mind: that the work of art is not simply an

"object" — "the embodying of something inner in something outer"30 — but a performance presence exhibiting *a* way of doing things that, in turn, may or may not be judged creative in comparison to other ways of doing things. But, beyond the analogy between art works and performative utterances and a trailing suggestion that "creativity is a form of human freedom,"31 Maitland leaves us with little to go on. There are really two issues here. One concerns the nature of aesthetic performance and the other creative aesthetic performance. And the important point to grasp, though Maitland is apparently reluctant to put it as such, is that creativity comes down to a judgment of *merit* over the functions that works perform.

There are two notable advantages to this way of stating, or restating, the position: first, it dispenses with the animism of "performative presence" as applied to insensate works of art; and second, it circumvents a probable objection to the effect that the position fails to distinguish properly between performances *of* and performances *by* works. However delimited, the notion of aesthetic function cuts across that difference, inasmuch as both allographic works consisting of a class of performances compliant with a score or script as well as those that are identified by their history of production, autographically, like paintings, may be said to have an aesthetic function.32

The position taken herein is not unlike Collingwood's in denying there are any such things as *objets d'art;* but not, however, for Collingwood's reasons: not because aesthetic objects exist only in the imagination. Rather, it is because works of art are not *mere* objects but *symbolically* performing ones having an aesthetic function to fulfill. This is not the place to argue for the symbolic status of art33 except to note that such status offers a convenient explanation of what a work of art does when it "performs"; namely, it symbolizes in certain characteristic ways. Rather than possessing permanent status as aesthetic objects, works of art function aesthetically as characters in symbol systems of one kind or other. And as earlier observed (p. 14), a Brancusi functioning as a door stop is not performing aesthetically even if we *accord* it permanent status as "work of art."

By the same token, anything functioning aesthetically will likely exhibit one or a combination of the "symptoms" of aesthetic symbolization: density, literal or metaphoric exemplification (expressiveness), and repleteness.34 Then too, syntactic and semantic density and repleteness — what in the vernacular is

summarized by the term "nuance" — entail an indeterminacy of meaning, an unpreconceived cognitive wealth, that accords nicely with our popular notions of creative process on the one hand and, on the other, of an autonomous life for art works beyond that foreseen by their creators.[35]

Withal, creativity in art is less a matter of psychological process than an evaluation of aesthetic process. To create is not only to do but to do well. And for present purposes it is less important to settle the question, By what criteria? than it is to realize that by whatever criteria, a judgment of creativity is a judgment of the merit of such processes. By no means is creativity in art reducible to aesthetic function; but to see creativity in terms of aesthetic function draws attention away from the mystery of what creativity is "in itself" as a mental process to *how well* a work or performance functions aesthetically and *why* — questions grounded in the public character of works and performances themselves.

Furthermore, the same considerations apply to creative problem-solving for which the Unforeseen may be a necessary but hardly sufficient condition of a creative solution. To originate something, whether or not foreseen, is not enough to be creative, notwithstanding a partial synonmy of terms. Depending on the nature of the problem to be solved or the part of one's World to be made over, considerations of scope, generality, acuity, explanatory power, utility, expressiveness, and the like have at least equal roles to play in determining what is or is not creative.

4. *The Psychology of Creativity*

I have spoken of creativity in art as mostly a matter of symbolic rather than psychological process and of creativity in craft as a species of creative problem-solving, while allowing for all manner of their combination, especially in the area of art-craft. How does this square with the psychology of creativity with its express concern with mental processes — types of thinking, aspects of personality, and so on? Not as badly as might appear at first blush. For example, A. H. Maslow after encountering "a first-rate soup [that was] more creative than a second-rate painting . . . learned to apply the word 'creative' (and also the word "esthetic") not only to products but also to people in a characterological way, and to activities, processes, and attitudes. And furthermore, I had to apply the word 'creative' to many products other than the standard and conventionally accepted

poems, theories, novels, experiments or paintings."36 Similarly, Koestler remarks that "The aesthetic satisfaction derived from an elegant mathematical demonstration, a cosmological theory, a map of the human brain, or an ingenious chess problem, may equal that of any artistic experience — given a certain connoisseurship."37

Still, in all, the approach of these two broadly theoretical writers on creativity is not unlike that of others who take a more narrowly experimental approach. Namely, they begin with acknowledged or recognizable instances of creative activity or achievements and then proceed to inquire into the conditions of personality, mind, or culture that appear to co-vary with such achievements. This implies that creativity as a property of artistic, scientific, or ordinary achievements has already been identified (or assumed). Viewed in this light, the psychology of creativity concerns less the nature of creative process than its causes, more precisely, its co-variants. References to "creative process" or "creative activity" by psychologists are not so much to finished performances as to whatever appears *likely* to give rise to a creative achievement: "Where talent is identified purely in terms of activities, creative potential is what is identified; where the quality of the products is considered, the level of achievement as well as potential may be assessed."38 Thus, to speak of creativity as a process of self-actualization, of infolding, or of problem-solving is to speak of processes independently identified to which the adjective "creative" may or may not apply depending on the results achieved. The very significance of such hypotheses and theories depends on creativity — the very idea — *not* being identical to its explicans.

Though perhaps obvious, the point is easily lost sight of with the result that creativity gets reduced to one or another process with which, in some circumstances, it may co-vary or in which it may be manifested. Nowhere is this difference between creativity and its co-variants more apparent than where psychologists discover no co-variance where popular prejudice might have led us to expect one. For instance, is creativity the prerogative of those possessed of a high I.Q.? Gilchrist's survey of the experimental literature on creativity and intelligence concludes: "It appears that a reasonably high level of ability is necessary for creative achievement, but that past this level further increases in intellectual competence are no guarantee of higher levels of creative achievement."39 In a similar vein, MacKinnon records

that among architects, those whose professional accomplish-
ments were peer-judged most creative,

> were not generally A students. They averaged about
> B. They were not poor students, or lazy; rather, they
> were extraordinarily independent as students, turn-
> in an A performance in work and courses that caught
> their interest, but doing little or no work at all in
> courses that failed to stir their imagination.40

Spurred on by these exceptions to common sense reckoning,
a raft of investigations in the early 1960s sought the *locus* of
creativity in "divergent thinking" as contrasted with "right
answer" or "convergent" thinking41 The idea was to single out
the elements of originality and flexibility presumably ignored by
such convergent measures as standard intelligence tests. It was
also hoped to discover the unitary factor of creativity that is
(somewhat) independent of intelligence as measured by tests.
Summarizing this effort, Gilchrist says,

> To date, the evidence suggests that divergent-thinking
> skills bear some relationship to creative achievement,
> but that this relationship is comparatively slight. Cer-
> tainly it appears too small to justify the identification
> of creative potential with performance on divergent-
> thinking tests.42

But it is not only a question of evidence; an error of reason-
ing is involved. Beginning with the observation (a) that di-
vergent thinking is sometimes (oftentimes) creative, one postu-
lates (b) that divergent thinking is a high-frequency correlate of
creative achievement, from which, if confirmed, is supposed to
follow (c) that divergent thinking is the unitary factor of all
creative process, is *the* creative process. The shift from attribute
to correlate to defining process is evident in this line of argument
such that, even were (b) confirmed, (c) still would not follow.
Were it demonstrable that divergent thinking and creative achieve-
ment are, say, 70 percent co-variable, from the fact alone one
cannot infer that divergent thinking is either necessary or suf-
ficient to creative achievement, since the latter may yet occur
without the former and conversely.
As well, the argument is questionable in two of its presupposi-

tions. Besides assuming that creative thinking at the core is of *one* kind, the idea that it is always of a divergent or deviant kind entirely obscures how creativity according to plan is possible. At least it is not clear what allowance there is for creative approximation to a preconceived ideal, as in Zen calligraphy or disciplined musical or dramatic performance. Certainly it is no good to say that where there is a plan in force the divergent thinking has already occurred, for that merely reinstates the paradox of creativity all over again in psychological dress.

The root trouble with overall theories and hypotheses about creativity is that they lean toward a categorical answer to the question, What is creativity?, analogous to those proffered to What is art? and What is craft? Otherwise put, I object to an incipient "definitional approach"[43] to creativity, as if its philosophic *or* scientific study were to issue in a once-and-for-all "definitional answer" as to its ultimate nature. Furthermore, creative activity as a species of human behavior cannot be examined in isolation from the myriad useful as well as artistic and scientific patterns of thought and action in which it is likely to show itself.

As before, a functional rather than categorical approach stressing the "when" rather than the "what" of creativity has the twin advantages of not presupposing creativity to be amenable to real definition (in terms of necessary and sufficient conditions), and of focusing attention on the actual or presumed *symptomatic* conditions of creative achievement. Such an exchange of sharp boundaries for sharper empirical insights has two salutary consequences: on the one hand, less verbal legislation of what is *the* creative case or process; and on the other, a corresponding recognition of creativity in realms of practical knowledge such as craft, where heretofore it has been ignored.

5. *Craft and Inquiry*

Contrary to those wishing to follow his lead, Collingwood explicitly recognizes the creative dimension of craft. He writes, "Making an artifact, or acting according to craft . . . consists of two stages. (1) Making the plan, which is creating. (2) Imposing that plan on certain matter, which is fabricating."[44] What Collingwood denies is that the artifact is a product of creative imagination: "When we speak of making an artifact we mean making a real artifact. If an engineer said that he had made a bridge, made it in his head, we should think him a liar or a

fool."[45] By contrast, a poem or symphony made in the head, even if not written down, is no less real a poem or symphony than one recited or performed.

Or is it? We have considered reasons for doubting that works of art can be *identified* with mental acts of imagination any more convincingly than can works of craft. (See chapter 1, section 3.) Besides which, not every result of craft is a physical artifact; it might also be a performance capacity such as singing or a "healing art" such as psychiatry. If a psychiatrist fails to be creative, it is not because his results are any less mental than a poem in the head. In other words, creative imagination is not the redundant phrase it comes near to being at times for Collingwood. Uncreative imagination is an everyday occurrence. And, as said at the outset, a failure of imagination is but one way to be uncreative.

Neither is the mere presence of particular acts of imagination necessary or sufficient for either creative problem-solving or for creative process whether psychological or symbolic. Rather, insofar as the adjective "creative" implies an assessment of such solutions and processes, it is the quality of imagination manifest in them — not just their resulting from or existing in imagination — that determines the degree of their creativity. So failure to achieve imaginary status cannot be sufficient reason for denying creativity to the products of craft. There must be other reasons as well, and of course Collingwood has other reasons.

Whatever the status of craft products *in mens* or *in re,* Collingwood limits creativity in craft to the inception of plans, to the means to preconceived ends, while denying it to the "imposing" phase of fabrication. So far as fabricating is implementing plans already foreseen, it is uncreative. That is Collingwood's version of the Unforeseen Theory of Creativity applied to craft. I will object not so much to the Theory itself in this context of problem-solving where, if anywhere, it is most appropriate, but to its application. I will argue that craftsmanship requires a constant, often mutual, adjustment of means *and* ends that in turn requires extending creative possibilities to the fabrication phases of craft. As well, I want to show how imagination, in senses to be distinguished below, becomes involved in fabrication.

As an opening caveat, it is well to keep in mind that we are talking about fabrication, not prefabrication, about human, not machine, technology. We are concerned with using knowledge to make something, not turning on a machine to make it for us.

The crucial difference here is between fluid, mutually revisible means and ends and those that are fixed. Collingwood tends to fixity in the relation of means and ends: first come ends prefixed by our wishes (to span a river, to cure a disease) for which we create plans (of a bridge, of a course of treatment), fixing the means to those ends. If this appears rather too set and simplistic, it is because, as Dewey observes, that "theories of human activity have been strangely oblivious of the concrete function troubles are capable of exercising when they are taken as *problems* whose conditions and consequences are explored with a view to finding methods of solution."[46]

Perhaps so, but just to say that is not enough; for is not craft by definition a "method" whereby "troubles" are converted to "problems" whose solutions are bequeathed to us in the traditional lore? In other words, insofar as Dewey's remark may be taken to apply to craft, is he not describing its creative, not its fabricative, phases? The answer to both questions is a negatively qualified Yes. Yes, craft gives us a method but there remain all the problems (troubles) of applying it in particular instances with no guarantees of success. And yes, Dewey is talking about creative planning but such creativity is continual, if not continuous, throughout execution (fabrication) as new problems arise. Which is to say, that the specific procedures we follow tend to *emerge* not only from tradition but also from our momentary successes and failures in applying what tradition has given us.

Collingwood himself speaks of a hierarchical *nexus* of means and ends among related crafts, the end products of the instrument maker, for instance, supplying the means for the physician or engineer. (See p. 11.) What is the final end here? According to Dewey, it is "the *last* desire . . . ultimate for that particular situation."[47] "Final" is relative applying to "a specifiable *means-end relation* and not to something which is an end per se," so that, "There is a fundamental difference between a final property or quality and the property or quality of finality."[48] Well, what about something like "ease of travel," or better, "health" as final ends? Good health certainly seems as final an end as one could wish.

Dewey's reply: "Generalized ideas of ends and values undoubtedly exist," because as, "Similar situations recur . . . desires and interests are carried over from one situation to another and progressively consolidated."[49] The outcome is "A schedule of general ends . . . the involved values being 'abstract' in the

sense of not being directly connected with any particular existing case but not in the sense of independence of all empirically existent cases."[50] Such general *schedules* of ends and means — not a bad short definition of craft, incidentally — "are used as intellectual instrumentalities in judgment of particular cases as the latter arise . . . as tools that direct and facilitate examination of things in the concrete while they are also developed and tested by the results of their application in these cases."[51] In just such manner is craft occasionally revised in whole or part: by its successes *and* failures.

In this way, a stasis of ends and means (Maitland's "canned reaction"[52]) is displaced by a scheduled flux of "ends-in-view" in an "ongoing stream of events," what Dewey calls "the continuum of ends-means."[53] To clarify that notion Dewey gives the example of a physician diagnosing an illness; but note too the parallel with Husler and Rodd-Marling's diagnoses and treatment of "phonasthenic" singing in chapter 2 above.

> A physician has to determine the value of various courses of action and their results in the case of a particular patient. He forms ends-in-view having the value that justifies their adoption, on the ground of what his examination discloses is the 'matter' or 'trouble' with the patient. He estimates the worth of what he undertakes on the ground of its capacity to produce a condition in which these troubles will not exist, in which, as ordinarily put, the patient will be 'restored to health'. He does not have an idea of health as an absolute end-in-itself, an absolute good by which to determine what to do. On the contrary, he forms his general idea of health and an end and a good (value) for the patient on the ground of what his techniques of examination have shown to be the troubles from which his patients suffer and the means by which they are overcome. There is no need to deny that a general and abstract conception of health finally develops. But it is the outcome of a great number of definite, empirical inquiries, not an a priori preconditioning 'standard' for carrying on inquiries.[54]

Assuming the creative dynamic of Dewey's tandem relations

of ends and means-in-view, what is exactly the connection between craft and inquiry? It seems implausible that craft should be *basically* a form of inquiry, though much inquiry certainly goes into it and comes out of it. Rather, craft deals with recurrent kinds of problem, giving rise to "a sort of framework of conditions to be satisfied — a framework of reference which operates in an *empirically* regulative way in given cases."55 But those are Dewey's words to describe inquiry! Lest one be accused of quoting out of context, the clincher comes in the next sentence: "We may even say that it [the framework] operates as an 'a priori' principle, but in exactly the same sense in which rules for the conduct of a technological art are both empirically antecedent and controlling in a given case of the art."56

At the risk of digressing, this view of inquiry as at least very craft-like deserves a closer look. The reader will recall that conduct for Dewey presupposes habits, and at a more general, social level, custom imposed upon the active energy ("impulses") of the growing individual. "In conduct the acquired is the primitive . . . In short, the meaning of native activities is not native; it is acquired. It depends upon interaction with a matured social medium."57 "Impulse" is Dewey's substitute for "instinctive activities" referring to specific untutored responses shaped by habit and custom. Though usually channelled by habit and custom, impulse will sometimes impel the individual to deviant, new activity where habit and custom fail. Quite literally, ideas are plans of action. The new activity, where it is more than a howl of frustration, may be the outcome of "deliberation," the occasion of which "is an *excess* of preferences, not natural apathy or an absence of likings."58 "More 'passions', not fewer. . ." is Dewey's way out of a rut.59 In brief, thwarted effort is the wellspring of inquiry.

But the route from impulse to inquiry is yet rockier in epistemology. Scheffler, for instance, argues that such a course commits Dewey to a "discontinuous" view of intelligent thought (inquiry) motivated intermittently by the breakdown of established habits. Impulse as a response to stress, conflict, or other difficulty attendant upon the failure of prior habit dissolves with the resolution of the particular problem which gave it rise. "There is no provision in Dewey's account for putting impulse to use in revising habits that are currently functioning perfectly well and adequately."59 Hence there is no continuous flow of impulse

"for general use in advance reconstruction of potential break-downs foreseeable only in imagination."[61] This "discontinuous conception of habit-reconstruction,"[62] which Scheffler also calls the "problem-theory of reflective thought,"[63] conflicts with Dewey's interpretation of ends and means as requiring continuous and mutual reevaluation, and, as such, exemplifies "The general tendency of pragmatism . . . to interpret theory as intermediary between practical problem and practical solution."[64]

Dewey seems to have gotten things backward. In craft, ends and means may well require constant mutual vigilance but not necessarily *constant* mutual reevaluation (revision). For both convenience and efficiency of production the habit-reconstruction of craft is discontinuous. Indeed, the whole point of craft is to standardize as much as possible the results of practical inquiry without, of course, overlooking problems of applying such know-how to particular cases nor closing off possible new developments in the know-how itself. Consequently, the craft-role of theory is precisely "as intermediary between practical problem and practical solution,"[65] as amply demonstrated by Husler and Rodd-Marling's researches on the physiology of the singing voice described in chapter 2. In short, Dewey's craft theory of inquiry is a better theory of inquiry in craft.

The continuum of ends and means in craft is thus continual, not continuous as in pure inquiry, with deliberation coming in, as it were, over the head of preestablished rules, routines, and habits both as a guide to application and as a prod to changes in the lore. That, if anything does, marks a significant difference between the master craftsman and the journeyman hack. The former's idea of a schedule of ends and means *is* that of a plan of action revisible under the stress of unforeseen difficulties. In effect, the master knows when to be doubtful — and creative.

6. *The Place of Imagination in Craft*

If a qualified continuum as opposed to a stasis of ends and means allows greater scope for the creative as well as inquisitive aspects of craft, where does imagination come into the picture? Certainly Collingwood makes a great deal of imagination in art, but, except for the origination of plans, excludes it from craft. Dewey, on the other hand, emphasizes the dynamic of ends and means in problem-solving and inquiry generally but nowhere connects it to his views of imagination. But there *is* a connection, especially for a thinker of Dewey's persuasion, and unsurpris-

ingly we find it buried in his discussion of "the human contribu-
tion" to art.66

There he speaks of "intuition" as "that meeting of the old
and new in which the readjustment involved in every form of
consciousness is effected suddenly by means of a quick and
unexpected harmony . . . like a flash of revelation; although in
fact it is prepared for by long and slow incubation."67 This is
very close, if not identical, to the trained Understanding trig-
gered by tips earlier discussed in chapter 3. "Where old and new
jump together, like sparks when the poles are adjusted, there is
intuition."68

There too is imagination, at least as judged by the results
achieved. For what is revealed "is a *way* of seeing and feeling
things as they compose an integral whole. It is the large and
generous blending of interests at the point where the mind comes
in contact with the world. When old and familiar things are made
new in experience, there is imagination."69 At the risk of throw-
ing together terms much too overworked by what Dewey calls
"enthusiastic ignorance,"70 we might say that intuition, as an
adjustment of old and new, and imagination as a revealed way of
seeing things, are the Janus faces of Understanding, as previously
discussed.

Be that as it may, the issue at hand comes down to this:
Until they are enacted, how are means and ends-in-view *held?*
With the possible exceptions of recipes and drill manuals, they
are not simply read off from either tradition or the particular
situation confronting one. Rather, I shall argue, they are held
in imagination as directives (rules and routines) and frequently
revised therein according to the exigencies of the situation. In
effect, it is imagination that enables us to adjust our know-how
to particular cases and even to revise it radically or transfer it
to new realms of application.

Consider, for instance, Scheffler's succinct description of
Dewey's dynamic of ends and means:

> Having chosen a particular end-in-view, or plan, we
> . . . justify subsidiary ends-in-view, i.e., sub-plans,
> as means *relative* to the main end-in-view, when they
> are suitably connected with the latter. But this does
> not imply that the main end-in-view is to be held as
> a dogma [even blueprints contain error tolerances],
> conferring justification but itself beyond the reach of

all rational criticism and review. For the contrasting process is also relevant; that is, we criticize the main end-in-view by reference to the subsidiary ends-in-view that it seems to require.71

The point left out of account here as by Dewey himself is how such ends are *viewed*. There is an explicit distinction in all this between critical foresight and mere preconception or slavish adherence to habit or imposed routine. Either way, such ends are viewed — in imagination. What, in a purely colloquial fashion, I am calling critical foresight adjusts to changing conditions, even to changing goals, and then not only by an adjustment *to* them but *of* them. In short, I want to emphasize imagination not merely as original and inspirational, but as the central element of *control* in an ends-means continuum characteristic of creative craftsmanship.

Certainly not every kind of imagination but that which is useful in execution is what interests here. Accordingly, the remainder of this chapter examines the sorts of imagination, the relevant senses of the term, involved in such tracking to completion of a complex task by a master craftsman or skilled performer.

7. *Using Imagination*

There is another, not necessarily conflicting, opinion on how things get done, whimsically captured in this vignette from a contemporary novel. "Widmerpool . . . strolled to the kerb. A cab seemed to rise out of the earth at that moment. Perhaps all action, even summoning a taxi when none is there, is basically a matter of the will."72 Late-night London provides identical challenges to the will of anyone to create taxis *ex nihilo*. But Widmerpool's summoning of a taxi by sheer act of will is the observer's droll description of how the event appeared to him, he being preoccupied with supporting a drunken third companion. Even then, we know that Widmerpool did not simply back away, clutch his arms to his sides, shut his eyes, and fiercely *wish* for a taxi; rather, he acted with an end-in-view. He strolled to the kerb, saw the taxi first, and, as we say, seized the opportunity by doing something else: "Widmerpool made a curious, pumping movement, using the whole of his arm, as if dragging down the taxi by a rope. It drew up in front of us."73 So now we know that Widmerpool used his imagination as well as his ferocious will to set events in motion, likely before any taxi loomed any-

where, made the necessary adjustments as further events transpired, and got a taxi. A very poised and prescient performance, his.

But what does it mean to use one's imagination in such a deliberate way? Or better yet, what sort of imagination is it that gets so used? Further, what are we to make of the idea of *using* imagination, tool-like, so to speak, to get something done? Obviously, there are two questions here among the many that may be asked about the imagination, but I shall keep the spotlight on these without any pretense of doing justice to the topic generally or to the immense literature on imagination.

Since Ryle, a useful gambit for the sorting of mental verbs like "think," "know," "perceive," "express," including of course "imagine," has been to separate their predicative from their adverbial uses. As Roger Scruton observes in *Art and Imagination,*

> On the one hand, we talk of 'X imagining Y', 'X seeing Y as Z', 'X forming an image of Y', 'X imagining that *p*, what it would be like if *p*' and so on, all of which predicate an activity of X. On the other hand, we talk of X doing something with imagination, or imaginatively, using his imagination in the performance of some task (whether it be fulfilling a practical aim, or acquiring some particular piece of knowledge) — in this sense imagination qualifies a further activity, identified separately. The predicative activities are all mental acts, whereas the activities performed with imagination need not be. This is exactly like thinking: thinking is a mental activity; doing something thoughtfully is often not.[74].

Singing, building, or teaching imaginatively (creatively, with flair, etc.) are mostly nonepisodic qualifications of separately identified activities. And the same holds true for the vast majority of adverbial uses of mental verbs. But whether expressed adverbially or predicatively, the sense relevant here of doing something with imagination, of using imagination in the performance of a task, is definitely episodic — a mental act of imagining Y or seeing Y as Z. So that, in effect, using imagination, say, to hold an end-in-view, straddles the predicative and adverbial uses in falling into the episodic minority of the latter use.

Unlike doing something creatively, using imagination to do

it involves more than a normative qualification, at least in the cases I shall consider. It involves forming an *image* by partial means of which the task is carried out. Again, unlike the non-episodic, adverbial uses of "imagine," there are two things going on at once: the entertaining of an image and the performance itself presumably under some degree of control by the image. One thinks of the singer's "dome of the voice," the dancer's "carving of space," the woodworker's "following the grain," and so on. Merely for convenience, and to single it out from the other varieties of imagination, I shall call this *heuristic imagination*.

What is the range of phenomena covered by heuristic imagination? Such things as "mental rehearsal" and habit formation: going over something "in the mind's eye" before or after actually doing it; control by holding an end-in-view, such as having a vivid aural image of the sound one wishes to produce, or visual image of the shape one wishes to draw; direction by imagery in precept, such as "Imagine yourself as carving, not merely occupying or reaching out in space"; and discrimination of perceptual aspects — everything from Necker cubes and duck-rabbits to feeling the flow of colors one into another in a Titian. The examples are quickly multiplied in every direction.

Already more questions than can possibly be dealt with here rush forward; but let us first address the most perplexing one, at any rate the one that has perplexed recent philosophy most, namely, What is the nature of the mental image? Or what does it mean to see, feel, touch, hear, smell, and do, all, as we say, "in the mind's eye"? Hume's famous answer is that the images of fancy are like perceptions only fainter, lacking the "vivacity or solidity or firmness or steadiness" that engenders belief.[75] If so, then a difference of veracity reduces to a difference of vivacity having obvious troublesome consequences for anyone of vivid imagination, but especially artists. Imagining is not perceiving weakly in the head.

Ryle's by now equally famous reply to Hume and to the aforementioned question is that imagining is not perceiving at all. Not even "picturing" in the mind's eye can be assimilated to picturing on paper or canvas. "Imagining," he says, "is not having shadowy pictures before some shadow-organ called the 'mind's eye'; but having paper pictures before the eyes in one's face is a familiar stimulus to imagining."[76] Ryle is of course not denying that we have images; what he denies is that they are like real

pictures or perceptions: "We do picture or visualize faces and mountains, just as we do, more rarely, 'smell' singed hoofs, but picturing a face or mountain is not having before us a picture of the face or mountain, it is something that having a physical likeness in front of one's nose commonly helps us to do, though we can and often do it without any such promptings."[77]

The central thrust of Ryle's denial that imagining is inwardly perceiving the mental analogues of physical pictures, smells, and the like, is to argue against the quantifiable existence of mental images taken separately from their contents, like so many portraits of a separately identified sitter. When, for instance, I describe my image of a face, it is features of the face that I describe, not features of my mental image. Even should it be an image of Charles II's face based on portraits, still it is features of his face as physically portrayed that I describe and not details of my private, inner portrait. Assuming I have an image of Charles II's face, what sense is there in asking *its* size and coloration separately from his size and coloration or that of his physical portraits? The futility of the question marks the failure of any attempt to introspect the nature of mental imagery apart from its contents and what we do when we imagine.[78]

In other words, there are no facts based on observable properties of mental images as such to be known that would enable us to say what an image is. As Roger Scruton notes, "Mere 'observation' of our images will tell us nothing about them: the only facts about images are facts about the third-person case. . . . If we wish to know what an image is, we must ask, 'What is it about another than enables us to say of him that he has images?' "[79] In a similar vein, Mary Warnock remarks that "the image cannot be treated as an independent object which can be examined on its own, even though the word for it must occur in our accounts of imagining. We may need the noun; but to understand it we have to understand the verb."[80] Hence, if we are to understand heuristic imagination — the role of imagery in controlling skilled performances — it is not a question of what images *are,* their specifiable features, but what they *do,* how they function to control. Notwithstanding the privacy of mental images, their functions may yet turn out to be surprisingly public.

8. *Imagining and Reference*

Let us take the two classic cases: imagining X (forming an image of X) and imagining X as Y (e.g., the voice as a hollow

dome). It might be argued that to imagine X as it is, as we wish it to be, or as something else, while not *depicting* X in shadow-pictures observed by the mind's eye, is nonetheless to *represent* X to ourselves in some way. That is the position Warnock takes: "The images we form are necessarily incomplete, but they are ways of representing for ourselves some of the features of the object of our thought, those features which will identify what we are thinking of. . ."81 — by which she means that "The image *is* our attempt to reach the nonexistent or absent object in our thoughts as we concentrate on this or that aspect of it, its visible appearance, its sound, its smell."82

Now, representation, whatever else it may be, is a form of reference.83 One thing represents another transitively; but in the cases before us reference by what to what? Are we not worse off than before with image-entities-we-know-not-what referring to nonextant fictional or real entities? Not necessarily. A more plausible construction (whether Warnock's is irrelevant) is to construe "image of X" or "thoughts of X" as one-place rather than two-place predicates; as referring to the *kinds* of images and thoughts we are having: sound-images or Pickwick-thoughts rather than images and thoughts denoting the voice and appearance of a nonexistent Pickwick. The ambiguity is in the prepositions "of" and "about" in *saying* what our thoughts (including imagery) are about. On the two-place construction, we are committed to saying what our thoughts taken separately refer to or denote. On the one-place construction, what they are about is what they are. And we can entertain in thought and fancy anything we like.

So in describing what our imaginings, like the rest of our thoughts, are of or about, we may only be describing their contents rather than anything, if anything, to which they refer; still less are we alluding to what mental stuff they are made of. This yields at least the following options: we can imagine X as it is, or as we should wish it to be, or as something else Y, or merely entertain an X-image or X as Y-image without reference to anything "real"; though, obviously, in describing our imaginings we refer *to* all these possibilities. In all but the first instance (imagining X as it is), imagining X as Y and so forth does not entail a belief that X *is* Y or than anything corresponding to X actually exists. So in general, imagination does not entail belief even if we sometimes do believe or believe in (in the sense of try to bring about) what we imagine. The range of exceptions is con-

siderably enlarged, however, if we allow that some cases of imagining X as Y metaphorically (e.g., Churchill as a bulldog) do imply a belief that X *is* metaphorically Y; that is, when the image is referred to a real person or thing. In such instances, to say what our thoughts and imaginings are about is to say what they metaphorically denote or refer to. Briefly, imagination as a species of thought can literally or metaphorically reflect our beliefs about something — notwithstanding the *general* disconnection of imagination from belief (and reference).

That some of our imaginings do refer to reality as we believe it to be poses difficulties for Roger Scruton who ventures that "imagination is esentially thought that is unasserted, while being entertained as 'appropriate' to its subject matter."[84] Admitting the oversimplicity of this formulation and its inability to account for how imagination is "directed at its object,"[85] Scruton proposes two further amendments: (1) that "Imagination involves thought which is unasserted, and hence which goes beyond what is believed," to the extent that, "one cannot imagine X to be as one knows or has good reason to think it to be. In imagination one is engaging in speculation. . ."[86] and (2) that "Imagining is a special case of 'thinking of X as Y' . . . is a rational activity," wherein one "is trying to produce an account of something" that is somehow "appropriate" and therefore exclusive of "mere fantasy or whim."[87]

If Scruton's position appears somewhat legislative, it is because it is too extreme to begin with. In the first place, the logical independence of imagination and belief entails the contingency of belief (that we may or may not believe what we imagine), not that necessarily we cannot believe (or assert) what we imagine. In imagining something we are not *necessarily* engaging in speculative thought without assertion even if such "entertaining" of ideas constitutes the greater part of our imaginative thinking. To imagine the Chairman as an elephant[88] may well be to assert something metaphorically of him. Accordingly, there is no need counterfactually to deny that I can imagine, say, Russell Square as I happen to recollect it or reckon it now to be. Conversely, why should fantasy and whim be excluded from imagination when in fact it is precisely such imaginings that go "unasserted," referring to nothing? Finally, thinking of X as Y (where Y is a metaphoric predicate) is one way of producing a fitting account of something — the *bon mot*, as it were — but it hardly seems necessary to think of X as Y metaphorically to imagine X. Still,

it is unclear whether Scruton is so far commited, though his claim that "one cannot imagine X as one knows or has reason to think it to be" would suggest as much.

It is unclear, because elsewhere[89] he, like Warnock,[90] follows Wittgenstein's hints of a continuum from imagination to perception via the notion of "seeing as" or aspect perception. Roughly, imagining, thinking of X as Y gives over to perceiving X as Y where Y is a recognizable aspect of X. In Wittgenstein's words, "The concept of an aspect is akin to the concept of an image. In other words: the concept 'I am now seeing it as . . .' is akin to 'I am now having *this* image'. Doesn't it take imagination to hear something as a variation on a particular theme? And yet one is perceiving something in so hearing it."[91] This and similar remarks of Wittgenstein gave rise to a controversy, having now ravaged the pages of the philosophical journals nigh on to thirty years, as to whether any sharp distinction can be drawn between seeing, hearing, and seeing, hearing an aspect: whether indeed all perception is not perceiving as . . .Clearly, one can hold out for a continuum from imagination to perception, for sharp boundaries, or for all perception (or just certain modalities) being aspect perception without, as it were, stretching imagination from one end to the other as Wittgenstein appears to do.

In what is perhaps the clearest treatment in print of the vagueness of "seeing as . . ."[92] Scruton holds out for a sharp difference between imagination and perception while allowing a qualified aspect perception. His restrictions on imagination only are at issue here. He says, "What is essential to seeing is the thought (or belief) *that* there is an object (answering to some description). This thought is not subject to the will. . . ." Since imagination is subject to the will in ways that belief is not, that, he thinks, "only serves to confirm that sensory experience is not, as it stands, one of the phenomena of imagination, since it lacks the essential relation to unasserted thought."[93] But, subtract the requirement that imagination must *always* be unasserted; add instead the logical contingency of the relation between imagination and belief, and the argument favors (in the sense of permits) a larger participation of imagination in perception.

Certainly Wittgenstein allows a large role for imagination in aspect perception, which in this context is the crucial kind, whether or not *all* perception should turn out to be of that kind. What is the picture that emerges? Warnock fairly sketches its main

elements: "a kind of continuum in our experience begins to suggest itself, a continuum which runs from (1) envisaging things when they are not there before us, through (2) having a certain vision, and imposing it upon what we *do* have before us (noticing an aspect), to (3) perceiving things in general, and recognizing them as familiar, in the cases when we do indeed know them, or know things like them, of old."94

Warnock omits pure, "unasserted" fancy which would extend the continuum one step further back. All the more reason, then, to underscore the contingency of the relation between imagination and belief as preserving (and illuminating) the continuum from unfettered fancy to fettered perception. Because the episodic character of some imagery and the functional significance of imagination generally are both independent of the ontological status of images, yet another continuum suggests itself as cutting across the four phases of imagination just distinguished. That is the continuum from imagining construed as a psychological event — as a mental experience "in the mind" — to imagining as predicative and metaphoric wherein *the* image comes down to a figure of speech. Either way, or at any intermediate stage between, the question of heuristic imagination is not so much a matter of what or when it is as of how it works to set and control what earlier was described as "rule-guided" behavior. (See chapter 4, section 4.) In short, how, to what ends, is imagination *used?* The outline, at least, of an answer can now be given.

9. *Nonverbal Thinking*

Consider a singer who claims to have some literal or metaphoric (e.g., dome-like) image of the sound he or she desires to produce. What is such talk about? Irrespective of the ontological status of images "in the mind," the description is of a species of nonverbal thinking, in this case a subspecies of imagination closely linked with aspect perception and recognition. One is reminded, for instance, of Black's notion of "phenomenological compression" of separately digested details and routines (see p. 95) en route to practical understanding as discussed in chapter 3. And here again the tests for such enlightenment, however induced, are public demonstrations, not introspected dawnings. This suggests a way of "unwinding" talk about imagery and imagination controlling performance — in effect, accommodating the control factor by translating such talk into reference to how we function.

Generally, to say that we have an accurate image of something is to say that we can respond with a degree of accuracy to certain types of question, test, or stimuli; hence, the degree of fidelity of the image reduces to accuracy of response or other behavioral function. So, for example, my saying that I have a certain image of the sound I wish to produce may be taken as a fanciful, picturesque way of saying that I constitute myself an instrument that says "yes" to some adjustments and "no" to others — that I set myself to "go off" at some point in a certain way. Conversely, I as an instrument have the capacity to respond with some degree of accuracy (plus corrections) to tests as to whether the picture — the image — given to me is a correct and useful one. If a teacher were to suggest that I imagine the voice as issuing from my left kneecap or as echoing within a closed cigar box, there is virtually nothing that I can *do* short of slapstick that would conform to such instructions. Heuristic imagery, like any other metaphor, may fail in a variety of ways: through being misconceived, misdirected, mistimed, or simply misunderstood. Besides one's own responses to imagery, the teacher's repertoire of samples and demonstrations offers the best indication of their meanings for action and, simultaneously, the best defense against misinterpretation or plain nonsense.

Logically, the point of construing such imagery as fanciful descriptions of one's adjustment as an instrument is that it turns the issue around, putting the image forward, as it were, as a standard by which one measures one's responses to particular stimuli. Imagining X or X or Y just *is* the function of setting the standard, while doing X "with imagination" is the function of responding to the image — the effort put out to approximate to the standard thus set forth. The question of images as entities is left behind in favor of the uses of imagery to refer to behavior in terms of the kinds of tests and standards applied and the responses given.

Translating talk of images and doing with imagination as referring to standards and performances by no means resolves the mental status of images or acts of imagination generally. What it does is give us some third-person purchase on what such talk is about in the context of practical knowledge and action.

And certainly not all imagery, heuristic or not, is verbally expressed; which is to say that much of our nonverbal thinking reduces to the use and interpretation of nonlinguistic symbol systems incorporated into what I have broadly called the lang-

uages of craft and skill. Among many things, that includes interpreting properly the patterns of exemplification — the samples ideal and diagnostic of action, of achievement, of "how to" — set before us.

10. *The Psychology of Imagination*
As in philosophy, the psychology of imagination has dwelt mainly on the role of imagination in creative (original) thinking; in thought and perception generally; and on the nature and types of mental imagery.[95] While theories of imagination abound, typologies of imagery reflect common experience and mostly extrapolate from Galton's turn-of-the-century investigations of the varieties of mental imagery.[96] So, for example, a recent study opens with this set of distinctions: "We distinguish, first, visual occurrences such as phosphenes or the phantasms of migraine from *image,* by which we refer to that mental process in which we represent aspects of the world to ourselves in the absence of the imagined object . . . Moreover, the term image has been used in different ways. According to modality one may have visual images or auditory or kinesthetic images. According to kind, one may have memory images, sensory images, eidetic images, and so on."[97]
Gradually, psychologists are abandoning mental-picture theories of imagery in favor of a view, not unlike Warnock's, to the effect that imagery is a way of expressing one's thoughts to oneself and is closely tied to perception and the development of motor and cognitive skills.[98] And, as Kolers observes, "the form of the representation of imagery — pictorial or propositional — has been confused with the means or cognitive processes that operate the imagery . . . a description of the symbol system used to capture imagery should be kept separate from proposals regarding the underlying mechanisms."[99] However, Kolers' notion that "Mental imagery is symbolic activity in that it represents or substitutes for aspects of the perceivable world,"[100] seems unfair to fantasy at one extreme and to aspect perception at the other, wherein imagination is an ingredient of, not a substitute for, perception. As well, the symbolism, if any, is usually of, not by, our imaginal mental contents which in turn may on *some* uses previously discussed serve to abbreviate, encapsulate, or otherwise conceptualize behavioral goals and procedures.
A possible source of confusion here is the fact that many perceptual-imaginal contents associated with the learning of skills

of discrimination and motor action strongly resemble the phenom-
enon of synaesthesia — the evoking of sensations or imagery in
one sensory modality by stimulation in another. A commonly
reported type of synaesthesia is the evocation of visual images
of colored patterns or physical shapes upon hearing music or
perhaps any sound. Besides this visual-auditory variety (where
the second term indicates the primary sensory experience) other
bimodal forms of synaesthesia are tactile-auditory (feeling
sounds), tactile-visual (feeling colors, for instance); even cases
of kinaesthetic-olfactory (motion and smell) and visual-gustatory
(color and taste) have been recorded.101 And Luria reports a
case of multimodal synaethesia in which reading evoked all
the senses coupled with perfect memory.102

Such arousal of one sensory modality by another in itself
implies no conceptual or referential link between the two mo-
dalities and must, therefore, be distinguished from synaesthetic
description.103 Synaesthetic description is a mode of metaphor
wherein descriptions of one sensory modality are given in lang-
uage literally applicable to another. Thus we commonly speak
of wines as tasting "big," "smooth," or "dry"; of colors as "loud,"
"cold," or "warm"; of musical sounds as "light" or dark,"
"crisp" or "shattering"; of pains as "sharp" or "dull," and so
on. Generally, such talk is more common to the domains of taste
and pain than to the domains of vision and hearing where the
available literal vocabularies are larger, notwithstanding the
ubiquity of metaphor in all sensory modalities. Since instances
of pure, idiosyncratic, involuntary synaesthesia are likely to be
expressed in the same intersensory language as synaesthetic
description, confusions can arise. For example, "The sound of
the trumpet feels like cold, shiny porcelain" could be either a
literal simile describing the synaesthesic's tactile imagery, the
feel, of the trumpet's sound; or it could be a metaphoric descrip-
tion of the "feel" of the trumpet's sound intended to elicit a
publicly accessible quality of the sound itself.

In principle, heuristic imagery, so far as it resorts to synaes-
thetic description, is a public vehicle of communication and
control even if one's choice of intersensory metaphors should
turn out to be inappropriate, uninformative, or outrageous. From
that standpoint, the languages of craft and skill, laced as they
are by innumerable cross-modal references, represent specialized
(and in that sense "technical") extensions of common sense
and ordinary language rather than the unique experiences of

extraordinary individuals.

Of especial interest, particularly for the role of imagination in thought generally, is Galton's discovery that some people can visualize with a clarity comparable to perception itself, while others are virtually devoid of sensory imagery of any kind.[104] Aside from lending support to the idea of a continuum from fantasy to perception, rather than a series of closed categories, the fact that some people have limited imaginal capacities suggests constraints on imagery for purposes of communication and instruction. As McKellar remarks, "The importance of Galton's findings can hardly be over-emphasized, and Galton himself stressed the ways in which unacknowledged differences of imagery readily lead to intolerant incredulity. For example, those who lacked visual imagery 'naturally enough supposed that those who affirmed it were romancing.' "[105]

Having said so much in defense of imagery, one must also say that undue rigidity of imagery, however vivid, like an inflexible metaphor or precept, may well interfere with understanding and block the routes of flexible response — becoming, in effect, an *ideé fixe*. Worse yet, certain kinds of imagery, for example, "reaching" for a high note by great muscular contractions in the throat, may serve only to imprint disastrously bad response habits.[106]

Indeed, one is tempted to speculate that overemphasis of either or both the paucity or fixity of imagery in some cases is at least partly responsible for the prevalent view that "pictorial thinking is an earlier and more primitive form of mentation than conceptual thinking — in the evolution of the individual as in that of the species,"[107] and that, therefore, "the 'picture-strip' language of concrete imagery pre-dates conceptualized thought."[108] Whatever the complex relations between nonverbal and verbal thinking, the tendency to equate nonverbal with preconceptual and verbal (linguistic) with conceptual thought is questionable (1) in the assumption that nonlinguistic forms of symbolization are somehow conceptually inferior to linguistic forms (as if a description were inherently a better vehicle of thought and cognition than a portrait or an equation); and (2) in the implication that imagery must always precede conceptualization. Whereas, we have seen that for some purposes imagery or other nonverbal types of thinking are the most effective or appropriate conceptualizations, often painstakingly worked out in the "picture-strip" languages of skill.

Similar assumptions about the low levels of thought and conceptualization required for drill and the mastery of routines afflict philosophical as well as popular notions of practice as the crafty element of artistic process. In the next chapter, I turn to that thorny topic.

REFERENCES

CHAPTER 5

1. Cf. Vincent Tomas, "Creativity in Art," *The Philosophical Review* 68, 1958, pp. 1-15; reprinted in Vincent Tomas, ed., *Creativity in the Arts* (Englewood Cliffs: Prentice-Hall, 1964); citations are to the latter volume.

2. Collingwood, *The Principles of Art,* p. 128.

3. Ibid., p. 129.

4. Tomas, op. cit., p. 100.

5. Osborne's suggestion that traditional craftsmen could "initiate modifications and innovations" comes close to being an exception. See his "The Aesthetic Concept of Craftsmanship," p. 144.

6. Monroe C. Beardsley, "On the Creation of Art," *Journal of Aesthetics and Art Criticism* 23, 1965, pp. 291-394; reprinted in L. A. Jacobus, ed., *Aesthetics and the Arts* (New York: McGraw-Hill, 1968); citations are to the latter volume.

7. Collingwood, op. cit., p. 128.

8. Jeffrey Maitland, "Creativity," *Journal of Aesthetics and Art Criticism* 34, 1976, p. 397.

9. Collingwood, op. cit., p. 117.

10. Beardsley, op. cit., p. 58.

11. First ascribed to Absurdides of Ionia (fl. 350 B.C.) who, because he was unable to articulate the theory, declared the theory itself unforeseen and creative.

12. Tomas, op. cit., p. 108.

13. Maitland, op. cit., p. 399.

14. J. Glickman, "On Creating," in H. E. Kiefer and M. K. Muntiz, eds., *Perspectives in Education, Religion, and the Arts* (Albany: SUNY Press, 1970), p. 265.

15. W. E. Kennick, "Creative Acts," ibid., p. 247.

16. Ibid., p. 256. Cf. H. Osborne, "The Concept of Creativity in Art," *The British Journal of Aesthetics* 19, 1979, pp. 224-231.

17. Kennick, op. cit., p. 247.

18. Ibid., p. 257.

19. Something Glickman denies outright; see op. cit., p. 265.

20. Maitland, op. cit., p. 401.

21. John Dewey, *Art as Experience* (New York: Putnam, 1958), p. 144.

22. Ibid., italics mine.

23. D. W. Ecker, "The Artistic Process as Qualitative Problem Solving," *Journal of Aesthetics and Art Criticism* 21, 1963, p. 285.

24. Ibid.

25. Cf. Beardsley, op. cit., pp. 59-61.

26. Dewey, op. cit., pp. 48, 50.

27. Ibid., p. 51.

28. Maitland, op. cit., p. 403.

29. Ibid., p. 402.

30. Ibid., p. 403.

31. Ibid., p. 408.

32. On the distinction between autographic and allographic arts, see Goodman, *Languages of Art,* pp. 112-115.

33. See V. A. Howard, "The Convertibility of Symbols: A Reply to Goodman's Critics," *The British Journal of Aesthetics* 15, 1975, pp. 207-216.

34. See chapter 1, section 3 above.

35. Cf. p. 21 above.

36. A. H. Maslow, "Creativity in Self-Actualizing People," in A. Rothenberg and C. R. Hausman, eds., *The Creativity Question* (Durham: Duke University Press, 1976), p. 87.

37. Arthur Koestler, *The Act of Creation* (London: Pan Books, 1975), p. 264.

38. Margaret Gilchrist, *The Psychology of Creativity* (Melbourne: Melbourne University Press, 1972), p. 25.

39. Ibid., p. 62.

40. Quoted in Gilchrist, ibid., p. 61.

41. Ibid., p. 53.

42. Ibid., p. 59.

43. The phrase is Morris Weitz's in his "Research on the Arts and in Aesthetics: Some Pitfalls, Some Possibilities," in S. S. Madeja, ed., *Arts and Aesthetics: An Agenda for the Future* (St. Louis: CEMREL, 1977), p. 226.

44. Collingwood, op. cit., p. 133.

45. Ibid., p. 132.

46. John Dewey, *Theory of Valuation* (Chicago: University of Chicago Press, 1972), originally published in 1939, p. 47.

47. Ibid., p. 45.

48. Ibid.

49. Ibid., p. 44.

50. Ibid.

51. Ibid.

52. See p. 5 above.

53. Dewey, *Theory of Valuation*, p. 43.

54. Ibid., p. 46.

55. Ibid., p. 47.

56. Ibid.

57. John Dewey, *Human Nature and Conduct: An Introduction to Social Psychology* (New York: Modern Library, 1930), p. 63.

58. Ibid., p. 192.

59. Ibid., p. 196.

60. Israel Scheffler, *Four Pragmatists* (London: Routledge & Kegan Paul, 1974), p. 225.

61. Ibid., p. 226.

62. Ibid., p. 236.

63. Ibid., p. 237.

64. Ibid., p. 251.

65. Ibid.

66. Dewey, *Art as Experience,* pp. 245-271.

67. Ibid., p. 266.

68. Ibid.

69. Ibid., p. 267.

70. Ibid.

71. Scheffler, op. cit., p. 230.

72. Anthony Powell, *The Acceptance World* (Glasgow: Fontana Books, 1955), pp. 212-213.

73. Ibid., p. 213.

74. Roger Scruton, *Art and Imagination* (London: Methuen, 1974), p. 93.

75. David Hume, *Treatise of Human Nature,* ed. L. A. Selby-Bigge (Oxford: Oxford University Press, 1888), p. 628.

76. Ryle, *The Concept of Mind,* p. 254.

77. Ibid., pp. 254-255.

78. Cf. Mary Warnock on Sartre in her *Imagination* (Berkeley: University of California Press, 1978), pp. 161-166.

79. Scruton, op. cit., p. 94.

80. Warnock, op. cit., p. 172.

81. Ibid., p. 173.

82. Ibid.

83. See Goodman, *Languages of Art,* pp. 42-43.

84. Scruton, op. cit., p. 91.

85. Ibid.

86. Ibid., pp. 97-98.

87. Ibid., p. 98.

88. The example is Scruton's, ibid., p. 90.

89. Ibid., pp. 114-115.

90. Warnock, op. cit., pp. 190-193.

91. Wittgenstein, *Philosophical Investigations,* p. 213.

92. Scruton, op. cit., pp. 115-120; see also Norwood Russell Hanson, *Perception and Discovery* (San Francisco: Freeman, Cooper, and Co., 1969), ch. 6.

93. Scruton, op. cit., p. 115.

94. Warnock, op. cit., p. 193.

95. See especially Peter McKellar, *Imagination and Thinking, A Psychological Analysis* (London: Cohen and West, 1957).

96. Thoroughly surveyed by McKellar, ibid., ch. II.

97. Paul A. Kolers and William E. Smythe, "Images, Symbols, and Skills," *Canadian Journal of Psychology* 33, 1979, p. 159.

98. Ibid., p. 181.

99. Ibid., p. 179.

100. Ibid., p. 172.

101. McKellar, op. cit., p. 62.

102. A. R. Luria, *The Mind of a Mnemonist,* tr. Lynn Solotaroff (New York: Basic Books, 1968) pp. 21-38.

103. Cf. McKellar, op. cit., p. 64.

104. Ibid., p. 21.

105. Quoted by McKellar, ibid.

106. On the role of mental imagery in athletics, especially gymnastics, see Michael J. Mahoney and Marshall Avener, "Psychology of the Elite Athlete: An Exploratory Study," *Cognitive Therapy and Research,* vol. 1, no. 2, 1977, pp. 135-141; in a more popular vein, see W. Timothy Gallwey's *Inner Tennis, Playing the Game* (New York: Random House, 1976).

107. Koestler, *The Act of Creation,* p. 322; see also p. 173.

108. Ibid., p. 343.

GARFIELD

6 *Practice and the Vision of Mastery*

1. *Paradoxes of Practice*

Nearly anyone who takes the trouble to look into this book can recollect labors of love or loathing at the keyboard, at the drawing board, in the exercise studio, or on the playing field. The sheer drudgery of it all as measured against the evolving vision of perfect mastery is perhaps one of the most daunting, humbling experiences known to us. Long periods of Sisyphean despair punctuated at intervals by the elation of small accomplishments, the wagering of one's talents against the odds of perfection, the feeling that pain and failure are one's only reliable companions, such are the moods of ambition when subjected to a hard discipline. The pathos of the quest for mastery is amusingly captured in baritone Louis Quilico's mock prayer: "Dear God, you gave me a voice, I didn't ask for it. So help me!"[1] At the opposite extreme, one imagines another version: "Dear God, I asked for a voice, you didn't give it to me. So help me to practice!" Whatever the speed of learning or the proportion of one's "gifts," the fact of practice — the necessity of honing one's talent — remains.

As used herein, both the verb "to practice" and the noun "practice" refer to those repeatable patterns of thought and behavior considered essential to the development of various artistic skills. Practice thus encompasses everything from finger drills to dress rehearsals, while artistic skills are distinguished less by anything inherently "aesthetic" about them as by their frequent or occasional use to produce works of art. Joinery and masonry as well as the more obvious examples of speech and writing may qualify under appropriate circumstances as artistic skills, along with the ability to execute a proper *plié* or musical phrase. Accordingly, mention of *artistic* practice or skills is intended more to underscore a point of view — that of the arts — on practice and skills than to suggest that they constitute a unique or exclusive category.

So much is relatively straightforward, but there are several paradoxes in our common views of practice as an aspect of artistic process. For example: that practice makes perfect versus practice is no substitute for talent; that practice is mindless drill

versus practice requires concentration; that practice aims at doing things without thinking versus practice aims to refine critical judgment; that practice is sheer repetition versus practice is never the same from one trial to the next; that practice builds reflexive habits versus practice builds knowledge. Surely practice is, and does, all these seemingly incompatible things. The aim of this chapter is to show how that is so. Again, as in the case of creativity, disagreement is not so much over the facts about practice as over how they can be coherently interpreted in a general view of the nature and functions of practice within the context of artistic process.

Accordingly, I shall begin by examining certain popular misconceptions of practice, including the idea of repetition, with an eye toward clarifying the use of exercises and routines in artistic problem-solving. Following this initial ground clearing, the rest of the book undertakes three tasks: to analyze the crucial roles of critical judgment and self-scrutiny in the deliberate drill and routinizing of special facilities; to sketch out a rudimentary taxonomy of skills, facilities, habits, competencies, and attainments developed or required by practice in one or another of its phases; and, last, in the postscript, to place epistemological and experimental approaches to practice in reciprocal perspective. Throughout, the objective is to relate hard-won procedural insight to scientific conceptions of practice within a broad philosophical overview.

2. *The Work of Artists: Two Conceptions*

Behind most popular accounts of artistic process are two classic views to which may be given classical names. The one I call the Athena Theory[2] emphasizes the artist's spontaneous inspiration, imagination, or creativity against the background of a deliberately acquired experience. As the saying goes, one must "live" before one can create, or similar advice to that effect. A view somewhat contrary to the Athena Theory, labeled the Penelope Theory,[3] stresses more the honed skills and abilities required to produce mature works of art summed up in the maxim, Practice makes perfect. In light of the earlier discussion of the Creativity Paradox (chapter 5, section 1), the Athena Theory of artistic process appears as the natural corollary of the Unforeseen Theory of Creativity, and the Penelope Theory the corollary of the artist's quest for prescient control over the ends and means of production. What are the practical implications?

On the Athena Theory, the inspiration for complex works of art is supposed to spring to the artist's mind in one or more flashes of archetypal intuition. The artist is pictured as preparing for such *sui generis* moments by accumulating relevant experiences, by "steeping" himself in his subject matter, living in different settings, developing depths of feeling and perception, and so on. Under the direction of the holistic vision of his aesthetic demon, such experiences may be transformed into art. What is more, the artist accomplishes all this without ever quite knowing what he is doing. "For a poet is a light and winged thing, and holy, and never able to compose until he has become inspired, and is beside himself, and reason is no longer in him."[4] With those words from the *Ion,* Plato went so far as to make irrationality a necessary condition of artistic creation. By separating the sagacity of handicraft from the inspiration of art, Plato forged the familiar three-way link between creation, inspiration, and unreason characteristic of the Athena Theory.

Another consequence of heavy stress on Grace-like inspiration is that credit for an achievement is meted out in proportion to the inscrutability of the means employed. The steps leading up to the accomplishment in question may even be hidden or disguised in order to increase wonderment. As Aschenbach, the protagonist of *Death in Venice,* remarks, "It is better for people to know only the beautiful product as finished, and not in its conception, its condition of origin. For knowledge of the sources from which the artist derives his inspiration would often confuse and alienate, and in this way detract from the effects of his mastery."[5] Just as realistic painting may be reduced to seeing with an "innocent eye,"[6] artistic skill may be reduced in theory or by propriety to creating with an innocent mind.

Unlike the Athena Theory, the Penelope Theory is less inherited from aesthetic doctrine than distilled from work experience. It depicts the artist as a kind of devoted weaver of works, doggedly repeating the same sequence of motor acts, bits and pieces of works, or whole performances until they "come out right." Getting things right may refer either to the artist's particular facilities such as his handling of a brush, bow, or metaphor, or to his final achievements in a finished painting, performance, or novel. The theory chiefly concerns the skills and abilities of the artist as measured by the merit of his accomplishments. Thus, a Penelopean interpretation of "practice makes perfect" would be something like "technique makes the artist,"

where technique is construed as voluntary control over those parts of one's body involved in making a work of art; or, what amounts to the same thing, as manipulative (some would say expressive) facility in certain media.

More often than not, technique is related to practice by mechanical-causal analogy as being automatic, cue-determined action induced by serial repetition until, in the telling phrase, one can "do it without thinking." As a principle of education, for example, William James lent his support to the efficacy of thoughtless habit, first in *The Principles of Psychology* and later in his *Talks to Teachers* when he said, "The great thing . . . in all education is to make our nervous system our ally instead of our enemy. . . . The more of the details of our daily life we can hand over to the effortless custody of automatism, the more our higher powers of mind will be set free for their own proper work."7 The suggestion is that the "higher powers" of intelligence and creativity, being spontaneous and original, have little to do with the habits and routines built up by practice; that, instead, the higher powers come into play only after the lower ones have been thoroughly stamped in. It is not unusual, therefore, to find the Athena and Penelope theories combined in a total view of the artist as a kind of inspired media mechanic extrapolating in rote fashion upon the mysteriously given kernel of a new idea.

Taken as descriptions of individual experiences or achievements, there is much that is true in both accounts of artistic process, but much that is false and misleading as well. An underlying fallacy is synecdoche, in this instance the identification of one or another aspect or stage of a complex process with the whole. Beyond that is the reifying in explanation of such overworked notions as inspiration, intuition, creativity, and imagination which themselves require explanation. And, finally, there is a normative leap from the "is" to the "ought" of practice, from mere repetition to "getting it right" that similarly goes unaccounted for. Thus, taken separately or together, such views as the aforementioned encourage a popular conception of the artist as exploiting or expressing his "experience" by a sort of mindless competence enhanced, if not acquired, by sheer repetitive drill.

3. *What Practice Is*

Ordinarily, to practice an action involves repeating it, although we often repeat actions such as tapping a foot or finger

in ways that could hardly be described as practicing them. As an element of practice, repetition is guided by such specific aims as solving various sorts of problems, enhancing native abilities, and building or improving acquired skills. Moreover, to practice an action is not only to repeat it with an end in view but to repeat it in accord with some developmental criteria of performance; that is, criteria that enable us to judge the stages of successive approximation to mastery of that activity. Such criteria may be as specific as the elimination of note errors in a scale run or as recondite and pervasive as capturing the proper expressive mood of an entire symphony or play.

Besides aims and criteria of improvement, another cognitive feature of practice needs be heavily underscored. That is the fact that even effective practice, which is to say by some standard "successful" practice, is fraught with setbacks and failures, some instructive some not, which figure as positive or negative reinforcement regarding how and what to practice.[8] In other words, what the psychologists call "aversive controls" (for instance, pain or fatigue) are as crucial to consider as positive controls of practice behavior. Certainly, learning from one's mistakes and learning to cope with the frustration that so frequently accompanies them are of central importance to learning how to practice.

What emerges from this stress on the intersection of teleological, evaluative, and cognitive (including aversive and emotional) features of practice is a rather more complicated picture than that afforded by either of the views previously considered. The following sections attempt to fill in a few of the details, without prejudice to the ever elusive "higher powers" of exceptional artists, or, for that matter, scientists, athletes, or artisans. Having sketched in outline what practice is, we are in better position to examine what it cannot be — though it is often treated as being — *mere* repetition.

4. *What Practice Is Not*

Many confusions engulf the notion of practice, none more perplexing than those relating to the nature and role in it of repetition, of repeating the "same thing" over and over. As already noted, one popular view is that practice is essentially repetition of exercises until somehow the performer "gets it right" and can "do it without thinking." But "getting it right" implies an *achievement threshold* — performing up to some pre-

conceived standard — while "doing it without thinking" sug-
gests *routinization* which in turn requires at least a modicum of
critical judgment at some stage along the way.

Thus while it is common to speak of practice as if it were
merely repetition, clearly more than that is presupposed. Neither
achievement thresholds nor deliberate routinization are character-
istic of mere repetitive behavior such as nervous gestures, a
peculiar gait, peristaltic movements, or a speech stammer. None
of these serve any chosen aim and would hardly qualify as skills.
Digestion and stuttering are not competencies in the usual sense
of the term, and the former is not even a habit, whereas the pur-
posive repetition of practice has much to do with competencies
and the cultivation or elimination of certain habits.

Given that practice is purposeful, the characterization of prac-
tice as mere repetition is further misleading in suggesting both
that practice reduces to drill, and, where drill is involved, that it
amounts to heedless routine from the very beginning. One need
only to contemplate the spectacle of military recruits awkwardly
standing to arms for the first time to realize that "mere repeti-
tion" is an inadequate description of drill. Indeed, routine tasks
properly executed may require as much deliberate attention as
novel ones that more obviously draw upon the full measure of
an individual's awareness.

Consider, for example, the practice of advanced musical per-
formers. Rarely is their practice repetition as a whole, for seldom
is a piece repeated in its entirety again and again. Rather,
troublesome passages are excerpted for special attention and may
undergo considerable change in rhythm, dynamics, or expression
while the performer concentrates on the aspect that is causing
difficulty. Rather than mechanically duplicating a passage, one
strives for particular goals, say, of fluency, contrast, or balance.
Successive repeats reflect a drive toward such goals rather than
passive absorption of a sequence of motor acts. To be sure,
routinizing certain of those acts, for example, manual dexterity
at the keyboard, may be required for higher levels of mastery.
But that only shows that routinization is among the goals or
achievements of practice, unlike repetition which is one of the
means or procedures of practice. Finally, as problems are solved,
errors eliminated, and difficulties diminished, the dissected pas-
sages are reinserted in the original piece and previously ignored
dimensions are restored for a run-through — all of which requires
vigilance at every stage. Where vigilance may succeed without

repetition (not everybody needs so much of it), repetition without vigilance is blind.

If it is somewhat clearer what besides repetition is involved in practice, its role as a procedure of practice remains vague. Some light is shed on that role by distinguishing what I shall call intrinsic from extrinsic achievements (or aims) of practice. When practice is *of* a performance or parts of it, as in the preceding example, performing up to standard and with relative ease are intrinsic achievements of non-rote ways of repeating an action. Accomplishing something by practice in this sense is more like throwing smoothly or quickly than throwing and hitting a target. The success or failure is in the manner of the performance, not in any separate result or effect of the performance.[9] In contrast, if a performance is improved by entirely separate (e.g., strength or facility-building) exercises directed at particular aspects of the performance but abstracted and simplified, this is then an extrinsic achievement. The distinction is of course relative to how the behavior in question is to be evaluated — in terms of how it is done, or in terms of its proximate effects.

Now among the cognitive aims of practice is knowledge not only *that* one has succeeded or failed to perform up to a given standard, but *why* — what earlier I called Type D know-how. The idea is to discover what works or what went wrong, to be able to account for either result of one's efforts. Even where separate artifacts like a score, sketch, or sculpture can be examined at leisure for the levels of skill they reveal, further scrutiny of the facilities involved, such as the use of a notation or handling of charcoal or a chisel, may yield important insights into the causes of one's success or failure. In other words, development or improvement is gauged not only by the results achieved, as in a standard test situation, but by how they are gotten, by the techniques one has acquired and the manner of their execution. A successful "accident" is not enough; it is a question of whether one can do it again. And that is often a matter of manner.

Development as gauged and directed through repeated trials is a primary concern of education not only in the arts, of course. In teaching, a clear conception of practice and what is to be accomplished by it is therefore more to the point of the novice's concerns than the teacher's possession or full comprehension of mastery except as the latter show the direction that practice ultimately should take. As earlier observed, ultimate ends and

ideals tend to emerge in individual experience, in the growth of skill, through realizing particular ends-in-view. That way *the* ideal may become *my* ideal as contrasted with a distant, extrinsic standard. The suggestion is that the common tendency of testing performance solely by the extrinsic aims of practice (reinforced by the natural emphasis upon finished work or presentations) is at least partly to blame for the Penelopean notion of practice as mostly rote drill culminating as if by chance in some later accomplishment.

5. *The Ambiguity of Repetition*

A further suggestion of the foregoing discussion is that the concept of practice is less vague than it is ambiguous. Scheffler, for one, notices the ambiguity between rote and critically repeated trials.[10] An even more basic ambiguity is in the notion of a repeated trial, or, as we more commonly say, "doing the same thing over again." Simply to say that someone repeats something when practicing is as ambiguous as saying that the successive trials are similar without specifying in what respects they are similar. Indeed, the ambiguity of repetition derives from that of similarity.

The reason is easy to see. Any two actions (or innumerable things in the universe) are similar in *some* respects, so that any action could be the "same" as or a repeat of any other.[11] Whether and in what respects a given action repeats another depends as much upon the perspective from which we observe and describe it as upon the inherent nature of the action. In experimental situations, the task is explicitly limited and specified — sending and receiving telegraphic code, perhaps, or running a maze, or matching pitches in a sequence of sounds. What we call the "variables" of an experiment specify the relevant similarities. Something like a specification of variables occurs in practice situations though with far greater fluidity of description and far less concern for the logical interconnectedness of concepts. Thus, while it is commonplace to speak of the artist as "experimenting" in practice, the emphasis on actions and results, variously captured in metaphor and jargon, heavily outweighs categorical consistency.

Some indication of what is to be repeated — for example, pitches, dynamics, rhythm, or resonance — is normally supplied. But the specifications can be highly variable: more than one task may have the same purpose, and one task may serve

multiple purposes. Consequently, what one may be explicitly described as doing or instructed to do will not always correspond to what one is implicitly expected or thought to be doing. For example, to say that a pianist is working on finger exercise *A* is not to say (though it may well be understood) that he is striving for fluency of execution. Conversely, to say the latter is not necessarily to imply that his purpose need be served by exercise *A*. He may actually perform a number of different exercises and still be described as "doing the same thing"; or he may repeat the same exercise as identified, say, by a score while doing quite different things. This helps to pinpoint the question of the relation of similarity to repetition in practice.

There are many circumstances in which we should say that action *B* is similar to action *A* but not a replica or repeat of *A*. Betting on a horse is similar to but not the same as investing in stock. Or is it? The answer depends upon how one chooses to describe the two actions. A compulsive gambler, for instance, might well be described as behaving the same in both cases, namely, as taking a risk, making a wager, or satisfying a compulsion. Even then, there are many ways of accurately characterizing the "same" aim or action.

Given this variability of description, how may an action pass from being "different" to being "similar" to being the "same"? Obviously we would deny that *A* and *B* are replicas where they are taken to be dissimilar in certain crucial respects. But which ones are crucial? As said, there are many cases where one would deny that they are replicas even though they are similar in *some* ways. Similarity in some respects is at least a necessary condition of repetition, but repetition (in the sense of replication) further requires that some selection of those respects be *sufficient* to identify *B* as an action replica of *A* — that some shared property or properties serve as *criteria* for replicahood. Short of that, *A* and *B* are merely "similar."

The selection of criterial properties will vary with the context and the generality of the description. The example above of the gambler illustrates the change from insufficiency to sufficiency with the shift from a lower to a higher level of descriptive generality and from particular actions to their aims. More simply put, specifically different actions may be generically the same and vice-versa. Therefore, to say that *B* is similar to *A* though not a repeat of *A* amounts to a denial of the sufficiency of the labels common to *A* and *B* for sameness under a given description.

Criteria for sameness may also vary with one's concerns or the accuracy of one's descriptions. So it is quite possible to disagree over sameness — whether the criteria are applicable in this or that instance — as over anything else. At least this much, and likely more, is entailed by saying that whether one action can be taken to repeat another largely depends upon the perspective from which the actions in question are observed and described.

Previously it was noted that tasks and their purposes can be variously correlated and described. It also makes a difference to what counts as behavior replicas (trials) in practice, whether the behavior in question is identified by the task to be performed (e.g., running a C major scale) or by one or other of the purposes served by that task (e.g., improving manual dexterity). Even where a notation is available, as in dance or music, exercises may be identified in either of these alternative ways as well. In such cases, sameness of behavior can vary with perspective as delimited by a notation, by the tasks or achievements involved, or by shifts in the level of specificity or generality within all three. Since any of these viewpoints can yield true descriptions of what is being repeated in practice, the selection of one over another is a matter of knowledge, interests, and precision required. Thus an artist practicing may actually repeat himself in several ways though he be said or instructed to repeat himself in only one way. In summary, there are as many ways of repeating oneself in practice as there are ways of taking account of what one does, or tries to do, in practicing.

6. *Retrospect*

Before turning to certain details of the epistemology and psychology of practice, a review of the main points may help to locate the sources of common perplexities and confusions about practice. Working backward from the order of presentation: first, as perspective influences the identification of tasks, so, conversely, particular identifications shape the perspective one takes on what is going on in practice. Second, not only can different tasks have the same purpose and the same task different purposes, but, third, the connections between them are always contingent, not necessary or "automatic" after the fashion of the Penelope Theory. Rather, and fourth, practice presupposes at least a modicum of attention to tasks and their goals plus recognition of failures without which corrections are impossible to make. That modicum of attention becomes a maximum where

novel or complicated tasks and subtle improvement criteria are involved, however routinized such performances eventually may become. Finally, the critical judgment required for practice is calibrated to particular ends-in-view which, when put together, constitute a kind of interior portrait of the overall task or performance. In such manner, one builds up what I have chosen to call the vision of mastery out of the organized bits of one's own experience as well as the exemplars and models publicly available. In short, *it* becomes *mine*.

It is noteworthy too, that although prescribed exercises are usually *identified* by the sorts of tasks they constitute, they are *selected* according to what can be achieved by doing them — by the contribution they are likely to make to the development of special skills and problem-solving straetgies. This is not always clear to the novice to whom exercises may appear as overwhelming *pre*-occupations, detached and only remotely related to their ultimate goals. Such detachment, as Dewey observes, tends to take two forms: drudgery or footless fantasy. "Wherever, for example, there is sheer drudgery, there is separation of the required and necessary means from both the end-in-view and the end attained. Wherever, on the other side, there is a so-called 'ideal' which is utopian and a matter of fantasy, the same separation occurs, now from the side of the so-called *end*."12 Little can be gained from means without ends or dreams without means.

On this point, many psychological studies demonstrate that informed intervention and knowledge of aftereffects of an action being practiced have a significant influence on its future performance.13 This has consequences not only for the critical performance of stereotyped tasks (of the kind laid out in the exercise books) but for the equally important business of learning how to select exercises and to construct new ones according to a wide range of demands. Failure at any stage to comprehend how practice conduces by degrees to chosen achievements or, conversely, what those achievements require in the way of preparation leads either to drudgery or to empty wishes.

Given that means and ends are properly connected up, it is equally important to know *how well* one is doing. Accordingly, a crucial aspect of practice in any area is cultivation of the secondary skills of self-observation (and self-criticism). (See section 7 below.) A precondition of these skills is having an answer to the question, Why am I doing this? A fully detailed answer is seldom the result of a single inspired effort. It is more likely to

emerge gradually after careful pursuit, often with the help of others, and as the product of extended toil.

The foregoing remarks underscore the dependency of any analysis of training and practice upon our common stock of mental concepts as well as the established lore, where it exists, peculiar to different arts, crafts, or skills. By the same token, we are forewarned that a melange of conflicting precepts and techniques, the inscrutable successes of a talented few, not to mention the cross-currents of tradition and common sense, will not of themselves yield up an orderly overview. In such confusing terrain as this we need constantly to remind ourselves of the whence and whither of our inquiries.

How do our commonplace ideas and observations of habits, facilities, judgment, awareness, routinization, competency, and mastery fit together? That is, what are the ranges and relations among these concepts as commonly used? And how do the discoveries and distinctions of the psychology of skill map onto this landscape, if at all? These are the focal questions for the remainder of this chapter, however unlikely it is that such brief treatment of them will satisfy anyone. Still, looking back over the ground already covered, an outline of practical knowledge is discernable within which can be fitted the bits and pieces of applied know-how and experimental findings. A useful conceit is to regard informed accounts of skills given in the vernacular (such as the singer's "language of the ear") as reflecting the outcomes of vast, natural trial-and-error experiments guided by highly refined practical objectives.

In pursuit of the aforementioned queries, and, simultaneously, to fill in crucial missing details in the outline of practical knowledge, I will undertake just two further tasks: a strategic distinction between types of awareness involved in the control and routinization of skilled actions (in sections 7 and 8); and, in the remaining sections, a conceptual topology of our ordinary skill concepts — habits, facilities, competency, and the like — with critical comments on the psychology of skill.

7. *Awareness and Routines*

One objective of practice is to become more aware of what one is doing. Another is to become less aware in the sense of handing over many details to what James called "the effortless custody of automatism."[14] Novices at the dance, for instance, are enjoined to be "aware" of their bodies and in the same breath to "routin-

ize" their movements. Some things we say are done "without conscious awareness" or "with unconscious awareness," the latter phrase having on the face of it the aura of self-contradiction. But of course we are not contradicting ourselves; but neither are we observing two quite separate senses of the same term (such as "sense" or "cape"). Rather, the ordinary uses of "aware" or "awareness" mingle our intuitions somewhat awkwardly. For instance, what are we to say of the driver who because of some distraction claims to have been unaware of the series of curves in the road that he has just negotiated? Was he or wasn't he?

A number of writers on knowledge and perception have stressed the "tacit dimension" as Polanyi calls it, the "fact that we can know more than we can tell."[15] And psychologists have long been fascinated by the phenomena of "subliminal perception,"[16] including our ability to respond to sensuous cues far below the thresholds of normal acuity. My very limited objective here is not more knowledge of such phenomena but a distinction applicable to the ordinary differences we already recognize, if sometimes confusedly.

The most sustained philosophical effort along these lines in recent years is by D. C. Dennett[17] who examines such commonplace instances of skilled action without awareness, as that of the distracted driver. He notes that "Awareness sometimes seems to be a necessary condition for the successful direction of behavior, and yet in another sense awareness is clearly detachable from behavior (there are some limits on just how much of what one is doing one can be aware of)."[18] Recognition of the detachability of awareness both alleviates the conflicting uses of the term and leads on to a useful distinction.

> When we say of the driver that he must have been aware of the curves under some description we are relying on the former [attached] sense of 'aware', and when the driver replies that he was conversing or daydreaming and unaware of the curves he is relying on the latter [detached] sense, and the crucial point is that we and the driver can be right at the same time. These two notions of awareness are entirely distinct in spite of their customary merger; what one can report directly, infallibly, and without speculation or inference is one thing, and what serves, or is relied upon, to direct behavioral responses is another.[19]

Dennett calls these awareness$_1$ and awareness$_2$ respectively. To simplify and somewhat modify his definitions: A is aware$_1$ that p[20] at time t if and only if A can state (or otherwise symbolize[21]) a perceptual report to the effect that p at time t. Dennett's example is "I am aware that there is an apple on the table," the principal clause of which could, of course, be either true or false; that is to say, the definition covers hallucinatory as well as real apples. A is aware$_2$ that p at time t if and only if p is the content of an event internal to A at time t that is effective in directing current behavior even though A is unable himself to describe that content. Such contents might manifest themselves in a variety of subliminal cues and stimuli subject to experimental tests.[22] Thus the daydreaming driver is unaware$_1$ of the curves though clearly aware$_2$ of them.

A limitation on the distinction just drawn is that is applies principally to symbol-using animals: a dog staring hungrily at a bone could only be said to be aware$_2$, not aware$_1$, of it *as* a bone inasmuch as the latter meaning depends upon capacities for symbolization not possessed by the dog. A theoretical consequence of some practical importance is that the connection between attention or concentration and awareness$_1$ is contingent for both humans and animals.[23] This allows for paying attention without articulation, as in Wittgenstein's examples of "expert judgment" (or my "Understanding") based on imponderable evidence (see chapter 3, section 2 above). Not all of our heeding is articulate or first-person recountable. As well, the contingency of the connection between attention and awareness$_1$ enables us to acknowledge the dog's attending to the bone without thereby suggesting that the dog is aware of the bone in just the way we are.

In experimental or everyday circumstances, for humans as for animals, the tests of awareness$_2$ are largely behavioral; that is, a matter of what one does in response to stimuli known or suspected to be present. This leaves open the internal character of one's inarticulate heeding of things, including whatever degrees of consciousness or other mental mechanisms may be involved. In keeping with our earlier discussion of the languages of craft, the articulation of one's awareness$_1$ may take a variety of symbolic forms, not just *statable* versions. That possibility is built into my revision of Dennett's definition of awareness$_1$ and departs from philosophic orthodoxy in providing for other than

verbal versions of current consciousness. To mark that differ-
ence, I shall use the terms "articulate" and "inarticulate" aware-
ness as well as Dennett's awareness$_1$ or $_2$ wherein the latter shall
be understood to carry the broader meanings (and implications)
of the former set of terms.

The distinction between articulate and inarticulate awareness is
a strategic attempt to distill from everyday notions of awareness
just those aspects having to do with current consciousness and
behavior control. Yet another extract of awareness refers to what
is *known* independently of current consciousness or behavior.[42]
As a partial synonym of "know," to be aware (of the fact) that
Bruckner composed nine symphonies implies that it is true that
he did. Such awareness is subject to truth conditions that are
independent of present consciousness or behavior. Certainly one
might be aware of something in all three ways: that it is three
o'clock, be able to say or perhaps point to a clock, and rush
off to an appointment. In the present context, however, such
evidential awareness is less directly germane since it concerns
an individual's propositional knowledge about something as
contrasted with his current awareness of, say, aspects of a
skilled performance.

Articulate and inarticulate awareness extend at right angles,
so to speak, over the full range of skill and know-how, including
Understanding, but only when they are actually being exercised.
The qualification is necessary since one could be said to know
how to drive when not actually driving and quite devoid of
awareness$_1$ of anything to do with driving. Thus the appropriate
awareness is restricted to acts of driving, which is to say,
to particular bits of driving know-how as manifested on the
road.[25]

Armed with this distinction, it is now possible to give a
relatively straightforward characterization of the routinization of
some facility or other by practice. Regarding what one knows
how to do, one may be aware$_1$ of something p that influences
current action; *become* aware$_1$ of p by paying articulate atten-
tion to what one is doing; or simply be aware$_2$ (without articulate
attention) sufficiently to direct the action. Routinization is thus
a matter of *ceasing* to be aware$_1$ (or becoming aware$_2$) of a
relevant slice of know-how in the act of performing it.

However crude, the distinction between two types of aware-
ness helps to sort out a wide range of untrained as well as trained
behavior, as Dennett observes:

It is not only simple reflexes that can apparently be controlled without the intervention of awareness$_1$. An accomplished pianist can play difficult music beautifully 'with his mind on something else', and need not be aware$_1$ of the notes on the page, the sounds of his playing or the motions of his hands and fingers. He must, of course, be aware$_2$ of these . . . Experience suggests that although we can only be aware$_1$ of one thing at a time, the brain can control a number of complex activities at the same time.26

In emphasizing the role of perception without awareness$_1$ — which is to say the brain's control of complex behavior below the threshold of articulate awareness — Dennett indirectly throws light on the most puzzling aspect of the Penelope Theory of practice:

As we say, we do many things without thinking about them, but surely we do not do these things without the brains' controlling them: [sic] It would be rare for a man to drive long distances without occasionally being aware$_1$ of his driving or the landmarks, and similarly the pianist would not long remain unaware$_1$ of the notes, the sounds or his finger motions. In particular, if he made a mistake, some sort of 'negative feedback' would no doubt shift him to awareness$_1$ of what he was doing.27

In short, even as whole aspects of performance become routine, one's articulate awareness continues to range over the activities involved, correcting errors and noting improvements as they occur. Clearly, however, a good deal of what we learn to do never crosses the threshold of awareness$_1$ and so does not find articulate expression. Conversely, there is no *logical* connection between awareness$_1$ and improving one's control over the relevant behavior.28 But, as we have seen, there is a contingent, often imaginal, relation whereby we may seize control and at the same time shape the direction of our future efforts.

In other words, controlled improvement presupposes an effort to bring some things to the level of articulate awareness, while others may remain or be allowed to drift into awareness$_2$ for the sake of efficiency. But while effort is required to identify

and solve particular problems, routinization occurs quite effort-
lessly since a facility that encounters no extrinsic or intrinsic
obstacles tends to gravitate, as it were, across the $awareness_2$
line. Harkening back to what earlier I called Dewey's craft theory
of inquiry (chapter 5, section 5), it might be said that thwarted
effort is the wellspring not only of inquiry but of the very aware-
$ness_1$ that makes it possible.

8. *Focal and Peripheral Awareness*

Drawing a theoretical distinction and applying it accurately to
particular cases are quite different matters. There is evidence to
suggest that locating the line between articulate and inarticulate
awareness in given instances is highly dependent upon the timing
of the performing subject's reports. If not the general accuracy
of $awareness_1$ reports, certainly their detail seems to decrease
with lengthening the interval after performance. In "stream of
consciousness" experiments on the thought processes of artists
at work, D. N. Perkins discovered that "one can elicit reports of
complicated thought processes during thinking, and even more
detailed reports by interrupting subjects and asking them to
retrospect on the last few seconds. Subjects are surprised, say-
ing in effect, 'I never knew I thought about that'. In general, the
delay time in reporting is immensely important. The key point is
that people are aware of much more than they ordinarily think
they are."[29] Perkins's experiments, mainly with poets, would
seem to challenge Dennett's claim that "we can only be $aware_1$
of one thing at a time."[30] Dennett appears to confuse the fact
that we can only make one *report* at a time with the multiplicity
of things of which we may simultaneously be $aware_1$.

Two caveats are worth noting about the distinction between
articulate and inarticulate awareness. First is the fact that by
itself the distinction implies nothing about the character — the
richness or paucity — of the perceptual terrain stretching away
on either side of the $awareness_1$ line. That being so, the logical
terracing of awareness no more implies a psychological "quantum
leap" from one disjoint state to another than crossing the Tropic
of Capricorn implies an abrupt change in the weather. As a line
of latitude does not of itself depict the terrain it bisects, so also
there are types and degrees of awareness ignored by the afore-
mentioned distinction.

For instance, to be $aware_1$ of what one is doing, to be able
to describe or even to explain one's actions, is not necessarily to

know to what one ought properly to attend — to be *focally* aware₁ of — in doing it. One can say, "I am executing a *plié*," and still be unaware that kinesthetic concentration on an imaginary plumb line from head to floor enhances its proper execution. Such privileged information is but a small part of the dancer's lore. As an aspect of knowing how, we often speak of knowing *what* to think about, what precepts, percepts, images, or sensations to keep upppermost in mind at one or other stage of a skilled activity. (Cf. the discussion of chapter 4, sections 1 and 2.)

Whatever the focal center of attention at any given moment, one continues to be peripherally aware₁ of innumerable kinesthetic, visual, auditory, or other sensations grading into a penumbral awareness₂ of the more routine aspects of the performance. Many such background perceptions and sensations are of course irrelevant if unavoidable, while others contribute in an ancillary way to the guidance of behavior. As Polanyi reminds us, even the homely act of driving a nail requires both focal and peripheral attention to several factors:

> When we use a hammer to drive in a nail, we attend to both nail and hammer, *but in a different way*. We *watch* the effect of our strokes on the nail and try to wield the hammer so as to hit the nail most effectively . . . we are certainly alert to the feelings in our palm and the fingers that hold the hammer. They guide us in handling it effectively, and the degree of attention that we give to the nail is given to the same extent but in a different way to these feelings . . . The latter are not, like the nail, objects of our attention but instruments of it . . . I have a *subsidiary awareness* of the feeling in the palm of my hand which is merged into my *focal awareness* of my driving in the nail.[31]

Elsewhere,[32] Polanyi speaks in deliberate paradox[33] of having "knowledge that we may not be able to tell" wherein we attend *from* certain things for attending *to* something else. Thus, as in the preceding example, "we are relying on our awareness of a combination of muscular acts for attending to the performance of a skill."[34] So intent are we on the effects of our actions that our subsidiary awareness grades into complete unawareness

of innumerable factors also involved in achieving the result be it as simple as driving a nail or as subtle as recognizing another person's mood. Such attending *from* constitutes what Polanyi calls the "tacit dimension" of knowledge, judgment, and skill.[35]

Polanyi's distinctions between focal and subsidiary awareness and descriptions of the tacit dimension of knowledge (including knowing-how) are intriguing but problematic. In the first place, not everything of which we are consciously aware is subsidiary in the sense of instrumental to what it is that we are doing. A good many thoughts, sensations, or perceptions are irrelevant "static." Accordingly, I prefer the term "peripheral awareness" to encompass both subsidiary (instrumental) as well as accidental or irrelevant secondary perceptions and sensations. But that is a minor matter.

A more serious difficulty concerns Polanyi's claim that we attend to different areas of the perceptual field "to the same extent but in a different way." (See p. 172 above.) The different ways are focal and subsidiary. But what sense is there in claiming mutually exclusive focal awareness of some things and subsidiary or peripheral awareness of others, yet awareness "to the same extent" of both sets of things? Alternatively, does any sense attach to being aware of different things in the same way but to a different extent? Polanyi does not address these queries, but in alluding to the "extent" of awareness, he nonetheless pinpoints what in fact is missing from his account of awareness, namely, the *boundary* between articulate and inarticulate awareness.

Dennett draws a line between two types of awareness without graded differences on either side of the line. Polanyi, on the other hand, describes such graded differences without being able to say to what extent (on which side of the line) one is aware particularly of peripheral perceptual contents. Some clarity as well as completeness are gained by combining the two rubrics. So, for example, driving a nail might be characterized as involving focal and peripheral awareness$_1$, respectively, of the observed effects of the blow and certain sensations in the arm and hand. That is, someone performing that task can report all these contents, though the effects of the blow on the nail occupy the center of attention.

Thus it makes sense to speak of being aware to the same extent (that is, aware$_1$) of contents of which one is aware in different ways (focally and peripherally). Similarly, to be aware of different things in the same way but to a different extent is

more simply expressed as peripheral awareness$_1$ and peripheral awareness$_2$. (On the combined rubric, one could not be focally aware$_2$, since by definition focal awareness is of our current conscious aim or end-in-view, whatever else we may be inarticulately heeding in order to accomplish it.) So, for example, one's peripheral awareness$_1$ of the feelings in the arm and hand while driving the nail merge into peripheral awareness$_2$ of the positions, say, of the shoulders, torso, legs, and feet. One is sufficiently aware of the latter to guide one's behavior, though not always to the extent of being able to issue a first-person report of the contents of the awareness.36

With virtually any complex skill, there will have been a learning phase that required focal awareness$_1$ of one or other of its now routine components. Chronic errors or lapses in efficiency as measured by changes in the final effect will often precipitate a quick "cognitive review" of these supporting facilities in an effort to eliminate the decrement. Obviously, while much of what one is peripherally aware of in action can be observed in the first person, the performing subject is not always in the best position to survey all the relevant components. As with the singer or gymnast, one requires the aid of a therapeutic observer. The role of the therapeutic observer (and of Type D Know-how) is heightened by the fact, as noted, that many factors controlling behavior operate entirely below the threshold of awareness$_1$ and therefore require articulation by someone else before coming within the control of the performer. And once again we are reminded of the major part played in this drama by the languages of craft and skill in promoting intersubjectivity in alleviating problems of self-scrutiny and the "retrieval" of lost or yet unfound sensations and habits.

9. The Constituents of Skill

Among philosophers the concept of skill has been assimilated to habit at one extreme as by James, and to "intelligent performance" at the other by Ryle.37 In fact, skill comprises at the very least both certain habits and their intelligent deployment in situations demanding continuous means-ends adjustments across a wide range of sensory-motor, symbolic, and evaluative frontiers. The special facilities, techniques, or habits required for intelligent performance, including critical judgment, I shall call the "constituents" of skill. Whereas, terms like "competency," "proficiency," "mastery," and their cognates refer to "attainments"

of skill; that is, to evaluative phases of the development and use of the constituents of skill. Attainments will be discussed in the following section.

Through procedures of training and drill, practice aims first at acquiring the constituents of skill and thereinafter at developing competency in and mastery of them. Initially, it may seem odd to speak of competency at certain habits, but contrary to Ryle,[38] not even the lowliest of finger drills can safely be described as the mere "imposition of repetitions," since drill by no means excludes intelligent intervention, guidance, demonstrations, and painstaking care in the manner of execution. That fact is alone reflected in the different types and degrees of conscious control involved at one or another stage of learning or deployment of such a routine facility as, for example, typing. What Educators are fond of calling "hands on experience" emerges as something more than a cliché when understood in this way. Some trained habits are radiant with knowledge.

On the side of artistic lore, craftsmanship, and common sense, it remains to delimit the ranges (extensions) and relations among the principal constituents of skill without unduly violating their standard uses. The idea is to distinguish different concepts to which ordinary terms are attached with somewhat less consistency than the demarcations sketched herein would suggest. On the side of the psychology of skill and learning theory, it remains to show the bearing of work in these areas on the common stock of practical knowledge.

In discussing the relations among cognitive and educational terms, Scheffler notes that the ranges of "learning" and "teaching" far outstrip "knowledge" so as to encompass habits ("propensities") such as smoking or being punctual at one extreme and "attainments" such as understanding or appreciation at the other.[39] Take Scheffler's example of punctuality: learning how to be punctual (the procedures that will ensure punctuality) is not equivalent to learning to be punctual (the habit); someone who knows how to be punctual may seldom or never exercise the procedures of punctuality, whereas someone who is in the *habit* of being punctual nearly always does.

Habits or propensities do often have "strictly associated" techniques. To be in the habit of smoking implies knowing how to smoke, though not conversely. Attainments, on the other hand, have no strictly associated techniques or procedures, nor, one might add, can they be *withheld* as skills can. One can begin to

understand or cease to understand but not, except elliptically, refuse to understand. Neither is understanding or appreciating a theory, poem, or painting reducible to some equivalent piece of "understanding know-how" or "appreciation know-how" as such. As Scheffler puts it, "Certainly there are techniques *embedded* in attainments: One who understands quantum theory knows how to read, and one who appreciates music knows how to listen. But these bits of know-how are not strictly associated; they are not equivalent to knowing how to *understand,* and knowing how to *appreciate* respectively."40

In other words, attainments are the contingent achievements of the exercise of various kinds and combinations of know-how. Being punctual, understanding a theory, appreciating a poem *are* matters of knowing what it is to do or experience something (of "instancing" in the sense explained in chapter 2, section 1 above), and as such they presuppose but are not guaranteed by bits of procedural know-how. However, we do speak of teaching or learning such habits and attainments. This suggests not that attainments and habits should be excluded from the realm of knowledge but rather that not all knowledge (or "Understanding" in the sense of chapter 3) should be considered a matter only of establishing beliefs or procedures.

Scheffler divides procedural knowledge, the notion of a trained capacity or skill in the broad sense, into "critical skills," which involve an irreducible element of critical judgment, and "facilities" which are mostly routinizable competencies such as typing or spelling.41 At maturity, the former continue to require both focal and peripheral awareness$_1$ while the latter are given over to peripheral awareness$_2$. That anyway, would seem to be one implication of Scheffler's distinction.

Practice applies to both critical skills and facilities, both being "typically built up through repeated trials or performances"; and though habits too are formed through repeated trials, Scheffler stops short of saying that they are practiced.42 The reason is that the concepts of proficiency, competency, and mastery are peculiarly applicable to skills (in the broad sense), but neither to attainments (one does not become a master understander of theories) nor to habits (one does not develop a competent habit of smoking or fingernail biting). To that extent, ordinary discourse may itself be seen as corroborating the anti-Penelopean thesis of section 4 in the present chapter, in that the concept of practice cannot be simply equated with that of repeated trials,

nor even drill with "the imposition of repetitions." Habits, on the other hand, are often so imposed deliberately or accidentally.

Notwithstanding the *a*-competency of most habits, some habits at least do appear to be practiced, especially those closely associated with skills. For example, the artisan's or surgeon's careful arraying of tools and instruments, the musician's habits of posture and placement of limbs, or the writer's work schedule: all lie somewhere between *mere* habits and what Scheffler calls facilities. Indeed, our everyday notion of habit ambiguously refers to propensities or tendencies of any sort, including trained facilities (as in "good performance habits")[43] as well as to repeated behavior below the threshold of trained facilities. Important differences among types of behavior may be obscured as a result. (It is assumed that all the behavior in question is acquired, not reflexive.) In fact, the concept ranges from such attainment-like "habits" as making a habit of success or playing beautifully as a habit to subfacilities such as sitting up straight while typing.

Generally speaking, the more attainment-like the habit, the more elliptical the usage of the term: making a habit of success says more about the predictability of the achievement than it does about the ingredients of success. At the opposite extreme of subfacilities, it is well to keep in mind that in acquiring a skill one usually strives to acquire some habits while eliminating others. In so doing one not only avoids certain obstacles or interferences; one *does* something in their place, practices doing them regularly until the old behavior is eclipsed. One is then "set" to go on. Conducive subfacilities or habits *of* competency, as we may call them, such as special breathing habits or postures, therefore overlap with many of the routinary facilities required for competent performance. On the other side, some habits of competency may already be in place without special training or they may grade into nervous "tics" or other idiosyncratic behavior that is functionally (if not always psychologically) irrelevant. For these reasons, it is futile to sharply set off facilities from habits on grounds that the former but not the latter are practiced, even if that is usually true.

Further light is shed on the relation between practice and habits of competency by considering the most general aims of the former. Earlier, in section 3, practice was seen to involve not only repetition but repetition with an end in view. The ultimate aim of practice is mastery of or at least competence in a skill.

The first aim of practice, however, is the acquisition of the requisite facilities and critical skills (in Scheffler's sense). Habits *of* competency would then encompass not only behavior judged generally conducive to the growth of skill, such as proper sleep, avoidance of conflicting stress, heeding others' achievements, and so on, but also many of the constituents of the skill itself once they have been acquired and routinized. (But only then, since up to that point they could hardly be described as "habitual.") So, for example, habits of phrasing or intonation in music or of gestural nuance in acting or the dance may become performance facilities — ones which by their particular refinements often distinguish a performer from all others. And that goes as well for the physical products of craftsmanship.

Naturally, many habits are either untrained (and therefore *a*-competent) or irrelevant; but relevence is relative to interest. It is common among actors, for instance, to speak of competency at certain everyday habits like smoking, walking with a peculiar gait, speaking in a certain way, or even punctuality at picking up cues ("timing"). This is because the actions in question are being considered as acting skills — part of the actor's repertoire of "normal" behavior which is often abnormally difficult to control on stage. A habitual off-stage smoker may be an on-stage fumbler, so aware$_1$ of what must seem to be "automatic" (though precisely timed and executed) that he must practice the habit until it is smoothly blended in with the rest of his performance. Though eventually on-stage smoking habits, like off-stage ones, may drift to the level of awareness$_2$, the starting point of the former is quite different: namely, a script that prescribes in more or less detail when and how to smoke. Whether a common habit like smoking or even a supposedly "involuntary" response like crying is to be skill-assessed, so to speak, depends upon the viewpoint one takes of it — whether or not the action, however humble otherwise, qualifies under the circumstances as a facility to be learned and refined.

Still other habits are *merely* associated by accidental conditioning with special skills and may eventually be deemed wrong or harmful because of their immediate or potential interference. Examples would be the singer "anticipating" a high note, or the actor "jumping" his cue, or a boxer "telegraphing" his punches. Withal, practice aims not only at the *attainment* of competency but at the acquisition of skill-constituent habits *of* competency as well as at the extinction of those that may interfere.

What all habits have in common, be they skill-constituent or not, is their tendency to be regularly repeated and routinized under the aegis of awareness$_2$.

10. *The Attainments of Skill*

Competency, proficiency, and mastery may be listed along with understanding and appreciation as "attainments," as achievements of the exercise of skill. Accordingly, one does not repeat and, hence, does not practice competency or mastery. Rather, like understanding or appreciation, they are *shown* (exhibited, exemplified) in activities that can be repeated and practiced. Normatively, the general category of "attainments" refers to the positive side of a sliding scale of evaluative, polar predicates characterizing the manner of something done: well or poorly, intelligently or stupidly, competently or incompetently. In other words, one practices *for* competency or mastery and may exhibit it in varying degrees or not at all.

How much, then, of a competent or even masterful performance can be routinized by practice? Scheffler maintains that proficiency at a critical skill as opposed to a facility is not increased by routinization: "A critical skill such as chess is quite different from capacities in which increased proficiency does result from increased routinization."[44] Maybe not chess as such, but certainly many of the critical skills *of* chess, including aspects of strategy, would appear to be both routinizable and improved by routinization. Care should be taken, however, to distinguish the question whether critical skills are improved by routinization from whether they are improved by repetition and practice — by repeated exercise under different circumstances. Critical skills, as Scheffler uses the term, are limited to situations offering some opportunity for intelligent, strategic choice and are therefore unroutinizable by definition, though yet repeatable and practiceable.

Still, it is questionable whether the element of choice excludes routinization; for even strategic judgment may be highly schematic and routinely adjusted to *typical* variable conditions. Dennett's examples above (section 7) of the driver and pianist performing "automatically" illustrate the extent to which critical skill may become routine. So it would appear that just as some habits may be skill-assessed, some critical skills may be enhanced by routinization, although they can never entirely (safely) be relegated to automatic control. The extent to which a critical

skill actually becomes routine will vary with times, persons, and situations: one man's hard-pressed decision is another's routine choice.

So rather than restrict critical skill to whatever bit of strategy happens at the moment to be under the control of awareness$_1$, it seems preferable to maintain that *any given* critical skill — say, controlling the center in chess — is likely to pass from deliberate, focal attention to routinized, reflexive status with increasing mastery of the game. Grandmasters at chess and master musicians alike are conspicuous not only for their virtuosity but for the perspicacity of their play, an economy of means aided by the routinizing of vast areas of judgment and strategy. In short, it is not that critical skills as such resist routinization but rather that such activities as chess and music allow for indefinite further development of critical skills as others become routinary. To that extent, neither chess nor music is routinizable; but such critical skills of chess or music as can be are no less judgmental for becoming second nature.

The last point brings us to an essential feature of critical skills: their irreducibility *overall* to routine response. Unlike, for example, a simple tracking task in a psychological experiment, a critical skill involves continuous, judgment-based adjustment of reponses, usually of a highly complex nature, to changing contingencies. Judgments, like anything else, may fall into standard patterns, and to that degree they admit of partial routinization. They may even admit of algorismic representation as do the elementary valid argument forms in logic. But new contingencies will always arise to challenge the performer of complex tasks. Scheffler contrasts chess, as requiring strategy and choice from among permissible moves, with fully routinizable skills such as typing or spelling which lack any such "comparable occasion for choice."[45] But principles of chess strategy, like canons of logic or musical composition, are primarily heuristic, incomplete, and without any guarantees of success. The procedural judgment required for their proficient use indeed presupposes, without being *entirely* reducible to, previously mastered routines and patterns of judgment. Judgment, in the form of new insights not previously experienced, is always at the cutting edge of mastery. Otherwise, relentless Penelopean persistence at established routines would make a grandmaster or master musician of anyone.

It is common enough to know how to play chess or the piano without playing well, where "playing well" may encompass any-

thing from minimal to maximal critical competency or mastery. The notion of critical skill thus overlaps but does not coextend with that of know-how. By the same token, know-how as representing a standard of performance, overlaps but does not coextend with "being able," particularly in the habit-forming early stages of learning. As Scheffler observes, "We may, in given contexts, wish to withhold the attribution of *know how* from the student until a certain level of intelligent play is attained. But such a decision is not forced on us, and we may well construe intelligent play as a further condition beyond the achievement of a minimal strategic know-how."[46] In other words, as a subset of the concept of skill, *critical* skill exceeds the upper limits of know-how just as the ordinary notions of ability and habit overlap while extending below the lower limits of procedural knowledge.

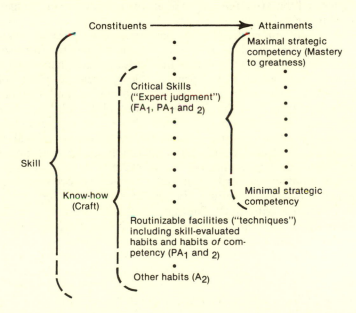

Figure 1

Relative Ranges of the Major Practice and Skill Concepts

Figure 1 shows the relative ranges of the major practice and skill concepts discussed above, including the types of awareness, whether focal (FA) or peripheral (PA), that are normally associated with them at maturity. Dotted lines between terms indicate graded, continuous differences, while the broken line of a brace indicates an area of variable or vague application of a term.

11. *The Ambiguity of Critical Skill*

It is clear from the context of his discussion of critical skills that Scheffler is concerned with skilled performances of various kinds, and the present discussion has deliberately kept within those confines. I will conclude this chapter with an all too brief examination of some allied forms of criticism. To begin with, the notion of "critical skills" is ambiguous between performative (or productive) skills on the one hand and evaluative skills on the other, between the *deployment* of facilities or special techniques and the *assessment* by oneself or others of results achieved — skills *of* criticism, as it were.

Depending upon the sorts of performance in question, evaluative skills are essentially propositional and detachable from some performances. But even where the performances themselves are propositional, as when we speak of "doing" science, philosophy, or history, the contrast between performative and evaluative skills continues to hold. In science and philosophy, as in art, there are "creators" and "critics": those who are productive, innovative thinkers, and those who are basically critical and evaluative of the work of the former. Of course, one and the same individual may alternately undertake both tasks, and surely the innovator is a critic too but at first-order levels of artistic activity or scientific inquiry rather than second-order levels of art or science criticism.[47] The point is that, relative to a primary performance of some kind, the contrast between critical skills of production and of evaluation holds in varying degrees for art and science alike and across the propositional-procedural divide.

The reason critical skills of performance and evaluation are mutually detachable is that they tend, on the whole, to be different skills, differently trained, and having different aims. Critical skill in the performative sense is the meeting place of propositional and procedural knowledge with emphasis upon the latter. Criticism, on the other hand, deals mainly in propositional knowledge, with statable versions of things. Art and science criticism appear to be alike in that respect, notwithstanding dif-

ferences in subject matter, formulation, and evidence, and notwithstanding also art criticism's promotion of felt "appreciation" by illumination of elusive aspects or expressive nuance in art works. Science too has its performance side in various laboratory, research, and field techniques, but they also culminate in their contributions to linguistic or quasilinguistic world versions. There are no duets for beam balance and centrifuge, and a musical performance is not normally thought to "confirm" its score.

What then of those activities where the contrast between critical action and reflection is not so sharp? With certain "intellectual" games like chess or bridge, for instance, criteria of criticism are largely drawn from constitutive rules and strategies of play — rather like a philosophical or scientific argument. Knowing how to play up to, say, minimum levels of competency therefore is both necessary and sufficient for making informed critical observations (if not to write critical reviews of matches which requires additional writing skills). Here the difference between doing and criticizing appears less pronounced, and, if misleading as a *general* model for the arts, nonetheless suggests exceptions to the rule.

Might there not be significant analogues in art, the literary arts, for example, where writing skills are the common denominator of both literary art and criticism? Certainly there are particular writers who, like Bernard Shaw, bridge the gap. But even here (and one suspects in chess and bridge too) the difference between "creative" and "critical" abilities is widely recognized. And as soon as one considers the nonlinguistic arts and the performing arts, some of which naturally involve language, is it clear that knowing how to produce such works is neither necessary nor sufficient for making informed critical comment. Conversely, one may succeed in becoming a competent critic without first being a practicing artist. Yet, as Dewey rightly insists, the practicing artist embodies within himself the *attitudes* of criticism as he interprets and applies them to his work. (See p. 124 above.) Perhaps, after all, the difference dissolves to one of perspective and degree of active involvement — to the ways the results of cool reflection come to inhabit one's performance.

REFERENCES

CHAPTER 6

1. Quoted in the *Toronto Globe and Mail,* 12 February 1972.

2. After the Greek goddess of skills, as of wisdom and warfare, who sprang full-grown and armour-clad from the brow of Zeus.

3. After the faithful weaving wife of Odysseus.

4. From the *Ion* in the *Collected Dialogues of Plato,* ed. Edith Hamilton and Huntington Cairns (New York: Pantheon, 1961), p. 220.

5. Thomas Mann, *Death in Venice* (New York: Vintage Books, 1954).

6. Goodman, *Languages of Art,* pp. 6-10.

7. William James, *Talks to Teachers* (New York: Dover, 1962), p. 34; the passage is taken verbatim from *The Principles of Psychology,* vol. 1 (New York: Dover, 1950), p. 122.

8. See Frederic C. Bartlett, "Fatigue Following Highly Skilled Work," *Proceedings of the Royal Society* 131 (1943), 248-247; reprinted in *Skills,* ed. David Legge (London: Penguin Books, 1970).

9. Cf. Ryle, *The Concept of Mind,* pp. 149-153.

10. Israel Scheffler, *The Conditions of Knowledge* (Glenview: Scott, Foresman, 1965), p. 103.

11. For a discussion of the vacuity of appeals to similarity, see Nelson Goodman, "Seven Strictures on Similarity," in his *Problems and Projects* (Indianapolis: Hackett, 1972), pp. 437-446.

12. John Dewey, *Theory of Valuation,* p. 49.

13. See, e.g., Dennis H. Holding, "Knowledge of Results," in Legge, *Skills;* and James Deese and Stewart H. Hulse, *The Psychology of Learning,* 3rd ed. (London: McGraw-Hill, 1967), pp. 454-455.

14. See p. 158 above. At the opposite extreme of effort one is reminded of Thomas Edison's memorable epigram: "Genius is one percent inspiration and ninety-nine percent perspiration."

15. Michael Polanyi, *The Tacit Dimension* (New York: Double-day, 1967), p. 4.

16. For an excellent review of the psychological literature on "perception without awareness," see Norman F. Dixon, *Sub-liminal Perception, The Nature of a Controversy* (London: McGraw-Hill, 1971).

17. D. C. Dennett, *Content and Consciousness* (London: Rout-ledge & Kegan Paul, 1969).

18. Ibid., p. 117.

19. Ibid., pp. 117-118.

20. " . . . where *p* is a statement informing us about the 'object' of awareness." Ibid., p. 119.

21. Dennett ignores the (not only) artistically important con-sideration that perceptions can be variously symbolized.

22. See Dixon, op. cit., passim.

23. Cf. Dennett, op. cit., p. 124.

24. Ibid., p. 118.

25. Awareness$_1$ and awareness$_2$ are by no means restricted to the range of "knowledge" only. One can be aware$_1$ or aware$_2$ of physical sensations or emotions having little or nothing to do with propositional or procedural knowing.

26. Dennett, op. cit., p. 123.

27. Ibid.

28. Cf. ibid., pp. 123-124.

29. D. N. Perkins, personal communication.

30. See p. 170 above.

31. Michale Polanyi, *Personal Knowledge: Towards a Post-Critical Philosophy* (London: Routledge & Kegan Paul, 1969), p. 55.

32. In *The Tacit Dimension,* p. 4.

33. For purposes of testing whether in fact we possess such knowledge, Polanyi eliminates the paradoxical formulation as follows: "This [suspicion of self-contradiction] is prevented . . . by the division of roles between the subject and the observer. The experimenter observes that another person has a certain knowledge that he cannot tell, and so no one speaks of a knowledge he himself has and cannot tell." Ibid., p. 8.

34. Ibid., p. 10.

35. Ibid., chapter 1.

36. Cf. Dixon, op. cit., for a detailed account of the experimental work on subliminal behavior control.

37. Ryle, op. cit., pp. 42-51.

38. Ibid., pp. 42-43.

39. Scheffler, op. cit., pp. 14-21.

40. Ibid., p. 19. Scheffler's sense of "embedded" is roughly synonymous with "implied by" as contrasted with the psychological embeddedness of awareness$_2$. Some logically embedded techniques may also be psychologically embedded.

41. Ibid., p. 98.

42. Ibid., pp. 20, 100.

43. Scheffler rightly denies this on grounds that while some habits imply parallel facilities, the converse does not hold. For example, one's being able to type does not imply that one is in the habit of typing. See ibid., pp. 19-20.

44. Ibid., p. 99.

45. Ibid.

46. Ibid., p. 98.

47. I would consider such disciplines as philosophy or history of science as second-order criticism in the sense of leading to works of philosophy or history rather than of science.

Postscript and Conclusion

1. *Finding the Right Response*

The overarching aim of this essay is to reinstate the inestimable importance of craft in art. For that it would be foolhardy to attempt to redress the celebration of art at the expense of craft by arguing that, after all, art somehow reduces to craft. It simply is not a question of autonomy *versus* mutual collapse. Rather, it requires a closer look at the details of craft itself, not only in art but elsewhere — in work, leisure, and education. Then, too, it is mainly in theory, especially among philosophers, that craft suffers demotion to the status of inflexible, unimaginative, uncreative routine. Routine it is, but not for that reason devoid of opportunities for discovery or creative, imaginative thought and action. No less a practical authority than Lord Olivier has been quoted as saying, "I would like them to remember me as a diligent, expert workman. I think a poet is a workman. I think Shakespeare was a workman. And God is a workman. I don't think there is anything better than being a workman."[1]

Lord Olivier is not suggesting that art is no more than craft but that, by and large, the grandest artistic achievements are manifest *through* expert craftmanship. Whatever its dimensions, one's aesthetic *demon* delivers more than mysterious kicks of inspiration one knows not whither. Rather, it is directed toward its object in a questioning way. As Picasso said, "A painting remains there like a question. And it alone is the answer."[2] In the end, for artist, artisan, or athlete, it is a matter of finding the right response, the "better way" of doing things. Practitioners in these areas instinctively grasp the significance of critical, creative, imaginative skill in the quest for a better way, though seldom with the intention of producing a better theory of craft.

Psychologists as well have made experimental inroads into the landscape of skills but seldom in ways that relate to what practitioners already know and how they express that knowledge. Accordingly, these final sections take a few last tugs at a connecting thread, namely, the mutual bearing of practical know-how and the experimental study of skills and practice. The idea is to complement the rather specialized discussion of singing in chapter 2 with a broader array of experimental concepts.

A prime purpose of ordering the specialized languages of skill in art and elsewhere is to make the procedural lore more acces-

sible to experimental test while also indicating new areas of investigation of particular skills. Preceding chapters emphasized the range of propositional knowledge involved in skilled procedures, notwithstanding the irreducibility of the latter to the former, ranging from acquaintance (knowing what it is), analogy and metaphor (what it is like), precept (what to do or think about in doing) to explanatory hypotheses about skills. While practitioners and teachers tend to be occupied with the uses of such knowledge to enhance performance and results, learning theorists are concerned to broach such questions as, What native capacities (sometimes called "abilities") are required for learned skills? How are particular skills learned? How do different skills interact; for example, how can the learning of new skills be helped or hindered by ones previously learned? How are skills "hierarchized"? How do adults and children differ in their learning of various kinds of skill? Are there features of practice and development shared by most or all skills, for instance, the occurrence of "plateaus" or the effects of "distributed" versus "massed" practice?[3]

Complete and secure answers to these and kindred questions are not yet available, and those that are available are not always applicable to tasks differing in certain fundamental respects from those on which the answers are based. Consider, for instance, the notion of choosing a response. In well known studies of maze learning, Brogden and Schmidt[4] and Miller[5] found that increasing the number of alternatives at each choice point (assuming the number of correct choices remains constant) increases both the time and number of errors during learning but *not* the difficulty of remembering the correct response. That is, once the correct response is made, recollecting it appears to be uninfluenced by whether there were two, three, five, or ten options per choice point.

One might expect a different result for tasks in which the disjunction between correct and incorrect responses is less clear. To take a common example from the arts: in learning properly to execute a difficult musical passage, it is likely that increasing the number of possible interpretations would increase not only the number of errors and the time required to learn but also the difficulty of remembering the correct response (assuming there is one preferable to others). This is because the very idea of what *is* correct is (a) difficult to communicate, and hence the guidance to be had from such communication is comparatively

limited; and (b) difficult to perceive first-hand and not easily distinguished from other close approximations.

This expectation receives some distant support from studies of the influence of syntactic and semantic similarity on rote serial learning of adjective lists and paired-associate (stimulus-response) learning of adjectives.6 Generally, an increase in similarity appears to result in an increase in the number of trials to criterion. I say "appears," because things designated similar under one description (e.g., the number of letters per word) may be quite dissimilar under another (e.g., sameness of meaning). Hence it is vacuous to claim, as one writer does, that "high stimulus similarity produces high stimulus generalization from one item to another."7 That follows, if at all, in reverse, and simply from things being grouped under a common label. (See chapter 4, section 3 above.) The significant claim is: "Since the stimulus items are less distinctive [in respect of one or other selected properties], they should be harder to discriminate. Likewise, if response items are highly similar, learners should have a harder time in finding and remembering their distinctive properties."8

Both difficulties are commonplace in learning (not only) artistic performance skills, especially those requiring high acuity of extraspection — the ability to monitor the details of one's own performance. Even if one knows circumstantially or by the results achieved that something went wrong, it may yet be difficult to discriminate and recall "right" from "wrong" responses. As athletic trainers are well aware, "being in a slump" is as much a perceptual as a motor problem.

At the level of particular facilities, compensatory and pursuit-tracking experiments on so-called "adjustive skills"9 — like tracing an outline, driving a car, or catching a ball — are applicable to a wide range of artistic skills. These would include aspects of pitch and rhythm perception, dance movements, use of various notations — anything, in fact, requiring continuous adjustment of responses to an unambiguously "correct" target state. Studies of adjustive skills involving kinesthetic, visual, and verbal "guidance" (information supplied prior to a response as contrasted with feedback "knowledge after") seem to confirm the practice lore regarding the usefulness of juxtaposing errors and correct responses in building up discriminatory capacities. D. H. Holding fairly summarizes the overall findings in this area:

> We began by considering how far reducing errors might contribute to learning. However, if this is done in such a way as to reduce the information available to the learner the learning will suffer. Knowledge of the correct response is incomplete if there is no opportunity to define it against the alternatives, just as we cannot be said to understand 'red' if we have never identified other colors.[10]

It is worth noting parenthetically that such comparisons by constant conjunction are an important step toward understanding the refinements of jargon and metaphor applicable to particular facilities. Holding continues:

> Kaess and Zeaman's experiment suggests that it is inefficient to present the learner with a number of possibilities without indicating which of them is correct. Giving both correct and incorrect alternatives while ensuring correct responses seems to be the best solution . . . A learner practicing alternatives is not learning errors if he knows which is the correct response.[11]

These remarks are especially apropos of perceptual nuance and the damaging effects of "practicing one's mistakes" but could equally apply to the discrimination of shades of meaning and expression in both the production and interpretation of works of art. Too often, for instance, do courses in art appreciation neglect the lesser works by contrast with which greater works may be seen to be great. The principle of significant contrast applies not only among masterpieces but among greater and lesser achievements of roughly the same sort, say, Cubist portraits of the early twentieth century. In any event, difficulty in learning to distinguish correct from incorrect responses, superior from inferior achievements, after the fact is not normally encountered by maze learners, typists, telegraphers, or spelling champions.

2. *Beyond Plateaus and Inhibition*

Most experimental studies of the arts deal with problems in the perception and interpretation of art: strategies of visual perception;[12] the expressive conventions of Western tonal music;[13]

or the information-theoretic effects of style, mode, or medium.[14] Others focus on devising tests of artistic aptitude.[15] Relatively few studies tap the silent springs of artistic production — the work and practice habits of artists.[16] Still, a large literature exists on general skill development centering around the questions rehearsed in the previous section. In particular, studies of distributed versus massed practice and the related issues of "reminiscence," plateaus, reactive inhibition, and "hierarchization" contain many results readily adapted to the refinement of artistic skills. As well, further investigation of these phenomena in artistic settings may turn up new data and lines of psychological inquiry regarding how best to learn certain kinds of skills and the changes that take place during practice.

The question of distributed versus massed practice is the question whether learning is greater or quicker when practice is intermittent, interrupted by frequent rest periods ("distributed"), or when it is continuous and unremitting ("massed"). Since Lorge's classical experiments on mirror drawing and code substitution,[17] it has been repeatedly demonstrated over a wide range of psychomotor and verbal tasks that distributed practice is superior to massed practice, especially in the short run. In most instances, massed practice resulted in a marked temporary decrement and a lesser permanent one. In other words, distribution is likely to result in quicker though not necessarily greater improvement than massed practice.

Two notions relevant to artistic skill development have been adduced to account for this phenomenon: "reactive inhibition" and "reminiscence."[18] Reactive inhibition refers to a decrement in the rate or accuracy of response which accumulates under conditions of continuous responding and disappears with rest. Reminiscence, as its ordinary uses suggest, refers to an apparently spontaneous improvement in response after rest from practice, as contrasted with the decrements of overresponding or forgetting. Reactive inhibition presumably accounts for the temporary decrement of massed practice and reminiscence for the gradual evening out over the long run of the difference between massed and distributed practice.

A secondary inhibitory state called "conditioned inhibition," wherein the subject *learns* not to respond well as a result of induced reactive inhibition, aims to account for any long-term decremental remainder between massed and distributed practice. Although conditioned inhibition seems not to have survived

experimental testing — more accurately, a reliable test of it has yet to be devised[19] — it is intuitively useful for understanding a common practice phenomenon, namely, anticipatory fear of certain response decrements, or, as it might otherwise be put, habituation to failure. An example would be the difficulty a novice singer might experience in attempting a high note at the end of a strenuous passage. Later on, when the singer's skill and endurance have improved to the point of performing with relative ease other passages of comparable difficulty, he or she may yet experience the same difficulty with the original passage.

Referring indirectly to conditioned inhibitions, musicians, actors, and dancers often speak of "relearning" old works and routines in order to bring them up to current standards. Such relearning can be more difficult than learning new material because of previously entrenched habits. Among other things, relearning requires *unlearning* old bad habits, or, as the psychologists would say, extinction of previously conditioned response inhibitions imposed by past limitations.

So far, psychologists and practitioners are fairly much in agreement, but experimental results and practical lore do sometimes conflict. For example, it is commonly held that reminiscence does not occur in distributed practice, whereas practical opinion suggests that it often does: so-called "silent rehearsal" is but another name for imagery of the controlling kind worked out in the interval between trials. Indeed, the point of distributing practice, of inserting intervals between trials or clustered series of trials, is to allow not only for rest but for rumination as well. Again, while there is animal evidence to show that reminiscence is not an effect of mental rehearsal[20] ("thinking about it"), recent studies of athletic skills support the practical view that improvement frequently results from silent rehearsal, especially where continued overt responding is likely to build up some reactive inhibition; that is, where practice is distributed to avoid fatigue and frustration.

Mahoney and Avener's study[21] of male gymnasts at last confirms what practitioners have long held as common knowledge, namely, that the kinds of mental imagery employed have measurable effects on performance. As well, a raft of popular books with such titles as *Inner Tennis, Inner Skiing,*[22] and the like, have begun to appear on the "Crafts and Hobbies" shelves. A more serious study by David Sudnow, *Ways of the Hand,*[23] takes a phenomenological approach to learning to play jazz piano. Of

variable utility, cogency, and theoretical orientation, these books nonetheless agree on the practical effectiveness of imaginal controls and mental rehearsal in developing and deploying critical motor skills.

While we await the results of further experimental work on the imaginal aspects of skill, it is worth noting three guiding observations. First, execution of difficult tasks is made easier by reflection upon different aspects of the task — a shifting around, as it were, of articulate awareness in the interest of making corrective adjustments. Second, many of the critical judgments made during practice involve retrospection during the intervals between trials. Finally, much training advice, indeed the languages of instruction themselves, requires mental rehearsal and presupposes on practical evidence that some improvements (and failures) are directly attributable to how one conceives of the task at hand.

"Stream of consciousness" studies of the sort mentioned above (p. 171) wherein subjects record on tape their normally silent meditations may also shed light on the thoughtful varieties of reminiscence. Though the routes of artistry are many, certain patterns of travel are discernible, and a plotting of them is likely to yield insight into both reminiscence and the opposite phenomenon, namely, "plateaus," the flat areas of a learning curve where little or no improvement takes place over repeated trials. Prevailing opinion is that "the plateau occurs where the limit on lower-order habits has been reached and where the higher-order habits have not yet begun to appear."[24]

While some argue that plateaus are caused by a drop in motivation, it seems equally likely that plateaus cause such a drop if, in fact, they occur at points of *conceptual* arrest between lower-order and higher-order habits.[25] One might expect a decline in motivation (boredom) where efficiency levels off prior to the struggle for a new ordering of the task. Should it turn out that plateaus are primarily cognitive rather than emotional in origin, an analysis of the artist's "logic," his problem-solving and associative strategies, may clarify how past gains are finally consolidated to produce new improvements.

Such investigations thrust deep into educational concerns, for as Deese claims, "Something like this hierarchical structure must occur in all tasks where there is opportunity to recode the material into larger and larger units. Thus, learning to typewrite, read music, and the basic skill of learning to read itself must in-

volve something like hierarchies of habits."26 "Recoding" ma-
terials hierarchically inevitably involves changes in cognitive
strategies and shifts of articulate awareness, including routiniz-
ing of previously focal tasks, not to mention the recoding of
symbols in terms of how they are to be interpreted and used. An
extensive investigation of symbol systems and the cognitive
processes attached to their various uses emerges as the natural
corollary and extension of experimental work already done on
the conditions of practice.

3. *Beyond Piaget: the Adult Learner of Skills*
 Such a discussion as this cannot avoid the responsibility of
at least placing itself in relation to the monumental work of Jean
Piaget in developmental psychology. My thesis is an simple as
it is invitingly vague: if nineteenth-century learning theorists
tended to view the child as an adult writ small under the over-
whelming influence of Piaget in child development, the present
tendency among educators is to view learning in general as writ
simpler in the child. That is to say, *the* learning process is held
to be more accessible to close scrutiny in the relatively simpler
world versions of the child.
 Nothing could be further from the truth. Certainly Piaget
himself offers no support for such an opinion, but preoccupation
with children's cognitive "stages" and devising curricula to fit
them seems to have crowded out the equally legitimate demands
of the cognitive adult. As argued above (chapter 3, section 6),
the adult apprentice, however child-like at times, is not a child,
especially in regard to the symbolic resources available to learn
with. What difference does this make to the psychology of skills?
Specifically, how does this difference square, if at all, with
Piaget's picture of the developing child?
 The knowledge by acquaintance associated with "knowing-
how" is perhaps most explicitly represented among psychologists
by Piaget's "concrete operational" stage of thinking, with its
emphasis upon manipulative encounters with the physical-sensory
world.27 This follows upon a "sensory-motor" stage of mere
"figurative" acquaintance with the physical world limited to the
sensory modalities and one's own direct actions. The transition
from the preoperational to the concrete operational stage is
characterized in terms of hierarchies of "operational schemes"
that allow for increasingly complex interaction with the environ-
ment so long as it continues to be within direct, perceptual pur-

view. Through the gradual mediation of symbolic systems, the child of eleven to thirteen emerges into "formal operational" thinking, at which stage he learns to act on the world indirectly through various symbolic "representations": to make predictions, deductions, multiple classifications, and assessments of evidence having no direct perceptual counterparts. Such in brief is Piaget's three-ring theory of cognitive development in children.

Setting aside all other controversies, and solely for the sake of comparison, I will address the query raised above in the theory's own terms. In the first place, skilled motor activities learned after the achievement of logico-hypothetical thought, while indeed remaining concrete operations, cannot be construed as representing developmental stages en route to formal operations. In fact, formal operations are ingredient to them in ways impossible to the child. That would suggest, secondly, that what I am calling adult skills represent a higher level of integration, presumably through the complementary processes of "assimilation" and "accomodation," of abstract (formal) thought and action within a now broadened category of concrete operations. More simply put, adults' concrete operations, say, driving or swimming, cannot be adequately understood on the model of children's concrete operations.

Finally, in contrast with a child's slower (*because* less formal) development, an adult can quickly analyze and dissect his or her first "figurative" experiences in elaborate and diverse ways designed to increase his sensory discrimination and control over the outcome of his efforts.[28] Thus, in knowing how to go on, in "getting the feel of it," we combine sensory cues, recognized as such, with the received lore in ways that indicate a rather more intimate connection between theory and practice *in* action than educationists are accustomed to acknowledge. Dewey, on the other hand, grasped the point perfectly in what I called his craft theory of inquiry (see p. 133-134 above), as have generations of practitioners of the several arts and crafts in rather more intuitive ways. A *vision* of artistry, mastery, or craftsmanship is a symbolic integration of thought and action.

4. *Conclusion*

Lest anyone be misled by all this talk of theory and thought in practice to believe that I am advocating some kind of tandem connection between them, I can do no better than to quote Samuel Johnson: "You cannot, by all the lecturing in the world,

enable a man to make a shoe."29 Still, in showing him how, we may lecture him too, often in language so fragmentary and exactly calibrated to the task at hand as to be inscrutable apart from it. Under the circumstances, teaching proceeds less by elaborate literal description and explanation than by precise suggestion. The lines of suggestion are many: literal and metaphoric language, gestures, pictures, diagrams, samples, and demonstrations, all of them symbolic routes to skills that may or may not themselves be symbolic in nature.

The languages of craft and skill function not only as repositories of traditional lore (and sometimes wisdom), but as vestibules, well marked passages, from one experience or sensation to another, from knowledge *about* to understanding to *how,* from a mere wish to a Way. The singer or dancer sees, hears, or feels, but above all, uses his or her body in remarkably subtle ways that physiology can sometimes explain. And therein lies a crucial and complementary connection between theoretical and technical languages, the one aiming at theories and explanations, the other at actions and results.

The more science probes, vindicates, and especially revises accepted practices, the more its terms are woven into the lexicon of action as appears to be happening in several of the arts and sports. We are poised at the watershed of genuine technologies of art and sport that nevertheless must bow or be bent to the epistemological demands of first-person making and doing. Though scientific knowledge can inform, it cannot displace the practical perspective; for such a perspective, I have argued, is the essence of creative, imaginative understanding. If art is not craft, neither is it easily separated from craft, nor is craft devoid of creative dimensions. Great cooks and great composers alike have their recipes, and practice can, in combination with a superior Understanding, make perfect.

All that I have just said collapses into banality and platitude were it not for traversing the difficult terrain of the preceding chapters. The journey is worth the trouble if it has thrown some light on the grounds of what people of good educational sense and artistry have always known.

REFERENCES

POSTSCRIPT AND CONCLUSION

1. *TV Guide,* December 1, 1979.

2. I am not sure of the origin of this quote except that I heard it on a television program on Picasso who reportedly said it.

3. See James Deese, *The Psychology of Learning* (New York: McGraw-Hill, 1958), pp. 181-212; Robert Borger and A. E. M. Seaborne, *The Psychology of Learning* (London: Penguin, 1966), pp. 11-12.

4. Wilfred J. Brogden and Robert E. Schmidt, "Effect of Number Choices per Unit of a Verbal Maze on Learning and Serial Position Errors," *Journal of Experimental Psychology* 48, 1954, pp. 235-245; idem, "Acquisition of a 24-Unit Verbal Maze as a Function of Number of Alternate Choices per Unit," *Journal of Experimental Psychology,* 48, 1954, pp. 335-338.

5. George A. Miller, "The Magic Number Seven; Plus of Minus Two: Some Limits on Our Capacity for Processing Information," *Psychological Review* 63, 1956, pp. 81-87.

6. Benton J. Underwood, "Studies of Distributed Practice: X. The Influence of Intralist Similarity on Learning and Retention of Serial Adjective Lists," *Journal of Experimental Psychology* 45, 1951, pp. 253-259; Benton J. Underwood and David Goad, "Studies of Distributed Practice: I. The Influence of Intralist Similarity in Serial Learning," *Journal of Experimental Psychology* 42, 1951, pp. 125-134; Richard S. Lazarus, James Deese, and Robert Hamilton, "Anxiety and Stress in Learning: The Role of Intraserial Duplication," *Journal of Experimental Psychology* 47, 1954, pp. 111-114.

7. Deese, *The Psychology of Learning,* p. 208.

8. Ibid.

9. Dennis H. Holding, "Types of Guidance," from chapter 3 of his *Principles of Training* (New York: Pergamon, 1965), reprinted in *Skills,* ed. David Legge (London: Penguin Books, 1970), p. 272.

10. Ibid., p. 272.

11. Ibid., p. 272, 274. Holding's reference is to Walter Kaess and David Zeaman, "Positive and Negative Knowledge of Results on a Pressey-Type Punchboard," *Journal of Experimental Psychology* 60, 1960, pp. 12-17.

12. Rudolph Arnheim, *Art and Visual Perception* (Berkeley and Los Angeles: University of California Press, 1967).

13. Deryck Cooke, *The Language of Music* (London: Oxford, 1959).

14. Leonard B. Meyer, *Emotion and Meaning in Music* (Chicago: University of Chicago Press, 1956); and, for a good general survey of the perceptual and interpretative literature, barring a few glaring omissions, Hans Kreitler and Shulamith Kreitler, *Psychology of the Arts* (Durham, N.C.: Duke University Press, 1972).

15. Carl E. Seashore, *Psychology of Music* (New York: McGraw-Hill, 1938); Edwin Gordon, *Musical Aptitude Profile* (Boston: Houghton Mifflin, 1965); Herbert D. Wing, *Musical Intelligence Tests* (Buckinghamshire, U.K.: National Foundation for Educational Research, 1961).

16. For a survey of the available literature canted towards education, see Margaret Gilchrist, *The Psychology of Creativity* (Melbourne: Melbourne University Press, 1972). In the area of children's artistic development, see Howard Gardner, *The Arts and Human Development* (New York: John Wiley & Sons, 1973). An exceptional study of adults is David N. Perkins's "A Better Word: Studies of Poetry Editing," in David N. Perkins and Barbara Leondar, *The Arts and Cognition* (Baltimore: Johns Hopkins University Press, 1977).

17. I. Lorge, "Influence of Regularly Interpolated Time Intervals Upon Subsequent Learning," *Teach. Coll. Contr. Educ.*, no. 438, 1930.

18. By Clark L. Hull, in *Principles of Behaviour* (New York: Appleton-Century-Crofts, 1943).

19. Deese, *The Psychology of Learning,* p. 195.

20. Glen A. Holland, "Simple Trial and Error Learning: Massed and Distributed Trials with Habits of Unequal Initial Strength," *Journal of Comparative and Physiological Psychology* 46, 1953, pp. 90-94.

21. Michael J. Mahoney and Marshall Avener, "Psychology of the Elite Athlete: An Exploratory Study," *Cognitive Therapy and Research* 1, 1977, pp. 135-141.

22. W. Timothy Gallwey, *Inner Tennis, Playing the Game* (New York: Random House, 1976); W. Timothy Gallwey and Robert Kreigel, *Inner Skiing* (New York: Random House, 1977).

23. David Sudnow, *Ways of the Hand* (Cambridge: Harvard University Press, 1978).

24. Deese, *The Psychology of Learning,* p. 185.

25. Popular distinctions between lower-order and higher-order habits or simple and complex processes are misleading in suggesting atomic or noncomplex psychological processes. Such of these contrasts as are employed herein are intended merely to indicate the hierarchical inclusion of some processes within the relatively broader scope of others. For example, visual scanning is a prominent feature in the perception of whole objects.

26. Deese, *The Psychology of Learning,* p. 186.

27. Jean Piaget, *The Construction of Reality in the Child,* trans. Margaret Cook (New York: Basic Books, 1954).

28. For an interesting discussion of different "adult" approaches to keyboard training, see David Barnett, *The Performance of Music: A Study in Terms of the Pianoforte* (London: Barrie & Jenkins, 1971), particularly chapter 2, "Performance as the Synthesis of the Categories of Method."

29. Taken from August Kerker, *Quotable Quotes on Education* (Detroit: Wayne State University Press, 1968).

INDEX